EDWARD HOPPER
AND THE AMERICAN IMAGINATION

WITH CONTRIBUTIONS BY PAUL AUSTER ■ ANN BEATTIE ■ TESS GALLAGHER
THOM GUNN ■ JOHN HOLLANDER ■ WILLIAM KENNEDY ■ GALWAY KINNELL
ANN LAUTERBACH ■ GAIL LEVIN ■ NORMAN MAILER ■ LEONARD MICHAELS
WALTER MOSLEY ■ GRACE PALEY ■ JAMES SALTER

EDWARD HOPPER
AND THE AMERICAN IMAGINATION

DEBORAH LYONS AND ADAM D. WEINBERG

JULIE GRAU, EDITOR

WHITNEY MUSEUM OF AMERICAN ART IN ASSOCIATION
WITH W·W· NORTON & COMPANY · NEW YORK · LONDON

Published on the occasion of the exhibition, *Edward Hopper and the American Imagination*, organized by Adam D. Weinberg, Deborah Lyons, and Beth Venn.

Whitney Museum of American Art, June 22–October 15, 1995

The exhibition is supported by generous grants from The Norman and Rosita Winston Foundation, Inc., the Exhibition Associates of the Whitney Museum, and The Chase Manhattan Bank.

Research for this exhibition and publication was supported by income from an endowment established by Henry and Elaine Kaufman, The Lauder Foundation, Mrs. William A. Marsteller, The Andrew W. Mellon Foundation, Mrs. Donald A. Petrie, Primerica Foundation, Samuel and May Rudin Foundation, Inc., The Simon Foundation, and Nancy Brown Wellin.

© 1989 Paul Auster, excerpt from *Moon Palace*. Reprinted by permission of Viking Penguin, a division of Penguin Books USA Inc. © 1995 Ann Beattie, "Cape Cod Evening" © 1995 Tess Gallagher, "From Moss-Light to Hopper with Love" © 1994 Thom Gunn, "Phaedra in the Farm House," from *Collected Poems*. Reprinted by permission of Farrar, Straus & Giroux, Inc., New York © 1971 Thom Gunn, from *Moly*. Reprinted by permission of Faber and Faber Limited, London. © 1995 John Hollander, "Sun in an Empty Room" © 1979, 1981, 1983 William Kennedy, "Francis in the Jungle," excerpt from *Ironweed*. Reprinted by permission of Viking Penguin, a division of Penguin Books USA Inc. © 1994 Galway Kinnell, "Hitchhiker," from *Imperfect Thirst*. Reprinted by permission of Houghton Mifflin Co. All rights reserved. © 1995 Ann Lauterbach, "Edward Hopper's Way" © 1995 Gail Levin, "Edward Hopper: His Legacy for Artists" © 1940 Norman Mailer, "The Greatest Thing in the World" © 1995 Leonard Michaels, "The Nothing That Is Not There" © 1995 Walter Mosley, "Crimson Shadow" © 1968, 1974 Grace Paley, "The Burdened Man," from *Enormous Changes at the Last Minute*. Reprinted by permission of Farrar, Straus & Giroux, Inc., New York, and Andre Deutsch Ltd, London. © 1988 James Salter, "Dusk," excerpt from *Dusk and Other Stories*. Reprinted by permission of North Point Press, a division of Farrar, Straus & Giroux, Inc., New York, and Peters Fraser & Dunlop Group Ltd, London.

© 1995 Whitney Museum of American Art, 945 Madison Avenue, New York, New York 10021
All rights reserved.
Printed in England

First Edition

The text of this book is composed in Monotype Bell
with the display set in Raleigh Gothic
Composition by Trufont
Book design by Antonina Krass
Cover: *Stairway*, 1949

Library of Congress Cataloging-in-Publication Data

Lyons, Deborah.
 Edward Hopper and the American imagination / Deborah Lyons and Adam D. Weinberg ; with Julie Grau, editor; with contributions by Paul Auster . . . [et al.] ; with an essay by Gail Levin.
 p. cm.
 Catalog of an exhibition of the same name at the Whitney Museum, 1995.
 1. Hopper, Edward, 1882–1967—Exhibitions. 2. Hopper, Edward, 1882–1967—Themes, motives. I. Hopper, Edward, 1882–1967. II. Weinberg, Adam D. III. Grau, Julie. IV. Whitney Museum of American Art. V. Title.
ND237.H75A4 1995 95-4133
759.13—dc20

ISBN 0-393-31329-8

W. W. Norton & Company, Inc., 500 Fifth Avenue, New York, N.Y. 10110
W. W. Norton & Company Ltd., 10 Coptic Street, London WC1A 1PU

1 2 3 4 5 6 7 8 9 0

CONTENTS

DIRECTOR'S FOREWORD

This collection of short stories and writings by American authors is a response to and an extension of the exhibition "Edward Hopper and the American Imagination," presented at the Whitney Museum of American Art. To some readers, the very idea of an "American imagination" may seem preposterous or pretentious. After all, in the post-colonial world in which we find ourselves, it is difficult enough to define a nation's culture, no less something as abstract as a national imagination. What then are we speaking of when we talk about the American artist Edward Hopper and this thing we choose to call the American imagination? Are we ascribing to Hopper such a profoundly generative influence that American artists who follow in his wake must be measured in comparison to him? Or are we implying that the continuing search for what is most essentially American about American art need go no further than the sublime paintings of this quintessential American artist? Or are we perhaps asserting that Hopper's influence was so extraordinary that its impact can be felt in every facet of the American culture?

In fact, no such claims are made in this volume, and no such grandiose questions are seriously put forth. But something remarkable can be found in this anthology, something that is far more interesting than any of the pompous assertions implied by the questions above. What seems apparent, in the range and depth of the literary and cinematic response to Edward Hopper's art, is that there *is* something to the notion of an American imagination, and though no single artist can define such an abstract concept, the clarity and the deep resonance of

Hopper's work has made it possible to picture this fully ephemeral thing.

That Hopper is so deeply imbedded in the collective unconscious of twentieth-century American writers may simply be the result of the widespread reproduction of his work. Or it may be that the themes of isolation and transcendence which run through Hopper's work continue to evoke a powerful American mythology. Perhaps it is simply that Hopper's silence literally provides the psychic space which allows us to speak, and as such inspires and then renders visible thoughts that might otherwise remain safely tucked away.

We are grateful to the thirteen authors who have agreed to share their own creative engagement with Edward Hopper's art. This book, along with an extraordinary exhibition of the greatest and most beloved Hoppers and an accompanying film series, celebrates the artist on the occasion of the long-awaited publication of the catalogue raisonné of his paintings, watercolors, and illustrations. As such it is only fitting that the illustrations of this volume be preceded by an essay by art historian Gail Levin, author of the catalogue raisonné.

As a result of Jo Hopper's magnificent bequest of more than 2,500 works by Edward Hopper, the Whitney Museum has the honor and privilege of housing the world's largest and most important collection of the artist's work. We remain dedicated to supporting Hopper scholarship, as well as to presenting the richness of his oeuvre through exhibitions, loans, and other appropriate collaborations with scholars and educational institutions around the world.

The Museum is supported in this task by Deborah Lyons who, as Adjunct Associate Curator for the Hopper Collection, works with the Curator of the Permanent Collection, Adam D. Weinberg, and Beth Venn, the Associate Curator for the Permanent Collection. The present project has been conceived and executed by this team, and I would like to take this opportunity to thank them for their continuing creativity and intelligence. This volume has been guest-edited for the Museum by Julie Grau, and we are grateful for the fine work she has done in helping to assemble such a strong cross-section of American writers.

The overall project has been supported by major grants from The Norman and Rosita Winston Foundation, Inc., and the Exhibition Associates of the Whitney Museum. We are enormously grateful to Julian and Jane Perlman for making the Winston Foundation award possible. The Exhibition Associates is a group of the

Museum's most generous individual supporters, who each year fund a specific exhibition. We are delighted to have them as our partners in this major Hopper project. The Chase Manhattan Bank has also provided corporate support for this exhibition. On behalf of the Trustees of the Museum, I would like to thank all the funders for their generosity.

David A. Ross
Alice Pratt Brown Director

INTRODUCTION

In the vision of Edward Hopper, twentieth-century America has found a compelling reflection of itself. There may be no other American painter whose imagery has imprinted itself so powerfully on the way we picture our world. The exhibition "Edward Hopper and the American Imagination" and this accompanying volume of fiction and poetry, with an essay on the visual arts by Gail Levin, pay tribute to the lasting impact this vision has had in our contemporary culture.

In Hopper's paintings we find the seemingly ordinary experiences of our individual lives elevated to something epic and timeless, and yet his work appears deceptively simple and straightforward. Hopper shares with the American writers who were his contemporaries a commitment to speak a plain language—to use an economy of means. No luscious or virtuoso brushwork interferes with what he termed the pursuit of his "most interested vision." In the writing of Hemingway and, for example, in a very early work by Norman Mailer reprinted in this volume, we see the echo of the spare visual language of Hopper. It is Hopper's spareness, along with his progressive tendency to clear out detail and incident, which allows us to project the details of our own lives into his painted world, to

see the lives projected on canvas as standing for all lives. In their pared-down, anonymous environs, Hopper's characters exist in a strangely quasi-narrative stasis. They conduct silent commerce, are bewildered travelers, or are embroiled in dysfunctional relationships in which an oddly cold sexual tension simmers under the surface. Though most suffer in their isolation, at times they stop their simple tasks, or their waiting, and by some invisible prompt, seem to seek consolation in the light and in our despoiled landscape.

Hopper's unblinking look at modern life is framed by his particular view of the American landscape—our small towns and suburbs, the open roads with the icons of automobile culture (gas stations and motels), the often gritty urban spaces of diners and movie theaters. In these works, Hopper presents glimpses of private lives of quiet despair lived within the public arena. And though much of his art is centered on the failed relationships between people or the alienation of people from their environment, Hopper can also get an almost inexplicable sense of yearning and loss from a simple rendition of a lighthouse or an old clapboard barn. Some of his appeal may lie in a nostalgia for the more accessible world these structures represent, or in the desire to see something American and, by inference, virtuous, in a landscape that now exists only in small remnants. Yet this was a world that was disappearing even as Hopper painted it, and his view was never sentimental, though it could be starkly beautiful in its strength.

We may be most drawn to Hopper's work by the odd sensation of having seen such a thing many times before—a mundane view which, when painted by Hopper, suddenly becomes cause for epiphany. As Hopper once quoted Emerson, "In every work of genius we recognize our own rejected thoughts; they come back to us with a certain alienated majesty," so our own moments of revelation are often mirrored, transcendent, in his work. Once seen, Hopper's interpretations exist in our consciousness in tandem with our own experience. We forever see a certain type of house as a Hopper house, invested perhaps with a mystery that Hopper implanted in our own vision.

What is the nature of the *frisson* one might experience on a train at night, looking out the window and finding a "Hopper painting"—a person seen through the window of a distant house, unaware of being watched? Is it that the scenes that Hopper chose to create for us are so powerful that we tend to redraw our own

experience in their terms, or do they confirm that the reality itself is intrinsically powerful and revelatory? Hopper scholar Brian O'Doherty once related Hopper's imagery to "the intimate memory-traces all of us possess, persisting from experiences, often without memory of the experience," noting that Hopper's own methods of construction are bound up with memory.[1] Witness Hopper's description of his idea for *Office at Night*: "The picture was probably first suggested by many rides on the 'L' train in New York City after dark and glimpses of office interiors that were so fleeting as to leave fresh and vivid impressions on my mind."[2]

A great many of these memories were called into service to construct a vision that was formulated foremost in the artist's mind. And, as has become increasingly apparent, Hopper created this world not only from the thing observed, but also from his observation of other imagery, in film, theater, and literature.[3] As the lives lived on Hopper's canvases were limited (this is not a world of friends, relatives, and children), so Hopper's own life was simple and singularly directed. There was the one great preoccupation of painting, and endless reading and movie- and theatergoing. The parade of representations with which he filled his life also shaped the way he pictured his world. The resulting images Hopper forged, and the imagination he formulated, have in turn been inspiration for succeeding generations of artists seeking metaphors, in words or images, to describe common experience.

In the selection of fiction and poetry that follows, writers have found inspiration in Hopper's work, or have seen in their own work reflections of Hopper's sensibility—perhaps alienation and despair, failed relationships, a mood of ultimate disillusionment or lives gone wrong, or perhaps simply the wonder of Hopper's light. It is testament to the universal range of his vision that contemporary authors of such different orientation can all be so personally touched by Hopper. These writers give voice to the very direct and deeply felt relationship viewers have with Hopper's paintings. It may be, in fact, that while we celebrate the differences between us, we search the visual arts and literature for what we share. We take refuge in the confirmation of our similarities and look to the larger truths which may underlie the individual patterns of our lives in order that we not feel so singular. And while Hopper may be master of portraying our ultimate

loneliness, he also shapes that larger truth from imagination and the incidents of our combined lives. Hopper's ability to assure us that we are not alone in our aloneness, and that we may yet find redemption in the sunlight, may explain the tremendous, often undefinable appeal his art still holds for us.

Among those who graciously offered suggestions for this volume, special thanks are due May Castleberry, Thelma Golden, John Hollander, Virginia Hooper, Karl Kirchwey, Joanne Green Mackenzie, and Emily Russell. Adam Weinberg developed an overall concept for this exhibition and his counsel, as well as Beth Venn's, was indispensable. Lauren Ross was a trusted critical reader and adviser and organized the many details of publication with care. Anita Duquette's knowledge of Hopper's palette contributed much to the quality of the reproductions. Sincere gratitude is also due to Doris Palca, at whose urging this project began. For the brave task of undertaking a rather open-ended assignment, all the authors are heartily thanked, as is Gail Levin for her thoughtful essay. Finally, many thanks to Julie Grau, who edited this book with wisdom, humor, and good judgment.

Deborah Lyons

NOTES

1. Brian O'Doherty, "Portrait: Edward Hopper," *Art in America*, 52 (December 1964), p. 76. See also Peter Schjeldahl's provocative essay "Hopperesque," in *Edward Hopper: Light Years*, exh. cat. (New York: Hirschl & Adler Galleries, 1988), pp. 5–12.

2. Edward Hopper to Norman A. Geske of the Walker Art Center, Minneapolis, letter of August 25, 1948; quoted in Gail Levin, *Edward Hopper: The Art and the Artist* (New York: Whitney Museum of American Art in association with W.W. Norton & Company, 1980), p. 58.

3. See Gail Levin, "Edward Hopper: The Influence of Theater and Film," *Arts Magazine*, 55 (October 1980), pp. 123–27, and Erika Doss, "Edward Hopper, Nighthawks, and Film Noir," *Postscript: Essays in Film and the Humanities*, 2 (Winter 1983), pp. 14–36; see also Marc Holthof, "Die Hopper-Methode: Vom 'narrativen' zum 'abstrakten' Realismus," and Paul Levine, "Edward Hopper und die amerikanische Kultur," both in *Edward Hopper, 1882–1967*, exh. cat. (Frankfurt: Schirn Kunsthalle, 1992), pp. 19–27 and 28–32, respectively. These connections are also explored by curators Adam D. Weinberg and Beth Venn in the interpretive materials accompanying this exhibition.

EDWARD HOPPER
AND THE AMERICAN IMAGINATION

LEONARD MICHAELS
THE NOTHING THAT IS NOT THERE

The painting had the exciting effect of a beautiful face, shadowy and erotic, touched with savage reds. As with a beautiful face, I couldn't get enough of it, and I wanted to be alone with it. I was tantalized by a presence beyond what I looked at. Greedy and desirous, I'd go up to the second floor of the museum and look again and again at *New York Movie*. I was sixteen, a high school senior, when I first saw the painting. I had little money and never owned anything valuable, but I could go to the museum. Alone with the painting, I felt I could almost possess it, or be possessed, as in a religious mutuality of what you see and what isn't there. I thought *New York Movie* is about this strange mutuality, about living with desire, which is the effect of movies. A movie named *Laura*, also very haunting, was released about that time in the forties, soon after Hopper finished the painting. *Laura* is about a man who falls in love with the portrait of a woman he has never met. He believes she is dead. It turns out she isn't. The man is frightened to discover that his desire has a material body. I also felt frightened,

then tortured and sickened by love. *Laura* lived and might actually be had by the man, Dana Andrews. She'd have been better off dead, I thought, but I was ferociously jealous. Played by Gene Tierney, Laura seemed impossible not to love, and far beyond possession. She was a man's dream of endless desire. I suppose every movie is like *Laura*, a woman watched from the point of view of darkness, in a world of desire and disembodied presences. Hopper called his painting—which focuses on a woman—*New York Movie*, so he seems actually to say this woman is a movie, or this movie is a woman. He had the erotic relation in mind, the relation between desire and what isn't there. He was a painter of eroticometaphysics, the basis of a philosophical life as described by Plato. Hopper joked about the idea of himself as a philosopher, but he read Plato. In fact, Hopper was a philosophical painter, known to be solitary and thoughtful, like the blond woman in his *New York Movie*. In the forties and fifties, solitude was easier to appreciate than it is today. I can remember being alone with *New York Movie*, feeling the solitude it contains. Hopper painted public places, rooms where people gathered, but with few people or nobody present. Few people went to museums during the week. Galleries were vacant for long minutes. You could stand before a painting as if it were an icon, and not hear voices on every side. There was silence in those days. It was associated with solitude, sacredness, and internal life. Silence and solitude became very great in popular music, in songs like "Deep Purple," and "Old Man River" who "don't say nuth'n," or "Blue Moon" with the lyric "I saw you standing alone / without a song of your own," or the song "These Foolish Things" which carried a mood of solitude in almost every line. "A tinkling piano in the next apartment/ Those stumbling words that told you what my heart meant/ These foolish things remind me of you." No stumbling now, no tinkling, no haunting presences. Everything is here. "In your face," we say, and "I want it now." We rap, we shriek in the raving crowd, and wear clothing big enough to hold two or three people, and walk about wearing earphones, lest we feel alone. There are no philosophers. In Hopper's era, we wore tight clothing and held each other close, saying nothing, dancing slowly, shuffling a few inches this way and that, feeling possessed, or possessed by feeling. Everyone preferred feeling to sex. I'd look at the woman in *New York Movie*, at her blue uniform and elegant high-heeled shoes, and think her shoes were too

elegant for the usherette uniform. They gave away her yearning. Around midnight, when the last movie ends, she would take off the uniform, put on a black cocktail dress, and not have to think about what shoes to wear. She had a date. They were going to a party. Of course she wasn't going anyplace; couldn't leave the theater. I only mean that for me there was drama in the painting. It was more psychologically intense than the movie on the distant, blurry screen, a rectangle near the upper left corner of the painting, like the window of a dark room. The usherette wasn't involved in any movie drama, any mechanical story told with cuts and fades while music works on your feelings, exactly the same everytime you looked. Hers was a drama in the sense of myth, the myth of Eurydice, doomed to wait at the edge of darkness. You can suppose the red flashes in the shadows are streaks of fire, and streams and gouts of blood. Eurydice stands at the edge of Hades waiting for Orpheus. The movie theater, like many others, might be called the Orpheum. Hopper's Eurydice stands against a wall, holding her chin while thinking about the party she will go to later in a Village apartment, in an old brownstone on Hudson Street, a short walk from the theater. Small crowded rooms, high ceilings, and the whole apartment overheated by clanging iron radiators. She sees herself standing in the kitchen, always the loudest, most crowded room, with a drink in one hand, cigarette in the other, laughing, feeling slightly overdressed in those shoes which have begun to hurt her feet, but free of the costume she must wear amid the Byzantine phantasmagoria of the movie house, the palace of the unreal where people go for a shot of desire and confuse it with life. A man looked at Eurydice. She'd noticed him when she walked into the party. He was standing alone beside a tall window. The instant he looked at her, she looked away and left for another room. He followed, working slowly through the crowd. Now he was beside her in the kitchen. She ignored him. She was laughing because others were laughing. Someone had told a joke. She hadn't heard it, but she laughed, making herself part of the ha-ha group; unapproachable. "Are you here alone?" he said, terrible directness in his tone. She couldn't not turn, not look at him confusedly. "What?" she said. I felt such pleasing confusion, as if I were at a movie, when looking at *New York Movie*. But I would hardly ever look at a movie twice, let alone twenty times, as I would a great painting. Still, Hopper's painting pulled me into itself, like a wonderful

movie I'd never seen. Its drama resisted understanding. "A poem," says Wallace Stevens, "must resist the intelligence/ Almost successfully." The same for a painting. Stevens' poems, like Hopper's paintings, suggest elusive meanings, like women who can't be had; at least not easily. "Are you here alone?" he said. Eurydice said, "Go away, mister." With his dark, gangsterish stare, the man resembled the actor John Garfield, but taller, meaner-looking, and handsomer though his skin was bad. Eurydice's mouth said go. Her eyes said stay. "Finish your cigarette," said the man. "We'll leave." She said, "Pardon me?" She raised an eyebrow, at once quizzical and disdainful, then smiled coldly. He waited with the patience of an intelligent animal, unsmiling. She let go of her cigarette. It fell to the linoleum floor, sticky with spilled beer. She tried to remember where she'd put her coat. All women used to be virgins, so kids were shocked to learn what their fathers had done to their mothers. Now kids are shocked by nothing, bored by a lot of things, and they do it, too. In Hopper's painting *Two on the Aisle*, a man and woman are taking seats in a largely empty theater. The man is removing his coat. The woman is placing hers over the back of her seat. It's all very ordinary, very plain. But then you think maybe the show is over. Maybe they are leaving their seats. Maybe he is putting on his coat, and she is reaching for hers. What Stevens calls "The Plain Sense of Things" is anything but plain. Stevens and Hopper looked vaguely alike, and I have long suspected they were the same person. They lived on the East Coast, two philosophical artists with a sensuous eye, committed to monolithic marriages. They loved French culture, and were self-mocking fellows who saw themselves as comedians, and were fascinated by silence and ghostly presences. Of the sea, Stevens writes, "Body, wholly body, fluttering its empty sleeves." *Wholly* puns on holy. He means whatever is, is never all there is, for there is always the weight and palpable density of ubiquitous nothingness. The nothing that is not there. Hopper says that in his paintings. His lighthouses, stark, visionary towers at the edge of the sea, stand blindly in sunlight, full of dark seeing. Stevens talks of singing beyond what you can hear. Hopper's Eurydice, in her elegant shoes, thinks of Orpheus, great hero of song who fails to save her from Hades. Horribly sad. Orpheus' singing could enchant trees and birds, but no artist could save Eurydice. Besides, if Orpheus saved her, he'd make an end to desire, an end to art. His fate was to be torn to pieces by a

horde of mythical women who then flung his head into the ocean. It continues singing, in the myth, as it floats toward the island of Lesbos. Eurydice feels guilty. She must tell Orpheus she went to the party alone and met a man. Orpheus will be upset and want to know everything. He'll never stop asking questions. He'll cry. He'll say they can't be together anymore, but he won't leave. She'll cry. It will be hard to see the man again. Now, against her hip Eurydice holds a tragic flashlight to light the way into the sumptuous and fiery vault. Only a man and a woman are seen within. They are close to each other, but not seated together. They look lonely to Eurydice. The movie has been going for a while. Many seats remain empty. It wasn't important, in Hopper's day, to see a movie from the beginning. People often arrived in the middle, which led to an expression we no longer hear, "This is where I came in." The empty seats, and the man and woman who are not together, make the theater seem to loom all about, luxuriously overwrought, ceiling aglow with bulging red nipple-lights above red seats. In its luxurious excess, it seems hollow and wasted. A column of thick, massively involved carving stands between the people and Eurydice. It has a lacerated, bleeding, meaty look. You hardly notice it at first. Eurydice doesn't notice it at all, doesn't know it is the body of Orpheus. But who can tell what she notices? The way her head is turned, she might be willfully ignoring the column. She is petulant. Orpheus failed to save her. He got torn to pieces and she remained stuck in a dull job, in a silly uniform. The uniform looks very good on her, even rather exciting, but she wants to get rid of it and put on her dress and go to the party. She wants adventure. Orpheus' head is singing while poor Eurydice, without a song of her own, dreams of being saved from this lush and funereal theater, built for the primal drama of sacrifice, fire, blood, and shadows. The victims' ghosts play indistinctly on the cold blue distant screen. A guilty red line runs down the trouser leg of Eurydice's uniform. It means her connection to the theater is both formal and metaphorical. The theater is, formally, her workplace. Metaphorically, it is her body, an interior darkness of desire, pleasure, and fantasy. She stands below red-shaded lamps that cast intense light, catching the edges of her hair and giving a morbid whiteness to her temple and wrist. Perhaps the tendency of her thoughts is grim, like the woman in Stevens' poem "Sunday Morning," published about fifteen years before Hopper finished his paint-

ing. In the poem's sensual setting, a woman thinks of desire and sacrifice, and wonders, "Why should she give her bounty to the dead?" Her working-girl sister, Eurydice, might ask the same question in her sensual movie theater. I heard voices in the adjoining gallery. My trance was broken. I left quickly, as though I'd been discovered doing something illegal, maybe standing too close to Eurydice, like the gangsterish man, and I'd startled her. But it was I who was startled. She heard no voices. She was thinking; heard nothing. People used to think. There used to be silence, solitude, and thinking. Hopper was known for silence and solitude, living half the year in semi-isolation on Cape Cod, and he made paintings about the drama of thinking. That was almost fifty years ago. We no longer care about history. Still, from Hopper's paintings, you get an idea of what thinking felt like. In one painting, a fully clothed man sits on the edge of a bed, his back to the naked bottom of a woman. She sleeps. Of her nakedness, he is oblivious. He is thinking. The wife of the philosopher Heidegger used to say to unwelcome visitors, "He is thinking." Heidegger wrote a monograph called *What Is Thinking?* and spent his life thinking about thinking. In another of Hopper's paintings, a fully clothed woman sits at the edge of a bed with her back to a naked man. His nakedness means nothing to her. She is thinking. Wearing clothes means thinking is a personal experience, unlike nakedness, or impersonal, instinctive life. Today we are mad about nakedness. Some artists say, when working from live models, you must wait until they stop thinking. Too personal. Too old-fashioned. Thinking violates our obsession with surfaces. We hang totally black and totally white paintings in museums while outside, everywhere you look, graffiti attack surfaces. Names shout for recognition. They long for they know-not-what. There used to be selves before there were surfaces. As for Eurydice, she couldn't be less naked. She's in a uniform, immersed in her thinking self. The theater critic Friedrich Nietzsche would say she is an Apollonian figure in a Dionysian setting. Many theaters are called The Apollo. The best-known is in Harlem, and it becomes Dionysian when the entertainer, usually a singer, fails to enrapture the crowd. Eurydice is tightly contained in a bright blue uniform, consistent with her thinking mood. All about are the wild forms and strong reds of the theater where instinctive life is externalized, or made dramatic; that is, into forms of nakedness. People used to say "naked passion," or "raw emotion," the

very thing you see in the Orphic column in the center of the painting, so violently carved. Stevens writes: "To lay his brain upon the board / And pick the acrid colors out." He means you can tear off Orpheus' head, but can't see the singing or make it stop. I could have taken the subway downtown to Sheridan Square, which was only a few blocks from Hopper's movie theater, but Eurydice would be gone. She'd left years earlier, in 1939, to stand in *New York Movie*. It was the year the Hitler-Stalin pact was signed and Poland was invaded. Eurydice belongs to a moment, like the appointments of the theater. In a more philosophical sense, she is a property of time. There used to be time. Guys would say they "made time" with a girl. There used to be girls. Now there's just guys, and nothing like time in the rage and blare of movies or New York City's hyperflux. There used to be plenty of time. There used to be day and night. There was even a song called "Night and Day," which is utterly different from "A Hard Day's Night." In the thirties, forties, and fifties there was day and there was night. The distinction is biblical, verses four and five of Genesis. Hopper could put the hours into his paintings, the embrace of their shadows, their particular stillness, particular light. He painted a woman sitting up in bed as sunlight comes through a window. He painted a woman standing naked in sunlight before the window. People used to look out of windows. The woman is naked, but not for us to gape at, which would be obscene. There used to be obscenity. Artists ordinarily avoided it, but that has changed. There used to be a distinction, like the distinction between day and night, between private and public. There used to be privacy. In Hopper's painting, the light in the window has called the woman to look, to see moments of the day, the time. Time is real, according to the philosopher Henri Bergson. He means organic rather than abstract. He means it's part of creation, and it existed long before we began using it in clocks. Bergson, who died in Nazi-occupied Paris, was contemporary with Hopper and influenced Wallace Stevens. What Hopper sees, Bergson means. Hopper's usherette is adrift in her private thoughts, in the medium of real time, unlike the manufactured public time of movie darkness. There used to be real time and solitude and stillness. There used to be individual people, Apollonians, as well as the Dionysian public. Politicians used to say "Americans," but that implies individuals, so they now say "The American People." No president now says to the American people, as Roosevelt

used to say, "You and I both know." A body was once the reality of a soul. "I love you body and soul," said the popular song, yearning for a sacred equilibrium of inner and outer. The song asks much of the little word "and." Burdens it with pathos, makes it hopelessly banal. Hopper didn't worry about words, certainly not "and." He finds sacred equilibrium in paintings of wordless silence, moments of stillness, either indoors or out in the silent light of nature. Even nighttime in Hopper's paintings can seem darkly luminous, or strangely theatrical, noir-movie-like, a sensuous and enveloping darkness, alluring yet scary, as if something out there can't be dispelled by electricity. Hopper loved movies. They influenced his work, and movies have long paid tribute to Hopper. His New York movie theater is the eye of darkness. Hopper's people are sometimes indoors, seen through windows from the point of view of darkness, or they have left the house to be in nature, in the ancient light. There used to be inner and outer, indoors and outdoors, you and nature. There used to be nature. People left the house to be within its light. There used to be light.

ANN BEATTIE
CAPE COD EVENING

Our neighbor on Cape Cod the summer of 1939 was a painter. Ace avoided him whenever he could. Most things—Mr. Hopper included—drove Ace crazy: the daily grass mowing across the street (the other neighbor's son was retarded. That's what he did, beginning when the sun was strongest); Shirlene's letters, asking for money (paper punctured by the fountain pen, puddles of blue-black ink a landslide that followed behind as she toppled down the page in her excited desperation). There were real problems: Mother, suffering from heart disease; Little Roy running up such gambling debts he lost the gas station; my former husband, Lew Dial, persuading our son to work in a factory with him in Buffalo, New York, instead of going to study medicine the way he'd promised his grandfather he would. Now people think of Cape Cod and they hear that awful song in their heads, or they think of President Kennedy's family compound in Hyannis. Everywhere you look in the summer, the roads are jammed and people are buying candles shaped like Santas and Christmas trees. Then, let me tell you, Cape Cod was emptiness and working people. The house you see in Mr. Hopper's painting

burned the summer after Ace finally finished painting it. He'd been helped (not enough, according to him) by two brothers who drifted through and stayed for a month to make money doing chores. At night they slept in our shed. This was a fairly common thing. The way they cavorted on the lawn wasn't, but I liked their high spirits: they did cartwheels and handstands, showing off for each other in the evening, after they'd finished the day's work. They were as puppyish as their collie, and as unpredictable as their kitten that ran away and never was found, though who could blame it, after being slung in a sack on a stick? It was just part of their baggage when they first knocked on the front door. Next day it was gone, and we were all involved in the search, the neighbor's boy swearing he'd seen it climb a tree and then ascend to heaven. When he dropped in that detail, we went back to looking for it on the ground. The dog sniffed everywhere, acting more like a full-grown bloodhound than a collie, but to tell the truth, it was more interested in finding something to eat, or the exact right place to pee.

The men were named Jones (that was Mr. Miles's first name) and Chesapeake. According to them, they could do absolutely anything, though except for frying a good egg (Chesapeake) and painting very neatly, but much too slowly (Jones; Chesapeake was mediocre, at best, at painting), the only thing they really excelled at was their odd acrobatics: taking off to flip in the air from a standing position; curling into a ball and rolling, gathering speed as they rolled across our perfectly flat field. One night Jones almost crashed into the tree from which the cat had reportedly sprouted wings and flown to heaven. You would have believed he was a hoop, rolling downhill. Ace was speechless, he was so alarmed. He couldn't even get words out, just ran after him and blocked his way, ended up in a pile with Jones, and it was like the cartoons: you could all but see electrical charges in the air, dizzy stars drawn above their heads, question marks and exclamation points. The dog got into the fracas and nipped Ace's heel. Chesapeake, who actually did hold his sides when he laughed—probably because he was so thin his ribs might have popped out of his body otherwise—clapped his hands as he gasped for air, he was so amused. We had lemonade afterwards and agreed that in some ways, men were likely to remain boys. It was a funny night, though not necessarily the funniest we ever passed with Jones and Chesapeake, when I think about Chesapeake's abilities as a mimic and Jones' recreation of Charlie Chaplin routines.

On the evening I've been describing, Mr. Hopper's wife, Jo, happened to be outside, working in the garden at their house. I beckoned for her to come over, but she let me know by waving and pointing to the ground that she was busy with the flowers. Nevertheless, she must have let him know about what had gone on, because he asked Ace about "the circus" the next day. He said he was sorry he'd missed the circus, and at first Ace didn't know what he was talking about; could a carnival have come to town we hadn't known about? "Well," Ace said he told Mr. Hopper, "you look out the window most nights, those two will be spinning and doing headstands. I'm surprised you haven't seen it already."

Mr. Hopper had missed out on observing the fun because he had been landscape painting. Ace, who was never inordinately fond of Mr. Hopper, said that whenever Mr. Hopper mentioned the landscape, he rolled his eyes upward, as if what he really meant to say was the sky.

It was getting on to summer's end, as they talked. The air had changed. The light. The dog, who liked Mr. Hopper much more than Ace, had fallen on his back to writhe on the ground and try, with its paws, to push Mr. Hopper from where he was standing. I'd come out from the kitchen to let Ace know dinner was almost ready. The collie snorted when it saw me and bounded to my side. "Must be nice to have so many things to entertain you," Mr. Hopper said, bending to scratch the dog behind its ears. "When the landscape talks, I have to stay absolutely silent, to listen. Sort of like having a circus going on, but not being able to clap or laugh, for fear you'll miss something."

Ace usually didn't question people when they spoke. It wasn't his way. He said what he had to say, and he didn't seem to listen to anybody's reaction. When they spoke, he usually just took it in silently—though you can bet that a lot of the time, I heard exactly what Ace thought about somebody's comments afterwards. The thing that Mr. Hopper had said, though, provoked Ace. It provoked him because, as he later admitted to me, it was the straw that broke the camel's back. Because that summer, out of a job, stuck in a house with me, his older sister, whom he'd always regarded as a surrogate mother because of Mother's near-constant indisposition while he was growing up—that summer, Ace felt sure he was losing ground. That's why whatever ridiculous thing the neighbor's retarded son said upset him inordinately. That's why he never quite got in the spirit of

Jones and Chesapeake's antics—because they saw the world as absurd, but Ace was only afraid of it. Mr. Hopper, though, was making a living, and in a quite unconventional way. So: Mr. Hopper, who was one up on Ace, was at the very least to be listened to . . . but what had he just said? I saw the surprise, the absolute lack of comprehension, cross Ace's face. "You're saying the trees talk to you?" he said.

"In a manner of speaking," Mr. Hopper said.

"Then did you ever see a cat in a tree fly straight up to heaven?" Ace asked.

"Maybe if I keep looking," Mr. Hopper said. He was bemused. He wasn't bemused with Ace, he was bemused by himself, but I knew Ace didn't see that.

"We had to give up," Ace said. "Only Roy, over there, saw it," he said, nodding toward the neighbor's house. "Rest of us think the cat ran away."

Mr. Hopper hesitated a moment, then clapped me on the shoulder. When he first extended his hand, I thought he'd taken bad aim for a handshake, but then his hand squeezed the top of my shoulder. He was giving me courage. He had seen that my brother had no desire to imagine, which was enough to make him take his leave instantly, waving his hand the way I've heard the Queen of England waves from her carriage, greeting or taking leave of everyone, but of no one in particular.

That night, at dinner, I said: "You've heard music and it's made you imagine a waterfall. Or fairies dancing."

"Crazy people," Ace said. "You think about it. I'm surrounded by 'em."

"He only meant that the landscape put him in a particular mood. That he could communicate with it."

He glared at me, then at his soupbowl.

"How are you so smart?" he said. "You married a gambler who ran off with a waitress. You promised Daddy that Henry'd go to medical school, and where is he but a factory in Buffalo, New York, where it's probably already snowing, and he'll be at that factory all of his life."

"I didn't say I was smart," I said. "One thing I do understand, though, Ace, is that when and if something like the landscape speaks to you, it's magic, and you'd better listen."

"Crazy," he said again, and cut a thick slice of bread.

We were contentious, because somebody had to find a way to get more money to Shirlene. It was her house we were in, having said we'd pay her rent while she was off looking for a job in New York City. We'd assumed Ace could get the tugboat work he'd been promised, but it had never materialized. And because that morning a letter had come with more bad news, and by now we were both sure that by winter, Mother would be dead. What he said was true: I'd made mistakes I didn't seem to be able to recover from—at least financially. And Henry was lost to me, always influenced by his father, not enough self-confidence to fill a thimble.

Things weren't very cheerful, so I was happy for the collie, and its playfulness that gave us something to think about other than ourselves. The fact that Jones and Chesapeake left it behind when they disappeared one morning seemed to me a real kindness, not a burden. It was an entertaining dog, a rascal, sleek-coated in spite of mediocre feedings, quiet when we insisted on that. It learned everything we taught it, and it was a mouser, too, as good as any cat.

In August, I went over to the Hoppers' house. She'd asked me to make a dress, which I'd done two fittings for and still it wasn't exactly right, which we both could see. She shrugged around inside, tried to help me adjust the shoulders. This happens sometimes, for a reason I can't explain, except to say that the dress actually resists. It's as if it just doesn't want to be worn by that particular person. As if it could speak and say, *this is wrong*. I pinned it again, apologizing. She was nice about it, and I worried that maybe that was because she didn't have the money, though that was probably irrational. I really needed the money that day. I was hoping to redo the dress before evening, so I could send Shirlene the money in the next day's mail.

"I haven't seen your acrobats lately," Mrs. Hopper said.

"They disappeared without even a note," I said. "Ace says they were mad that it was such a big job to paint the house. You'd think we'd gone out and found them and misled them, or something, when what they did was show up hungry on our doorstep, with no great skills and nothing to eat and nowhere to sleep."

"He wanted to paint them. He'll be upset they're gone," Mrs. Hopper said.

"Mr. Hopper wanted to paint those two men?"

She nodded.

"Well," I said. "They left without even so much as a nod goodbye."

"Restless," she said. "Everybody's that way now. On the move."

I had finished lengthening the hem. "If they come back, I'll let you know," I said, talking through the pins in my teeth.

"In fact," she said, " I think he wanted to paint all of you. Not just the men."

"Paint us? My brother and me?"

"Yes," she said.

"Oh, we don't know how to model," I said, suddenly embarrassed.

"To tell you the truth, he may have been thinking of the house."

Why was I suddenly so disappointed? It had just been painted; I should be proud of the house. Also, what I'd told her was true: I'd be self-conscious posing for Mr. Hopper. Ace, of course, probably wouldn't even consider sitting still.

"Yes, I do think that's what he was thinking of," she said, letting me help her out of the dress.

As I lifted it over her head, I was lost in thought, creating the dress I'd wear in the painting. I could make it from the lovely blue fabric I had in the house. The lady who bought the material decided last week that it didn't flatter her and told me to hold off making it. I could trade her my services for the material she didn't want, let her pick out some other fabric. He might come intending to paint the house, but once he saw me in the dress, he would decide, instead, to paint my portrait. Imagine what that would be like: appearing in a painting, when I never even had a photograph of myself on my wedding day! Not exactly a chance to do things over, but a substitute for what I'd missed. I'd be in my favorite color, blue, instead of the white dress I wore to my wedding. I'd look confident, not young and nervous and falsely hopeful.

What a sweet notion: to imagine I might re-create the past, while Mr. Hopper painted the present. Then, like the dog, I could sense danger in the air, take notice of which way the wind was blowing, be skeptical because stars shone in my eyes, not overhead. Naturally, I would not marry the wrong man. My life would be different. And so would the world.

Such was my vanity, in late summer, 1939. Within a week—which makes me wonder: would it have been too early, just too early, for Mr. Hopper to see the future clearly?—the world would be at war.

GALWAY KINNELL
HITCHHIKER

After a moment, the driver, a salesman
for Travelers Insurance heading for
Topeka, said, "What was that?"
I, in my Navy uniform, still useful
for hitchhiking though the war was over,
said, "I think you hit somebody."
I knew he had. The round face, opening
in surprise as the man bounced off the fender,
had given me a look as he swept past.
"Why didn't you say something?" The salesman
stepped hard on the brakes. "I thought you saw,"
I said. I didn't know why. It came to me
I could have sat next to this man all the way
to Topeka without saying a word about it.

He opened the car door and looked back.
I did the same. At the roadside,
in the glow of a streetlight, was a body.
A man was bending over it. For an instant
it was myself, in a time to come,
bending over the body of my father.
The man stood and shouted at us, "Forget it!
He gets hit all the time!" Oh.
A bum. We were happy to forget it.
The rest of the way, into dawn in Kansas,
when the salesman dropped me off, we did not speak,
except, as I got out, I said, "Thanks,"
and he said, "Don't mention it."

PAUL AUSTER
FROM MOON PALACE

I had no clear idea of what I was going to do. When I left my apartment on the
first morning, I simply started walking, going wherever my steps decided to take
me. If I had any thought at all, it was to let chance determine what happened,
to follow the path of impulse and arbitrary events. My first steps went south, and
so I continued to go south, realizing after one or two blocks that it would prob-
ably be best to leave my neighborhood anyway. Note how pride weakened my
resolve to stand aloof from my misery, pride and a sense of shame. A part of me
was appalled by what I had allowed to happen to myself, and I did not want to
run the risk of seeing anyone I knew. Walking north meant Morningside
Heights, and the streets up there would be filled with familiar faces. If not
friends, I was sure to bump into people who knew me by sight: the old crowd
from the West End bar, classmates, former professors. I did not have the courage

to withstand the looks they would give me, the stares, the mystified second glances. Worse than that, I was horrified by the thought of having to talk to any of them.

I headed south, and for the rest of my sojourn in the streets, I did not set foot on Upper Broadway again. I had something like sixteen or twenty dollars in my pocket, along with a knife and a ballpoint pen; my knapsack contained a sweater, a leather jacket, a toothbrush, a razor with three fresh blades, an extra pair of socks, skivvies, and a small green notebook with a pencil stuck in the spiral binding. Just north of Columbus Circle, less than an hour after I had launched out on my pilgrimage, an improbable occurrence took place. I was standing in front of a watch-repair shop, studying the mechanism of some ancient timepiece in the window, when I suddenly looked down and saw a ten-dollar bill lying at my feet. I was too shaken to know how to react. My mind was already in a tumult, and rather than simply call it a stroke of good luck, I persuaded myself that something profoundly important had just happened: a religious event, an out-and-out miracle. As I bent down to pick up the money and saw that it was real, I began to tremble with joy. Everything was going to work out, I told myself, everything was going to come out right in the end. Without pausing to consider the matter any further, I walked into a Greek coffee shop and treated myself to a farmer's breakfast: grapefruit juice, cornflakes, ham and eggs, coffee, the works. I even bought a pack of cigarettes after the meal was over and remained at the counter to drink another cup of coffee. I was seized by an uncontrollable sense of happiness and well-being, a newfound love for the world. Everything in the restaurant seemed wonderful to me: the steaming coffee urns, the swivel stools and four-slotted toasters, the silver milkshake machines, the fresh muffins stacked in their glass containers. I felt like someone about to be reborn, like someone on the brink of discovering a new continent. I watched the counterman go about his business as I smoked another Camel, then turned my attention to the frowsy waitress with the fake red hair. There was something inexpressibly poignant about both of them. I wanted to tell them how much they meant to me, but I couldn't get the words out of my mouth. For the next few minutes, I just sat there in my own euphoria, listening to myself think. My mind was a blithering gush, a pandemonium of rhapsodic thoughts. Then my cigarette burned down to a stub, and I gathered up my forces and moved on.

By midafternoon, the weather had become stifling. Not knowing what else to do with myself, I went into one of the triple-feature movie theaters on Forty-second Street near Times Square. It was the promise of air conditioning that lured me in, and I entered the place blindly, not even bothering to check the marquee to see what was playing. For ninety-nine cents, I was willing to sit through anything. I took a seat in the smoking section upstairs, then slowly worked my way through ten or twelve more Camels as I watched the first two films, the titles of which I now forget. The theater was one of those gaudy dream palaces built during the Depression: chandeliers hanging in the lobby, marble staircases, rococo embellishments on the walls. It was not a theater so much as a shrine, a temple built to the glory of illusion. Owing to the temperatures outside, the better part of New York's derelict population seemed to be in attendance that day. There were drunks and addicts in there, men with scabs on their faces, men who muttered to themselves and talked back to the actors on the screen, men who snored and farted, men who sat there pissing in their pants. A crew of ushers patrolled the aisles with flashlights, checking to see if anyone had fallen asleep. Noise was tolerated, but it was apparently against the law to lose consciousness in that theater. Each time an usher found a sleeping man, he would shine his flashlight directly in his face and tell him to open his eyes. If the man didn't respond, the usher would walk over to his seat and shake him until he did. The recalcitrant ones were ejected from the theater, often to loud and bitter protests. This happened half a dozen times throughout the afternoon. It didn't occur to me until much later that the ushers were probably looking for dead bodies.

I didn't let any of it bother me. I was cool, I was calm, I was content. Given the uncertainties that were waiting for me once I walked out of there, I had a remarkably firm grip on things. Then the third feature began, and all of a sudden I felt the ground shift inside me. It turned out to be *Around the World in 80 Days*, the same movie I had seen with Uncle Victor back in Chicago eleven years before. I thought it would give me pleasure to see it again, and for a short time I considered myself lucky to be sitting in the theater on the precise day when this film was being shown—this film, of all the films in the world. It seemed as though fate was watching out for me, as though my life was under the protection of benevolent spirits. Not long after that, however, I discovered strange and unaccountable tears forming behind my eyes. At the moment when Phileas Fogg

and Passepartout scrambled into the hot-air balloon (somewhere in the first half hour of the film), the ducts finally gave way, and I felt a flood of hot, salty tears burning down my cheeks. A thousand childhood sorrows came storming back to me, and I was powerless to ward them off. If Uncle Victor could have seen me, I thought, he would have been crushed, he would have been sick at heart. I had turned myself into a nothing, a dead man tumbling headfirst into hell. David Niven and Cantinflas were gazing out from the carriage of their balloon, floating over the lush French countryside, and I was down in the darkness with a bunch of drunks, sobbing out my wretched life until I couldn't breathe anymore. I stood up from my seat and made my way for the exit downstairs. Outside, the early evening assaulted me with light, surrounded me with sudden warmth. This is what I deserve, I said to myself. I've made my nothing, and now I've got to live in it.

It went on like that for the next several days. My moods charged recklessly from one extreme to another, shunting me between joy and despair so often that my mind became battered from the journey. Almost anything could set off the switch: a sudden confrontation with the past, a chance smile from a stranger, the way the light fell on the sidewalk at any given hour. I struggled to achieve some equilibrium within myself, but it was no use: everything was instability, turmoil, outrageous whim. At one moment I was engaged in a philosophical quest, supremely confident that I was about to join the ranks of the illuminati; at the next moment I was in tears, collapsing under the weight of my own anguish. My self-absorption was so intense that I could no longer see things for what they were: objects became thoughts, and every thought was part of the drama being played out inside me.

It had been one thing to sit in my room and wait for the sky to fall on top of me, but it was quite another to be thrust out into the open. Within ten minutes of leaving the theater, I finally understood what I was up against. Night was approaching, and before too many more hours had passed, I would have to find a place to sleep. Remarkable as it seems to me now, I had not given any serious thought to this problem. I had assumed that it would somehow take care of itself, that trusting in blind dumb luck would be sufficient. Once I began to survey the prospects around me, however, I saw how dismal they really were. I was

not going to stretch out on the sidewalk like some bum, I said to myself, lying there for the whole night wrapped in newspapers. I would be exposed to every madman in the city if I did that; it would be like inviting someone to slit my throat. And even if I wasn't attacked, I was sure to be arrested for vagrancy. On the other hand, what possibilities for shelter did I have? The thought of spending the night in a flophouse repulsed me. I couldn't see myself lying in a room with a hundred down-and-outs, having to breathe their smells, having to listen to the grunts of old men buggering each other. I wanted no part of such a place, not even if I could get in for free. There were the subways, of course, but I knew in advance that I would never be able to close my eyes down there—not with the lurching and the noise and the fluorescent lights, not when I thought some transit cop might be coming along at any moment to crash his nightstick against the soles of my feet. I wandered around in a funk for several hours, trying to come to a decision. If I eventually chose Central Park, it was only because I was too exhausted to think of anything else. At about eleven o'clock I found myself walking down Fifth Avenue, absently running my hand along the stone wall that divides the park from the street. I looked over the wall, saw the immense, uninhabited park, and realized that nothing better was going to present itself to me at that hour. At the very worst, the ground would be soft in there, and I welcomed the thought of lying down on the grass, of being able to make my bed in a place where no one could see me. I entered the park somewhere near the Metropolitan Museum, trekked out toward the interior for several minutes, and then crawled under a bush. I wasn't up to looking any more carefully than that. I had heard all the horror stories about Central Park, but at that moment my exhaustion was greater than my fear. If the bush didn't keep me hidden from view, I thought, there was always my knife to defend myself with. I bunched up my leather jacket into a pillow, then squirmed around for a while as I tried to get comfortable. As soon as I stopped moving, I heard a cricket chirp in an adjacent shrub. Moments later, a small breeze began to rustle the twigs and slender branches around my head. I didn't know what to think anymore. There was no moon in the sky that night, not a single star. Before I remembered to take the knife out of my pocket, I was fast asleep.

I woke up feeling as though I had slept in a boxcar. It was just past dawn, and

my entire body ached, my muscles had turned into knots. I extricated myself gingerly from the bush, cursing and groaning as I moved, and then took stock of my surroundings. I had spent the night at the edge of a softball field, sprawled out in the shrubbery behind home plate. The field was situated in a shallow dip of land, and at that early hour a speckle of thin gray fog was hanging over the grass. Absolutely no one was in sight. A few sparrows swooped and chittered in the area around second base, a blue jay rasped in the trees overhead. This was New York, but it had nothing to do with the New York I had always known. It was devoid of associations, a place that could have been anywhere. As I turned this thought over in my mind, it suddenly occurred to me that I had made it through the first night. I would not say that I rejoiced in the accomplishment—my body hurt too much for that—but I knew that an important piece of business had been put behind me. I had made it through the first night, and if I had done it once, there was no reason to think I couldn't do it again.

I slept in the park every night after that. It became a sanctuary for me, a refuge of inwardness against the grinding demands of the streets. There were eight hundred and forty acres to roam in, and unlike the massive gridwork of buildings and towers that loomed outside the perimeter, the park offered me the possibility of solitude, of separating myself from the rest of the world. In the streets, everything is bodies and commotion, and like it or not, you cannot enter them without adhering to a rigid protocol of behavior. To walk among the crowd means never going faster than anyone else, never lagging behind your neighbor, never doing anything to disrupt the flow of human traffic. If you play by the rules of this game, people will tend to ignore you. There is a particular glaze that comes over the eyes of New Yorkers when they walk through the streets, a natural and perhaps necessary form of indifference to others. It doesn't matter how you look, for example. Outrageous costumes, bizarre hairdos, T-shirts with obscene slogans printed across them—no one pays attention to such things. On the other hand, the way you act inside your clothes is of the utmost importance. Odd gestures of any kind are automatically taken as a threat. Talking out loud to yourself, scratching your body, looking someone directly in the eye: these deviations can trigger off hostile and sometimes violent reactions from those around you. You must not stagger or swoon, you must not clutch the walls, you must

not sing, for all forms of spontaneous or involuntary behavior are sure to elicit stares, caustic remarks, and even an occasional shove or kick in the shins. I was not so far gone that I received any treatment of that sort, but I saw it happen to others, and I knew that a day might eventually come when I wouldn't be able to control myself anymore. By contrast, life in Central Park allowed for a much broader range of variables. No one thought twice if you stretched out on the grass and went to sleep in the middle of the day. No one blinked if you sat under a tree and did nothing, if you played your clarinet, if you howled at the top of your lungs. Except for the office workers who lurked around the fringes of the park at lunch hour, the majority of people who came in there acted as if they were on holiday. The same things that would have alarmed them in the streets were dismissed as casual amusements. People smiled at each other and held hands, bent their bodies into unusual shapes, kissed. It was live and let live, and as long as you did not actively interfere with what others were doing, you were free to do what you liked.

There is no question that the park did me a world of good. It gave me privacy, but more than that, it allowed me to pretend that I was not as bad off as I really was. The grass and the trees were democratic, and as I loafed in the sunshine of a late afternoon, or climbed among the rocks in the early evening to look for a place to sleep, I felt that I was blending into the environment, that even to a practiced eye I could have passed for one of the picnickers or strollers around me. The streets did not allow for such delusions. Whenever I walked out among the crowds, I was quickly shamed into an awareness of myself. I felt like a speck, a vagabond, a pox of failure on the skin of mankind. Each day, I became a little dirtier than I had been the day before, a little more ragged and confused, a little more different from everyone else. In the park, I did not have to carry around this burden of self-consciousness. It gave me a threshold, a boundary, a way to distinguish between the inside and the outside. If the streets forced me to see myself as others saw me, the park gave me a chance to return to my inner life, to hold on to myself purely in terms of what was happening inside me. It is possible to survive without a roof over your head, I discovered, but you cannot live without establishing an equilibrium between the inner and outer. The park did that for me. It was not quite a home, perhaps, but for want of any other shelter,

it came very close.

Unexpected things kept happening to me in there, things that seem almost impossible to me as I remember them now. Once, for example, a young woman with bright red hair walked up to me and put a five-dollar bill in my hand—just like that, without any explanation at all. Another time, a group of people invited me to join them on the grass for a picnic lunch. A few days after that, I spent the whole afternoon playing in a softball game. Considering my physical condition at the time, I turned in a creditable performance (two or three singles, a diving catch in left field), and whenever my team was at bat, the other players kept offering me things to eat and drink and smoke: sandwiches and pretzels, cans of beer, cigars, cigarettes. Those were happy moments for me, and they helped to carry me through some of the darker stretches when my luck seemed to have run out. Perhaps that was all I had set out to prove in the first place: that once you throw your life to the winds, you will discover things you had never known before, things that cannot be learned under any other circumstances. I was half-dead from hunger, but whenever something good happened to me, I did not attribute it to chance so much as to a special state of mind. If I was able to maintain the proper balance between desire and indifference, I felt that I could somehow will the universe to respond to me. How else was I to judge the extraordinary acts of generosity that I experienced in Central Park? I never asked anyone for anything, I never budged from my spot, and yet strangers were continually coming up to me and giving me help. There must have been some force emanating from me into the world, I thought, some indefinable something that made people want to do this. As time went on, I began to notice that good things happened to me only when I stopped wishing for them. If that was true, then the reverse was true as well: wishing too much for things would prevent them from happening. That was the logical consequence of my theory, for if I had proven to myself that I could attract the world, then it also followed that I could repel it. In other words, you got what you wanted only by not wanting it. It made no sense, but the incomprehensibility of the argument was what appealed to me. If my wants could be answered only by not thinking about them, then all thoughts about my situation were necessarily counterproductive. The moment I began to embrace this idea, I found myself staggering along an impossible tightrope of

consciousness. For how do you not think about your hunger when you are always hungry? How do you silence your stomach when it is constantly calling out to you, begging to be filled? It is next to impossible to ignore such pleas. Time and again, I would succumb to them, and once I did, I automatically knew that I had destroyed my chances of being helped. The result was inescapable, as rigid and precise as a mathematical formula. As long as I worried about my problems, the world would turn its back on me. That left me no choice but to fend for myself, to scrounge, to make the best of it on my own. Time would pass. A day, two days, perhaps even three or four, and little by little I would purge all thoughts of rescue from my mind, would give myself up for lost. It was only then that any of the miraculous occurrences ever took place. They always struck like a bolt from the blue. I could not predict them, and once they happened, there was no way I could count on seeing another. Each miracle was therefore always the last miracle. And because it was the last, I was continually being thrown back to the beginning, continually having to start the battle all over again.

I spent a portion of every day looking for food in the park. This helped to keep expenses down, but it also allowed me to postpone the moment when I would have to venture into the streets. As time went on, the streets were what I came to dread most, and I was willing to do almost anything to avoid them. The weekends were particularly helpful in that regard. When the weather was good, enormous numbers of people came into the park, and I soon learned that most of them had something to eat while they were there: all manner of lunches and snacks, stuffing themselves to their hearts' content. This inevitably led to waste, gargantuan quantities of discarded but edible food. It took me a while to adjust, but once I accepted the idea of putting things into my mouth that had already touched the mouths of others, I found no end of nourishment around me. Pizza crusts, fragments of hot dogs, the butt ends of hero sandwiches, partially filled cans of soda—the meadows and rocks were strewn with them, the trash bins were fairly bursting with the abundance. To undercut my squeamishness, I began giving funny names to the garbage cans. I called them cylindrical restaurants, pot-luck dinners, municipal care packages—anything that could deflect me from saying what they really were. Once, as I was rummaging around in one of them, a policeman came up to me and asked what I was doing. I stammered for

a few moments, completely off guard, and then blurted out that I was a student. I was working on an urban studies project, I said, and had spent the entire summer doing statistical and sociological research on the contents of city garbage cans. To back up my story, I reached into my pocket and pulled out my Columbia ID card, hoping that he wouldn't notice it had expired in June. The policeman studied the picture for a moment, looked at my face, studied the picture again for comparison, and then shrugged. Just be sure you don't put your head in too far, he said. You're liable to get stuck in one if you don't watch out.

I don't mean to suggest that I found this pleasant. There was no romance in stooping for crumbs, and whatever novelty it might have had in the beginning quickly wore off. I remembered a scene from a book I had once read, *Lazarillo de Tormes,* in which a starving hidalgo walks around with a toothpick in his mouth to give the impression that he had just eaten a large meal. I began affecting the toothpick disguise myself, always making a point to grab a fistful of them when I went into a diner for a cup of coffee. They gave me something to chew on in the blank periods between meals, but they also added a certain debonair quality to my appearance, I thought, an edge of self-sufficiency and calm. It wasn't much, but I needed all the props I could find. It was especially difficult to approach a garbage can when I felt that others were watching me, and I always made an effort to be as discreet as possible. If my hunger generally won out over my inhibitions, that was because my hunger was simply too great. On several occasions, I actually heard people laughing at me, and once or twice I saw small children pointing in my direction, telling their mothers to look at the silly man who was eating garbage. Those are things you never forget, no matter how much time has passed. I struggled to keep my anger under control, but I can recall at least one episode in which I snarled so fiercely at a little boy that he burst into tears. By and large, however, I managed to accept these humiliations as a natural part of the life I was living. In my strongest moods, I was able to interpret them as spiritual initiations, as obstacles that had been thrown across my path to test my faith in myself. If I learned how to overcome them, I would eventually reach a higher stage of consciousness. In my less exultant moods, I tended to look at myself from a political perspective, hoping to justify my condition by treating it as a challenge to the American way. I was an

instrument of sabotage, I told myself, a loose part in the national machine, a misfit whose job was to gum up the works. No one could look at me without feeling shame or anger or pity. I was living proof that the system had failed, that the smug, overfed land of plenty was finally cracking apart.

Thoughts like these took up a large portion of my waking hours. I was always acutely conscious of what was happening to me, but no sooner would something happen than my mind would respond to it, blazing up with incendiary passion. My head burned with bookish theories, battling voices, elaborate inner colloquies. Later on, after I had been rescued, Zimmer and Kitty kept asking me how I had managed to do nothing for so many days. Hadn't I been bored? they wondered. Hadn't I found it tedious? Those were logical questions, but the fact was that I never became bored. I was subject to all kinds of moods and emotions in the park, but boredom wasn't one of them. When I wasn't busy with practical concerns (looking for a place to sleep at night, taking care of my stomach), I seemed to have a host of other activities to pursue. By midmorning, I was generally able to find a newspaper in one of the trash bins, and for the next hour or so I would assiduously comb its pages, trying to keep myself abreast of what was happening in the world. The war continued, of course, but there were other events to follow as well: Chappaquiddick, the Chicago Eight, the Black Panther trial, another moon landing, the Mets. I tracked the spectacular fall of the Cubs with special interest, marveling at how thoroughly the team had unraveled. It was difficult for me not to see correspondences between their plunge from the top and my own situation, but I did not take any of it personally. When it came right down to it, I was rather gratified by the Mets' good fortune. Their history was even more abominable than the Cubs', and to witness their sudden, wholly improbable surge from the depths seemed to prove that anything in this world was possible. There was consolation in that thought. Causality was no longer the hidden demiurge that ruled the universe: down was up, the last was the first, the end was the beginning. Heraclitus had been resurrected from his dung heap, and what he had to show us was the simplest of truths: reality was a yo-yo, change was the only constant.

Once I had pondered the news of the day, I usually spent some time ambling through the park, exploring areas I had not visited before. I enjoyed the paradox

of living in a man-made natural world. This was nature enhanced, so to speak, and it offered a variety of sites and terrains that nature seldom gives in such a condensed area. There were hillocks and fields, stony outcrops and jungles of foliage, smooth pastures and crowded networks of caves. I liked wandering back and forth among these different sectors, for it allowed me to imagine that I was traveling over great distances, even as I remained within the boundaries of my miniature world. There was the zoo, of course, down at the bottom of the park, and the pond where people rented small pleasure boats, and the reservoir, and the playgrounds for children. I spent a good deal of time just watching people: studying their gestures and gaits, thinking up life stories for them, trying to abandon myself totally to what I was seeing. Often, when my mind was particularly blank, I found myself lapsing into dull and obsessive games. Counting the number of people who passed a given spot, for example, or cataloguing faces according to which animals they resembled—pigs or horses, rodents or birds, snails, marsupials, cats. Occasionally, I jotted down some of these observations in my notebook, but for the most part I found little inclination to write, not wanting to remove myself from my surroundings in any serious way. I understood that I had already spent too much of my life living through words, and if this time was going to have any meaning for me, I would have to live in it as fully as possible, shunning everything but the here and now, the tangible, the vast sensorium pressing down on my skin.

I encountered dangers in there as well, but nothing truly calamitous, nothing I did not manage to run away from in the end. One morning, an old man sat down beside me on a bench, stuck out his hand, and introduced himself as Frank. "You can call me Bob if you want to," he said, "I'm not fussy. Just as long as you don't call me Bill, we'll get along fine." Then, with barely a pause, he launched into a complicated story about gambling, going on at great length about a thousand-dollar bet he had made in 1936 which involved a horse named Cigarillo, a gangster named Duke, and a jockey named Tex. I lost him after the third sentence, but there was something enjoyable about listening to his scattered, half-cocked tale, and since he seemed perfectly harmless, I didn't bother to walk away. About ten minutes into his monologue, however, he suddenly jumped up from the bench and grabbed the clarinet case that I was holding on my lap. He ran

down the macadam footpath like some invalid jogger, moving with pathetic little shuffling steps, arms and legs shooting crazily in all directions. It wasn't hard for me to catch up to him. Once I did, I snagged his arm brusquely from behind, spun him around, and wrenched the clarinet case from his hands. He seemed surprised that I had bothered to go after him. "That's no way to treat an old man," he said, showing not the slightest remorse over what he had done. I felt a powerful urge to punch him in the face, but he was already trembling so hard with fear that I held myself back. Just as I was about to turn away, he gave me a frightened, contemptuous look, and then sent a large gob of spit flying in my direction. About half of it dribbled down his chin, but the rest of it landed on my shirt about chest high. I averted my eyes from him for a moment to inspect the damage, and in that split-second he scrambled away again, glancing back over his shoulder to see if I was coming after him. I thought that would be the end of it, but once he had put a safe distance between us, he stopped in his tracks, turned around, and started shaking his fist at me, jabbing the air with indignation. "Fucking commie!" he shouted. "Fucking commie agitator! You should go back to Russia where you belong!" He was taunting me to come after him, obviously hoping to keep our adventure alive, but I didn't fall into the trap. Without saying another word, I turned around and left him where he was.

It was a trivial episode, of course, but others had a more menacing air to them. One night, a gang of kids chased me across Sheep's Meadow, and the only thing that saved me was that one of them fell and twisted his ankle. Another time, a belligerent drunk threatened me with a broken beer bottle. Those were close calls, but the most terrifying moment came on a cloudy night toward the end, when I accidentally stumbled into a bush where three people were making love—two men and a woman. It was difficult to see much, but my impression was that they were all naked, and from the tone of their voices after they discovered I was there, I gathered they were also drunk. A branch snapped under my left foot, and then I heard the woman's voice, followed by a sudden thrashing of leaves and twigs. "Jack," she said, "there's some creep over there." Two voices answered instead of one, both of them grunting with hostility, charged with a violence I had rarely heard before. Then a shadowy figure rose up and pointed what looked like a gun in my direction. "One word, asshole," he said, "and I'll give it back to you

six times." I assumed he was talking about the bullets in the gun. If fear has not distorted what happened, I believe I heard a click at that point, the sound of the hammer being cocked into place. Before I understood how scared I was, I took off. I just turned on my heels and ran. If my lungs hadn't finally given out on me, I probably would have run until morning.

It's impossible to know how long I could have taken it. Assuming that no one had killed me, I think I might have lasted until the start of the cold weather. Aside from a few unexpected incidents, things seemed fairly well under control. I spent my money with excruciating care, never more than a dollar or a dollar and a half a day, and that alone would have deferred the moment of reckoning for some time. Even when my funds dipped perilously close to the bottom, something always seemed to turn up at the last minute: I would find money on the ground or some stranger would step forth and produce one of those miracles I have already discussed. I did not eat well, but I don't think I ever went an entire day without getting at least a morsel or two into my stomach. It's true that I was alarmingly thin by the end, just 112 pounds, but most of the weight loss occurred during the final days I spent in the park. That was because I came down with something—a flu, a virus, God knows what—and from then on I didn't eat anything at all. I was too weak, and every time I managed to put something into my mouth, it came right back up again. If my two friends hadn't found me when they did, I don't think there's any question that I would have died. I had run out of reserves, and there was nothing left for me to fight with.

The weather had been with me from the start, so much so that I had stopped thinking of it as a problem. Almost every day was a repetition of the day before: beautiful late-summer skies, hot suns parching the ground, and the air then drifting into the coolness of cricket-filled nights. During the first two weeks, it hardly rained at all, and when there was rain, it never amounted to more than a sprinkle. I began pushing my luck, sleeping more or less out in the open, by now conditioned to believe that I would be safe wherever I was. One night, as I lay dreaming on a patch of grass, utterly exposed to the heavens, I finally got caught in a downpour. It was one of those cataclysmic rains: the sky suddenly splitting in two, buckets of water descending, a prodigious fury of sound. I was drenched by the time I woke up, my whole body pummeled, the drops bouncing off me like buckshot. I started running through the darkness, frantically searching for a

place to hide, but it took several minutes before I managed to find shelter under a ledge of granite rocks, and by then it hardly mattered where I was. I was as wet as someone who had swum across the ocean.

The rain continued until dawn, at times slackening to a drizzle, at times exploding with monumental bursts—screeching battalions of cats and dogs, pure wrath tumbling from the clouds. These eruptions were unpredictable, and I did not want to run the risk of getting caught in one. I clung to my tiny spot, dumbly standing there in my waterlogged boots, my clammy blue jeans, my glistening leather jacket. My knapsack had been subjected to the same soaking as everything else, and that left me with nothing dry to change into. I had no choice but to wait it out, shivering in the darkness like a stray mutt. For the first hour or two I did my best not to feel sorry for myself, but then I gave up the effort and let forth in a spree of shouting and cursing, putting all my energies into the most vile imprecations I could think of—putrid strings of invective, nasty and circuitous insults, bombastic exhortations against God and country. After a while, I had worked myself up to such a pitch that I was sobbing through my words, literally ranting and hiccuping at the same time, and yet through it all managing to summon up such artful and long-winded phrases that even a Turkish cutthroat would have been impressed. This continued for perhaps half an hour. Afterward, I was so spent that I fell asleep right where I was, still standing up. I dozed for several minutes, then was roused by another onslaught of rain. I wanted to renew my attack, but I was too tired and hoarse to scream anymore. For the rest of the night I just stood there in a trance of self-pity, waiting for the morning to come.

At six o'clock I walked into a hash house on West Forty-eighth Street and ordered a bowl of soup. Vegetable soup, I think it was, with greasy chunks of celery and carrots bobbing in a yellowish broth. It warmed me to a certain extent, but with my wet clothes still plastered to my skin, the dampness was penetrating too deeply for the soup to have any permanent effect. I went downstairs to the men's room and dried off my head under the nozzle of an electric sani-blower. To my horror, the gusts of hot wind puffed up my hair into a ridiculous tangle, and I wound up looking like a gargoyle, a crazed figure jutting from the bell tower of some Gothic cathedral. Desperate to undo the mess, I impulsively loaded my razor with a fresh blade, the last one in my knapsack, and started hacking off

my wild serpent locks. By the time I was finished, my hair was so short that I scarcely recognized myself anymore. It accentuated my thinness to an almost appalling degree. My ears stuck out, my Adam's apple bulged, my head seemed no bigger than a child's. I'm starting to shrink, I said to myself, and suddenly I heard myself talking out loud to the face in the mirror. "Don't be afraid," my voice said. "No one is allowed to die more than once. The comedy will be over soon, and you'll never have to go through it again."

Later that morning, I spent a couple of hours in the reading room of the public library, counting on the stuffiness of the place to help dry out my clothes. Unfortunately, once the clothes began to dry in earnest, they also began to smell. It was as if all the folds and crevices of my garments had suddenly decided to tell their secrets to the world. This had never happened before, and it shocked me to realize that such a noxious odor could be coming from my person. The mixture of old sweat and rainwater must have produced some bizarre chemical reaction, and as my clothes grew progressively drier, the smell became uglier and more overpowering. Eventually, it got so bad that I could even smell my feet—a horrific stench that came right through the leather of my boots, invading my nostrils like a cloud of poison gas. It didn't seem possible that this was happening to me. I continued thumbing through the pages of the *Encyclopaedia Britannica*, hoping that no one would notice the smell, but these prayers soon came to naught. An old man sitting across the table from me looked up from his newspaper and started to sniff, then looked disgustedly in my direction. For a moment I was tempted to jump to my feet and scold him for his rudeness, but I realized that I didn't have the energy for it. Before he had a chance to say anything, I stood up from my chair and left.

Outside, the weather was gloomy: a raw and sullen kind of day, all mist and hopelessness. I could feel myself gradually running out of ideas. A strange weakness had crept into my bones, and it was all I could do to keep from stumbling. I bought a sandwich at a deli not far from the Coliseum, but then had trouble maintaining interest in it. After several bites, I wrapped it up again and stored it in my knapsack for later. My throat was hurting, and I had broken out in a sweat. Crossing the street at Columbus Circle, I went back into the park and started looking for a place to lie down. I had never slept during the day before, and all my old hiding places suddenly seemed precarious, exposed, useless with-

out the protection of night. I kept walking north, hoping I would find something before I collapsed. The fever was mounting inside me, and a stuporous exhaustion seemed to be eating up portions of my brain. There was almost no one in the park. Just as I was about to ask myself why, it started to drizzle. If my throat hadn't been hurting so much, I probably would have laughed. Then, very abruptly and violently, I began to throw up. Bits of vegetable soup and sandwich came bursting out of my mouth, splattering on the ground before me. I gripped my knees and stared down at the grass, waiting for the spasm to end. This is human loneliness, I said to myself. This is what it means to have no one. I was not angry anymore, however, and I thought those words with a kind of brutal candor, an absolute objectivity. Within two or three minutes, the whole episode felt like something that had taken place months before. I kept on walking, not willing to give up my search. If someone had appeared just then, I probably would have asked him to take me to a hospital. But no one appeared. I don't know how long it took me to get there, but at a certain point I found a cluster of large rocks surrounded by overgrown foliage and trees. The rocks formed a natural cave, and without stopping to consider the matter any further, I crawled into this shallow indentation, pulled some loose branches in with me to block up the opening, and promptly fell asleep.

I don't know how much time I spent in there. Two or three days, I would think, but it hardly matters now. When Zimmer and Kitty asked me about it, I told them three, but that was only because three is a literary number, the same number of days that Jonah spent in the belly of the whale. Most of the time I was barely conscious and even when I seemed to be awake, I was so bound up in the tribulations of my body that I lost all sense of where I was. I remember long bouts of vomiting, frenzied moments when my body wouldn't stop shaking, periods when the only sound I heard was the chattering of my teeth. The fever must have been quite high, and it brought ferocious dreams with it—endless, mutating visions that seemed to grow directly out of my burning skin. Nothing could hold its shape in me. Once, I remember, I saw the Moon Palace sign in front of me, more vivid than it had ever been in life. The pink and blue neon letters were so large that the whole sky was filled with their brightness. Then, suddenly, the letters disappeared, and only the two os from the word *Moon* were left. I saw myself dangling from one of them, struggling to hang on like an acrobat

who had botched a dangerous stunt. Then I was slithering around it like a tiny worm, and then I wasn't there anymore. The two *o*s had turned into eyes, gigantic human eyes that were looking down at me with scorn and impatience. They kept on staring at me, and after awhile I became convinced that they were the eyes of God.

The sun appeared on the last day. I don't remember doing it, but at some point I must have crawled from the cave and stretched myself out on the grass. My mind was in such a muddle that I imagined the warmth of the sun could evaporate my fever, literally suck the illness out of my bones. I remember pronouncing the words *Indian summer* over and over to myself, saying them so many times that they eventually lost their meaning. The sky above me was immense, a dazzling clarity that had no end to it. If I went on staring at it, I felt, I would dissolve in the light. Then, without any sense of falling asleep, I suddenly began to dream of Indians. It was 350 years ago, and I saw myself following a group of half-naked men through the forests of Manhattan. It was a strangely vibrant dream, relentless and exact, filled with bodies darting among the light-dappled leaves and branches. A soft wind poured through the foliage, muffling the footsteps of the men, and I went on following them in silence, moving as nimbly as they did, with each step feeling that I was closer to understanding the spirit of the forest. I remember these images so well, perhaps, because it was precisely then that Zimmer and Kitty found me: lying there on the grass with that odd and pleasant dream circulating in my head. Kitty was the one I saw first, but I didn't recognize her, even though I sensed that she was familiar to me. She was wearing her Navaho headband, and my initial response was to take her for an afterimage, a shadow-woman incubated in the darkness of my dream. Later on, she told me that I smiled at her, and when she bent down to look at me more closely, I called her Pocahontas. I remember that I had trouble seeing her because of the sunlight, but I have a distinct recollection that there were tears in her eyes when she bent down, although she would never admit that afterward. A moment later, Zimmer entered the picture as well, and then I heard his voice. "You dumb bastard," he said. There was a brief pause, and then, not wanting to confuse me with too long a speech, he said the same thing again: "You dumb bastard. You poor dumb bastard."

ANN LAUTERBACH

EDWARD HOPPER'S WAY

"Who looks upon a river in a meditative hour and is not reminded of the flux of all things?"

(Emerson)

Where did you want us to go?

What did you want us to see?

Where, fixed by waiting
at the gate, in the stairway

 plain as day

 slowed to a glassy halt
 irresolute prior utensil of a stage

roof-bound

penetrated sky or portrait

"sheltering locations"
 unsettling America

 the place is obvious and ample
 bliss of solid light

sucked from the street: *desperation and endurance*

(Robert Frank)

where space is
contingent/shadow in the bowl like a chimney on an upsidedown
roof/a green sky

(David Smith)

emotion will not resemble the tall guard walking

how remnant the rare calamities
spoking the revenant flag
uncircled, windless

 wearing red blazers and hats
 we are ordinary folk in search of insight

 "I see the light, I see the light
 at the end of the tunnel"

(Emmylou Harris)

Oil on the inched conveyance/is
this a bequest? In the year of Jeremiah

> 1941
> symphonic acclaim
> > (Leonard Bernstein)

at the advent of the storm

> > *"I beheld the earth, and, lo, it was*
> *without form, and void; and the heavens, they had no light. . . . I beheld, and lo, the*
> *fruitful place was a wilderness, and all the cities thereof were broken down at the presence*
> *of the Lord, and by his fierce anger."*

And the flat road
and the clapboard façade
and the Mansard roof
and the wife

along the quay—O, Paris!—

fastened or sundered

> > like a slip
> > over the body of it

> > so you find an instant which seems to be of itself but the
> temporal ignites and is its subject: *lobby, rooms, approach to a city, four lane road,*
> *by a railroad, hotel window, motel, bridge, path*

> > staircase

> everything in transit, all ghosts in wait

in search of a *great good place*

(James Thurber)

water to cliff

intellect of observation
reeled out to its edge

"Before I got my eye put out
I liked as well to see—"

(Emily Dickinson)

scale's syntax

isolates attention, a
distillate conserve
as if riveted

to realism's mirage

turn away from or toward

the spirit's pragmatic example
all that is air melts into objects

garland of language, habitat
of baskets and tropes—

But where did you mean us to go?

To the slow field
without noise/to the
rail/to the curb/to the fence/to cross out of the self

to the spare opulence of the horizon/to the trail
to the sea in our good hats, our tweeds, our
work ethic, our inability to listen to strangers.

Saturday December eleventh 1994

"My soul has grown deep like the rivers"
(Langston Hughes)

It rains on/into our dark river.

WALTER MOSLEY
CRIMSON SHADOW

1.

"What you doin' there, boy?"

It was six a.m. Socrates Fortlow had come out to the alley to see what was wrong with Billy. He hadn't heard him crow that morning and was worried about his old friend.

The sun was just coming up. The alley was almost pretty with the trash and broken asphalt covered in half-light. Discarded wine bottles shone like murky emeralds in the mud. In the dawn shadows Socrates didn't even notice the boy until he moved. He was standing in front of a small cardboard box, across the alley—next to Billy's wire fence.

"What bidness is it to you, old man?" the boy answered. He couldn't have been more than twelve but he had that hard convict stare.

Socrates knew convicts, knew them inside and out.

"I asked you a question, boy. Ain't yo' momma told you t'be civil?"

"Shit!" The boy turned away, ready to leave. He wore baggy jeans with a blooming blue T-shirt over his bony arms and chest. His hair was cut close to the scalp.

The boy bent down to pick up the box.

"What they call you?" Socrates asked the skinny butt stuck up in the air.

"What's it to you?"

Socrates pushed open the wooden fence and leapt. If the boy hadn't had his back turned he would have been able to dodge the stiff lunge. As it was he heard something and moved quickly to the side.

Quickly. But not quickly enough.

Socrates grabbed the skinny arms with his big hands—the rock breakers, as Joe Benz used to call them.

"Ow! Shit!"

Socrates shook the boy until the serrated steak knife, that appeared from nowhere, fell from his hand.

The old brown rooster was dead in the box. His head slashed so badly that half of the beak was gone.

"Let me loose, man." The boy tried to kick but Socrates held him at arm's length.

"Don't make me hurt you, boy," he warned. He let go of one arm and said, "Pick up that box. Pick it up!" When the boy obeyed, Socrates pulled him by the arm—dragged him through the gate, past the tomato plants and string bean vines, into the two rooms where he'd stayed since they let him out of prison.

The kitchen was only big enough for a man and a half. The floor was pitted linoleum; maroon where it had kept its color, gray where it had worn through. There was a card table for dining and a foldup plastic chair for a seat. There was a sink with a hot plate on the drain board and shelves that were once cabinets— before the doors were torn off.

The light fixture above the sink had a sixty-watt bulb burning in it. The room smelled of coffee. There was a newspaper spread out on the table.

Socrates shoved the boy into the chair, not gently.

"Sit'own!"

There was a mass of webbing next to the weak lightbulb. A red spider crawled slowly through the strands.

"What's your name, boy?" Socrates asked again.

"Darryl."

There was a photograph of a painting tacked up directly underneath the light. It was the image of a black woman in the doorway of a house. She wore a red dress and a red hat to protect her eyes from the sun. She had her arms crossed under her breasts and she looked angry. Darryl stared at the painting while the spider danced above.

"Why you kill my friend, asshole?"

"What?" Darryl asked. There was fear in his voice.

"You heard me."

"I-I-I din't kill nobody," Darryl gulped and opened his eyes wider than seemed possible. "Who told you that?"

When Socrates didn't say anything Darryl jumped up to run but the man socked him in the chest, knocking the wind out of him, knocking him back down in the chair.

Socrates squatted down and scooped the rooster up out of the box. He held the limp old bird up in front of Darryl's face.

"Why you kill Billy, boy?"

"That's a bird." Darryl pointed. There was relief mixed with panic in his eyes.

"That's my friend."

"You crazy, old man. That's a bird. Bird cain't be nobody's friend." Darryl's words were still wild. Socrates knew the guilty look on his face.

He wondered at the boy and at the rooster that had gotten him out of his bed every day for the past eight years. A rage went through him and he crushed the rooster's neck in his fist.

"You crazy," Darryl said.

A large truck made its way down the alley just then. The heavy vibrations went through the small kitchen, making plates and tinware rattle loudly.

Socrates shoved the corpse into the boy's lap. "Get ovah there to the sink an' pluck it."

"Shit!"

"You don't have to do it . . ."

"You better believe I ain't gonna . . ."

". . . but I *will* kick holy shit outta you if you don't."

"Pluck what? What you mean pluck it?"

"I mean go ovah t'that sink an' pull out the feathers. What you kill it for if you ain't gonna pluck it?"

"I'as gonna sell it."

"Sell it?"

"Yeah," Darryl said. "Sell it to some old lady wanna make some chicken."

2.

Darryl plucked the chicken bare. He kept wanting to stop halfway but Socrates kept pointing out where he had missed and pushed the boy back toward the sink. Darryl used a razor-sharp knife that Socrates gave him to cut off the legs and battered head. He slit open the old rooster's belly and set aside the liver, heart, and gizzard.

"Rinse out all the blood. All of it," Socrates told his captive. "Man could get sick on blood."

While Darryl worked, under the older man's supervision, Socrates made Minute Rice and then green beans seasoned with lard and black pepper. He prepared them in succession, one after the other on the single hot plate. Then he sautéed the giblets, with green onions from the garden, in bacon fat that he kept in a can over the sink. He mixed the giblets in with the rice.

When the chicken was ready he took tomatoes, basil, and garlic from the garden and put them all in a big pot on the hot plate.

"Billy was a tough old bird," Socrates said. "He gonna have to cook for a while."

"When you gonna let me go, man?"

"Where you got to go?"

"Home."

"Okay. Okay, fine. Billy be cookin' for a couple hours at least. Let's go over your house. Where's that at?"

"What you mean, man? You ain't goin' t'my house."

"I sure am too," Socrates said, but he wasn't angry anymore. "You come over here an' murder my friend an' I got to tell somebody responsible."

Darryl didn't have any answer to that. He'd spent over an hour working in the kitchen, afraid even to speak to his captor. He was afraid mostly of those big hands. He had never felt anything as strong as those hands. Even with the chicken knife he was afraid.

"I'm hungry. When we gonna eat?" Darryl asked. "I mean I hope you plan t'eat this here after all this cookin'."

"Naw, man," Socrates said. "I thought we could go out an' sell t'some ole lady like t'eat chicken."

"Huh?" Darryl said.

The kitchen was filling up with the aroma of chicken and sauce. Darryl's stomach growled loudly.

"You hungry?" Socrates asked him.

"Yeah."

"That's good. That's good."

"Shit. Ain't good 'less I get sumpin' t'eat."

"Boy should be hungry. Yeah. Boys always hungry. That's how they get to be men."

"What the fuck you mean, man? You just crazy. That's all."

"If you know you hungry then you know you need sumpin'. Sumpin' missin' an' hungry tell you what it is."

"That's some kinda friend to you too?" Darryl sneered. "Hungry yo' friend?"

Socrates smiled then. His broad black face shone with delight. He wasn't a *very* old man, somewhere in his fifties. His teeth were all his own and healthy, though darkly stained. The top of his head was completely bald; tufts of white hovered behind his ears.

"Hungry, horny, hello, and how come. They all my friends, my best friends."

Darryl sniffed the air and his stomach growled again.

"Uh-huh," Socrates hummed. "That's right. They all my friends. All of'em. You got to have good friends you wanna make it through the penitentiary."

"You up in jail?" Darryl asked.

"Yup."

"My old man's up in jail," Darryl said. "Least he was. He died though."

"Oh. Sorry t'hear it, li'l brother. I'm sorry."

"What you in jail for?"

Socrates didn't seem to hear the question. He was looking up at the picture of the painting up above the sink. The right side of the scene was an open field of yellow grasses under a light blue sky. The windows of the house were shuttered and dark but the sun shone hard on the woman in red.

"You still hungry?" Socrates asked.

Darryl's stomach growled again and Socrates laughed.

3.

Socrates turned over a trash can for his chair. There were three plates on the table—one for each dish. The man and boy shoveled down dirty rice, green beans, and tough rooster like they were starving men; eating off the same plates and saying not a word. The only drink they had was water—their glasses were mayonnaise jars. Their breathing was loud and slobbery. Hands moved in syncopation; tearing and scooping.

Anyone witnessing the orgy would have said that they hailed from the same land; prayed to the same gods.

When the plates were clean they sat back bringing hands across bellies. They both sighed and shook their heads.

"That was some good shit," Darryl said. "Mm!"

"Bet you didn't know you could cook, huh?" Socrates asked.

"Shit no!" the boy said.

"Keep your mouth clean, li'l brother. You keep it clean an' then they know you mean business when you say sumpin' strong."

Darryl was about to say something but decided against it. He looked over at the door, and then back at Socrates.

"Could I go now?" he asked, a boy talking to his elder at last.

"Not yet."

"How come?" There was an edge of fear in the boy's voice. Socrates remembering many a time reveling in the fear he brought to young men in their cells. He used to like the company of fear.

"Not till I hear it. You cain't go till then."

"Hear what?"

"You know what. So don't be playin' stupid. Don't be playin' stupid an' you just et my friend."

Darryl made to push himself up but abandoned that idea when he saw those hands rise from the table.

"You should be afraid, Darryl," Socrates said, reading the boy's eyes. "I kilt men with these hands. Choked an' broke 'em. I could crush yo' head wit' one hand." Socrates held out his left palm.

"I ain't afraid'a you," Darryl said.

"Yes you are. I know you are 'cause you ain't no fool. You seen some bad things out there but I'm the worst. I'm the worst you ever seen."

Darryl looked at the door again.

"Ain't nobody gonna come save you, li'l brother. Ain't nobody gonna come. If you wanna make it outta here then you better give me what I want."

Socrates knew just when the tears would come. He had seen it a hundred times. In prison it made him want to laugh; but now he was sad. He wanted to reach out to the blubbering child and tell him that it was okay; that everything was all right. But it wasn't all right, might not ever be.

"Stop cryin' now, son. Stop cryin' an' tell me about it."

" 'Bout what?" Daryl said, his chest vibrating like a bird's.

" 'Bout who you killed, that's what."

"I ain't killed nobody," Darryl said in a monotone.

"Yes you did. Either that or you saw sumpin'. I heard you deny it when you didn't know I was talkin' 'bout that bird. I know when a man is guilty, Darryl. I know that down in my soul."

Darryl looked away and set his mouth shut.

"I ain't a cop, li'l brother. I ain't gonna turn you in. But you kilt my friend out there an' we just et him down. I owe t'Billy an' to you too. So tell me about it. You tell me an' then you could go."

They stared at each other for a long time. Socrates grinned to put the boy at ease but he didn't look benevolent. He looked hungry.

Darryl felt like the meal.

4.

He didn't want to say it but he didn't feel bad either. Why should he feel bad? It wasn't even his idea. Wasn't anybody's plan. It was just him and Jamal and Norris out in the oil fields above Baldwin Hills. Sometimes dudes went up there with their women. And if you were fast enough you could see some pussy and then get away with their pants.

They also said that the army was once up there and that there were old bullets and even hand grenades just lying around to be found.

But there was some retarded boy who had come up there, with his brother he said. But his brother left him and the boy wanted to be friends with Darryl and his boys.

"At first we was just playin'," Darryl told Socrates. "You know—pushin' 'im an' stuff."

But when he kept on following them—when he squealed every time they saw some business—they hit him and pushed him down. Norris even threw a rock at his head. But the retard kept on coming. He was running after them and crying that they had hurt him. He cried louder and louder. And when they hit him, to shut him up, he yelled so loud that it made them scared right inside their chests.

"You know I always practice with my knife," Darryl said. "You know you got to be able to get it out quick if somebody on you."

Socrates nodded. He still practiced himself.

"I don't know how it got it my hand. I swear I didn't mean t'cut 'im."

"You kill'im?" Socrates asked.

Darryl couldn't talk but he opened his mouth and nodded.

They all swore never to tell anybody. They could kill the one who told about it—they swore on blood and went home.

"Anybody find'im?" Socrates asked.

"I'ont know."

The red spider danced while the woman in red kept her arms folded and stared her disapproval of all men—especially those two men. Darryl had to go to the bathroom. He had the runs after that big meal—and from telling his tale.

When he came out he looked ashy, his lips were chapped.

He slumped back in Socrates's cheap chair—drowsy but not tired. He was sick and forlorn.

For a long time they just sat there. The minutes went by but there was no clock to measure them. Socrates learned how to do without a timepiece in prison.

He sat there and counted the time while Darryl sat hopelessly by.

5.

"What you gonna do, li'l brother?"

"What?"

"How you gonna make it right?"

"Make what right? He dead. I cain't raise him back here."

When Socrates stared at the boy there's no telling what he thought. But what he was thinking didn't matter. Darryl looked away and back again. He shifted in his chair. Licked his dry lips.

"What?" he asked at last.

"You murdered a poor boy couldn't stand up to you. You killed your little brother an' he wasn't no threat; an' he didn't have no money that you couldn't take wit'out killin' 'im. You did wrong, Darryl. You did wrong."

"How the fuck you know?" Darryl yelled. He would have said more but Socrates raised his hand, not in violence but to point out the truth to his dinner guest.

Darryl went quiet and listened.

"I ain't your warden, li'l brother. I ain't gonna show you to no jail. I'm just talkin' to ya—one black man to another one. If you don't hear me there ain't nuthin' I could do."

"So I could go now?"

"Yeah, you could go. I ain't yo' warden. I just ask you to tell me how you didn't do wrong. Tell me how a healthy boy ain't wrong when he kills his black brother who sick."

Darryl stared at Socrates, at his eyes now—not his hands.

"Yo ain't gonna do nuthin'?"

"Boy is dead now. Rooster's dead too. We cain't change that. But you got to figure out where you stand."

"I ain't goin' t'no fuckin' jail if that's what you mean."

Socrates smiled. "Shoo'. I don't blame you for that. Jail ain't gonna help a damn thing. Better shoot yo'self than go to jail."

"I ain't gonna shoot myself neither. Uh-uh."

"If you learn you wrong then maybe you get to be a man."

"What's that s'posed t'mean?"

"Ain't nobody here, Darryl. Just you'n me. I'm sayin' that I think you was wrong for killin' that boy. I know you killed'im. I know you couldn't help it. But you was wrong anyway. An' if that's the truth, an' if you could say it, then maybe you'll learn sumpin'. Maybe you'll laugh in the morning sometimes again."

Darryl stared at the red spider. She was still now in her web. He didn't say anything, didn't move at all.

"We all our own judge, li'l brother. 'Cause if you don't know when you wrong then yo' life ain't worf a damn."

Darryl waited as long as he could. And then he asked, "I could go?"

"You done et Billy. So I guess that much is through."

"So it ain't wrong that I killed'im 'cause I et him?"

"It's still wrong. It's always gonna be wrong. But you know more now. You ain't gonna kill no more chickens," Socrates said. Then he laughed out loud. "At least not around here."

Darryl stood up. He watched Socrates to see what he'd do.

"Yo' momma cook at home, Darryl?"

"Sometimes. Not too much."

"You come over here anytime an' I teach you how t'cook. We eat pretty good too."

"Uh-huh," Darryl answered. He took a step away from his chair.

Socrates stayed seated on his can.

Darryl made it all the way to the door. He grabbed the wire handle that took the place of a long-ago knob.

"What they put you in jail for?" Darryl asked.

"I killed a man an' raped his woman."

"White man?"

"No."

"Well . . . bye."

"See ya, li'l brother."

"I'm sorry . . . 'bout yo' chicken."

"Billy wasn't none'a mine. He belonged to a old lady 'cross the alley."

"Well . . . bye."

"Darryl."

"Yeah."

"If you get inta trouble you could come here. It don't matter what it is—you could come here to me."

6.

Socrates stared at the door a long time after the boy was gone; for hours. The night came on and the cool desert air of Los Angeles came under the door and through the cracks in his small shack of an apartment.

A cricket played from somewhere in the wall.

Socrates looked at the woman, sun shining on her head. Her red sun hat threw a hot crimson shadow across her face. There was no respite for her but she still stood defiant. He tried to remember what Therese looked like but it had been too long now. All he had now was the picture of a painting—and that wasn't even her. All he had left from her were the words she never said. *You are dead to me, Socrates. Dead as that poor boy and that poor girl you killed.*

He wondered if Darryl would ever come back.

He hoped so.

After a long time Socrates went into his other room, through the doorless doorway. He lay down on the couch and just before he was asleep he thought of how he'd wake up alone. The rooster was hoarse in his old age, his crow no more than a whisper.

But at least that motherfucker tried.

GRACE PALEY
THE BURDENED MAN

The man has the burden of the money. It's needed day after day. More and more of it. For ordinary things and for life. That's why holidays are a hard time for him. Another hard time is the weekend, when he's not making money or furthering himself.

Then he's home and he watches the continuation of his son's life and the continuation of his wife's life. They do not seem to know about the money. They are not stupid, but they leave the hall lights on. They consume electricity. The wife cooks and cooks. She has to make meat. She has to make potatoes and bring orange juice to the table. He is not against being healthy, but rolls baked hot in expensive gas are not necessary. His son makes phone calls. Then his wife makes a phone call. These are immediately clicked into the apparatus of AT&T and added against him by IBM. One day they accidentally buy three newspapers. Another day the boy's out in the yard. He's always careless. Naturally he falls and rips his pants. This expense occurs on a Saturday. On Sunday a neighbor knocks

at the door, furious because it's her son's pants that were first borrowed then ripped, and they cost $5.95 and are good narrow-wale corduroy.

When he hears this, the man is beside himself. He does not know where the money is coming from. The truth is, he makes a very good salary and puts away five dollars a week for his son's college. He has done this every week and now has $2,750 in the bank. But he does not know where the money for *all* of life will come from. At the door, without a word, he gives the neighbor six dollars in cash and receives two cents in change. He looks at the two pennies in his hand. He feels penniless and thinks he will faint. In order to be strong, he throws the two pennies at his neighbor, who screams, then runs. He chases her for two blocks. Her husband can't come to her rescue because he's on Sunday duty. Her children are at the movies. When she reaches the corner mailbox, she leans against it. She turns in fear and throws the six dollars at him. He takes the floating bills out of the air. He pitches them straight from the shoulder with all his strength. They drift like leaves to her coat and she cries out, "Stop! stop!"

The police arrive at once from somewhere and are disgusted to see two grown-up people throwing money at each other and crying. But the neighborhood is full of shade trees and pretty lawns. The police forgive them and watch them go home in the same direction (because they're next-door neighbors).

They are sorry for each other's anger.

She says: "I don't need the pants. Billy has plenty of pants." He says: "What's the money to me? Six dollars? Chicken feed."

Then they have coffee at her house and explain everything. They each tell one story about when they were young. After this they become friends and visit one another on Sunday afternoons when both their families are on duty or at the movies.

On Friday nights the man climbs the three flights out of the deep subway. He stops at a bakery just before the bus for his remote neighborhood picks him up. He brings a strawberry shortcake home to his wife and son.

All the same, things changed. Summer came and the neighbor took her three children to a little summer house on the Long Island water. When she returned, she was tanned a light tea color with a touch of orange because of the lotion she had

used. It seemed to him that her first and subsequent greetings were very cool. He had answered her cordially. "You look real great," he said. "Thank you," she said, without mentioning his looks, which the vacation sun had also improved.

One Saturday morning he waited in bed for the house to become quiet and empty. His wife and the boy always went to the supermarket by 9 a.m. When they were finally gone with the cart, the shopping bags, and the car, he began to think that he and his neighbor had talked and talked through many Sundays and now it was time to consider different ways to begin to make love to her.

He wondered if the kitchen might not be the best place to start because it was narrow. She was a decent person with three children and would probably say no just to continue her decency a little longer. She would surely try to get away from his first effort. However, she would never get away if he approached at the dishwashing machine.

Another possibility: If the coffee were already on the table, he might be beside her as she prepared to pour. He would take the coffee pot away from her and put it on the trivet. He would then take her hands and look into her eyes. She would know his meaning at once and start all the arrangements in her mind about ensuring privacy for the next Sunday.

Another possibility: In the living room on the couch before the coffee table, he would straightforwardly yet shyly declare, "I'm having a terrible time. I want to get together with you." This was the strongest plan because it required no further plan. He would be able to embrace her right after making his statement; he would lift her skirt, and if she wore no girdle, he would enter her at once.

The next day was Sunday. He called and she said in her new cool way, "Oh sure, come on over." In about ten minutes he was waiting for coffee at her dinette table. He had clipped the first four flowering zinnias out of his wife's lawn border and was arranging them in the bowl when he became aware of his neighbor's husband creeping stealthily along the wall toward him. He looked foolish and probably drunk. The man said, "What...what..." He knew the husband by appearance only and was embarrassed to see him nearly on his knees in his own house.

"You fucking wop..." said the husband. "You ain't been here twenty minutes you finished already, you cheap quickie cuntsucker...in and out...that's what she

likes, the cold bitch. . ."

"No...no..." said the man. He was saying "No no," to the husband's belief that she was cold. "No no," he said, although he didn't know for sure, "she's not."

"What you waste your time on that fat bag of tits..." said her husband. "Hey!" said the man. He hadn't thought of that part of her much at all. Mostly he had thought of how she would be under her skirt and of her thighs. He realized the husband was drunk or he would not speak of his wife with such words.

The husband then waved a pistol at him in a drunken way the man had often seen in the movies but never in life. He knew it was all right for the husband to have that pistol because he was a cop.

As a cop he was not unknown. He had once killed a farm boy made crazy by crowds in the city. The boy had run all day in terror round and round Central Park. People thought he was a runner because he wore an undershirt, but he had finally entered the park, and with a kitchen knife he had killed one baby and wounded two or three others. "Too many people," he screamed when he killed.

Bravely the cop had disarmed him, but the poor boy pulled another long knife out of his pants-leg pocket and the cop had then had to kill him. He was given a medal for this. He often remembered that afternoon and wondered that he had been brave once, but was not brave enough to have been brave twice.

Now he stared at the man and he tried to remember what inhibition had abandoned him, what fear of his victim had given him energy. How had he decided to kill that crazy boy?

Suddenly the woman came out of the kitchen. She saw that her husband was drunk and bloody-eyed. She saw that he held a pistol and waved it before his eyes as though it could clear fogs and smogs. She remembered that he was a person who had killed.

"Don't touch him," she screamed at her husband. "You maniac! Boy-killer! Don't touch him," she shouted and gathered the man against her whole soft body. He hadn't wanted anything like this, his chin caught in the V-neck of her wrap-around housedress.

"Just get out of her shirt," said the husband.

"If you kill him, you kill me," she said, hugging the man so hard he wondered where to turn his nose to get air.

"O.K., why not, why not!" said the husband. "Why not, you fucking whore, why not?"

Then his finger pressed the trigger and he shot and shot, the man, the woman, the wall, the picture window, the coffee pot. Looking down, screaming, Whore! whore! he shot straight into the floor, right through his shoe, smashing his toes for life.

The midnight edition of the morning paper said:

QUEENS COP COOLS ROMANCE

Precinct Pals Clap Cop in Cooler

Sgt. Armand Kielly put an end today to his wife's alleged romance with neighbor Alfred Ciaro by shooting up his kitchen, Mrs. Kielly, himself, and his career. Arrested by his own pals from the 115th precinct who claim he has been nervous of late, he faces departmental action. When questioned by this reporter, Mrs. Kielly said, "No no no."

The burdened man spent three days in the hospital having his shoulder wound attended to. Hospitalization paid for nearly all. He then sold his house and moved to another neighborhood on another bus line, though the subway stop remained the same.

Until old age startled him, he was hardly unhappy again.

In fact, for several years, he could really feel each morning that a mixture of warm refreshments was being pumped out of the chambers of his heart to all his cold extremities.

THOM GUNN
PHAEDRA IN THE FARM HOUSE

From sleep, before first light,
I hear slow-rolling churns
Clank over flags below.
Aches me. The room returns.
I hurt, I wake, I know
The cold dead end of night.

Here father. And here son.
What trust I live between.
But warmth here on the sheet
Is kin-warmth, slow and clean.
I cook the food two eat,
But oh, I sleep with one.

And you, in from the stable.
You spent last evening
Lost in the chalky blues
Of warm hills, rabbitting.
You frown and spell the news,
With forearms on the table.

Tonight, though, we play cards.
You are not playing well.
I smell the oil-lamp's jet,
The parlour's polished smell,
Then you—soap, ghost of sweat,
Tractor oil, and the yards.

Shirt-sleeved you concentrate.
Your moleskin waistcoat glints
Your quick grin never speaks:
I study you for hints
—Hints from those scrubbed boy-cheeks?

I deal a grown man's fate.

The churns wait on in mud:
Tomorrow's milk will sour.
I leave, but bit by bit,
Sharp through the last whole hour.
The chimney will be split,
And that waistcoat be blood.

NORMAN MAILER
THE GREATEST THING
IN THE WORLD

Inside, out of the rain, the lunch wagon was hot and sticky. Al Groot stopped in front of the doorway, wiped his hands and wrung his hat out, and scuffed his shoes against the dirt-brown mat. He stood there, a small, old, wrinkled boy of eighteen or nineteen, with round beady eyes that seemed incapable of looking at you unless you were in back of him. He stopped at the door and waited, not sure of his reception, examining the place carefully, as if he might have need of this knowledge soon after. It was a little fancier than the ordinary lunchroom, having dark, old wood booths at the left that fronted the sharp, glittering stools and counter of well-polished chromium. A clock on the wall showed that it was after ten, which might have explained why the place was almost empty. There was no one at the counter and the few truck drivers, sprawled out on two adjoining booths to catch a late dinner, were tired, and very quiet, engrossed only in their sandwiches and hamburgers. Only one man was left behind the counter, and he was carefully cleaning the grease from the frankfurter griddle, with the slow mo-

tions of a man who has a great deal of time on his hands and is desperately afraid of finishing his work, to face the prospect of empty tables and silent people. He looked at Al, uncertain for a moment how to take him, and then he turned back to the griddle and gave it a last studious wipe. He spoke, without looking up, but his tone was friendly.

"Hi," he said.

Al said hello, watching the man scrape some crumblings off.

"It's a hell of a night, ain't it?" the counterman asked.

"Lousy."

"It sure is. Guess we needed it," he said. "The crops are hit bad when it don't rain enough."

"Sure," said Al. "Look, what does coffee and doughnuts cost?"

"Ten."

"Two doughnuts?"

"That's it."

"Uh-huh," said Al. "Could you let me have one doughnut and half a cup of coffee for five cents? I ain't got but a nickel."

"I don't know," he said. "I could, but why should I?"

"I ain't had nothing to eat today," Al pleaded. "Come on."

The man looked up. Al sucked expertly on his cheeks, just pulling them in enough to make it look good.

"I guess you could stand it. Only, pay me now."

Al reached into his pocket, and tenderly extracted a nickel from two halves of a dollar bill. He finished over one-third of the doughnut in the first bite, and realizing how extravagant he had been, he took a small begrudging sip of the coffee.

"Nice place," he said.

"I like it," the man said.

"You own it?"

"You're damn right, buddy. I worked to get this place. It's all mine. You don't find me giving anything away on it. Every cup of coffee a guy drinks feeds me too."

"Top of the world," Al said.

"Nyahr," he answered bitterly. "Lot of good it does me. You see anybody in here? You see me clicking the cash register? The hell you do."

Al was thinking of how tough his luck was that the truck drivers should be uniformed, which was as good as a NO RIDER sign. He grinned sympathetically at the owner, trying to look as wet as he could.

"Boy," he said. "I sure am stuck."

"Been hitching, huh?"

"Yeah, walked the last three miles, ever since it started to rain."

"Must be kind of tough."

"Sure, I figure I won't be able to sleep if it don't stop raining. That was my last nickel. Say, look, you wouldn't have a job for me?" he said stupidly.

"What'll I do, watch you work?"

"Then let me sleep here tonight. It won't cost you nothing."

"I don't run a flophouse."

"Skip it, forget it," Al said. "Only let me stay here a while to dry off. When somebody comes in, maybe they'll give me a ride."

"Stay," he said. "I have such a fancy trade. New chromium, brass fixtures. Ahhhhr."

Al slipped off the stool and sat down at a table in the rear, out of sight of the counterman. He slouched down against the side of the booth and picked up a menu, supported between the salt and pepper shakers, looking at it interestedly, but past all craving or desire. He thought that it had been almost a year since he had had a steak. He tried to remember what it tasted like, but his memory failed, and to distract him from the tantalizing picture he started examining the spelling on the sheet, guessing at a word first, then seeing how close he had been. Another company truck driver had come in, and Al shot a quick look back to see where the owner was. Finding him up front, almost out of sight, he quickly picked up the ketchup bottle and shook large gobs of it into his mouth as fast as he could get it out. It burned and stung inside his stomach, and he kept blowing, trying to cool his mouth. Noticing a few drops on the table, he took a paper napkin, and squeezed them over to the edge, where they hung, ready to fall. He ran his little finger underneath, gathering them up, and catching the drops in his mouth as they dripped off.

He felt for the split dollar bill, and fingered it. This time, he thought, it was really his last. Once, three months ago, he had five dollars. He thought back and tried to remember how he had gotten it. It was very vague, and he wondered whether he had stolen it or not. The image of five separate bills, and all that he could do with them, hit him then with all its beauty and impossibility. He thought of cigarettes, and a meal, and a clean woman in a good place, and new soles to his shoes, but most of all he thought of the soft leathery feel of money, and the tight wad it made in his pants. "By God," he said thickly, "there's nothing like it. You can't beat it. If I just had five dollars again."

He withdrew his hand, taking the two pieces out, smoothing them lovely on the table. He considered breaking the bill for another doughnut, but he knew he couldn't. It was the last thing between him and . . . He stopped, realizing that he had passed the last thing—there was no "and." Still, he did not think any more of spending this last bill. Tomorrow or tonight he would be in Chicago, and he could find something to eat for a day or two. He might even pick up half a buck by mooching. In the meantime he felt hungry. He stayed in the booth, staring at the end wall, and dreaming of his onetime hoard.

Three men came in to eat. Al saw them hesitate at the door, wondering whether to eat in a booth or at the counter.

"Take a booth," one said.

All looked at them. This might be a ride, he thought. He waited until they had started eating, and then he went over to them, hitching at his faded gray-blue dungarees.

"Hi, sports," he said.

"Hello, sweet-face," one of them said.

"They call me Al Groot."

"His father's name was Groot," said one of them turning to the others.

"I ain't asking for any dough."

They eased up a little. "Boy, you sure ain't, sweet-face," one of them said. "Sit down, sit down," he said. "My name's Cataract, account of my eye, it's no good, and this here is Pickles, and this is Cousin."

They all looked alike.

"I guess you know what I want," Al said.

"Ride?"

"Yeah, where you going?"

"Chicago."

"Start warming the seat up for me," Al said.

They grinned, and continued eating. Al watched Cataract go to work on a hamburger. He held it between thick, grease-stained fingers that dug into it, much as they might have sunk into a woman. He swallowed a large piece, slobbering a little, and slapping his tongue noisily against the roof of his mouth as he ate. Al watched him, fascinated. Wild thoughts of seizing the hamburger, and fighting the man for it, deviled him. He moved his head, in time to Cataract's jaws, and he felt madly frustrated as Cataract dropped the last bit into his mouth. Cataract lit a cigarette, and exhaled noisily, with a little belch of content.

"Jesus Christ," Al whispered.

He turned his attention to the other two, and watched them eat each piece down to the very bitter end. He hated them, and felt sick.

"Let's go," shouted Pickles. "Come on, sweet-face."

The car was an old Auburn sedan, with a short, humped-up body. Al sat in back with Cataract; Cousin was driving. Cataract took out a pack of Luckies, and passed them around. Al took the pack, and fumbled with it, acting as if he were having trouble extracting a cigarette. When he handed it back, he had a bonus of two more cuddled next to his dollar bill.

"Where you from?" Pickles asked.

"Easton," Al said. "It's in Pennsy."

Cataract rolled his tongue around. "Good town," he said, extending his arm, fist closed, twisting it in little circles at the wrist.

"Yeh," Al said. "One of the best. I ain't been there in four, no three, years. Been on the road since."

"Hitching?"

"Hell, no," Al exploded with contempt. "Its a sucker's game hitching. I work the trains; you know, 'Ride the rails in comfort with Pullman.'"

"Yeahr. How're the hobo camps?" Cousin asked.

It was Al's turn to extend his arm.

They all started laughing with wise, knowing, lewd laughs.

"What do you boys do?" Al asked.

They laughed again.

"We're partners in business," Cataract said.

Al looked at them, discarding one thing after another, trying to narrow down the possibilities. He decided they were sucker players of some sort.

"You guys know of any jobs in Chicago?" Al asked.

"How much you want?"

"About twenty a week. I'm in now. Got thirty-four bucks."

Pickles whistled. "What're you mooching meals for, then?"

"Who's mooching?" Al demanded. "Did I ask you guys for anything besides a ride?"

"Noooo."

"Awright, then don't go around being a wise guy."

Pickles looked out the window, grinning. "Sorry, bud."

"Well, awright then," Al said, acting sore.

"Well, awright then, dig, dig, dig, well awright," Cousin mimicked.

Cataract laughed, trying to be friendly. "They're funny boys, you know, just smart. They wish they had your thirty-four, that's all."

It worked, Al thought. He let himself grin. "It's okay," he said.

He looked out the window. They weren't in Chicago yet, but the lights shining from the houses on the side of the road were more frequent, making a steady yellow glare against the wet windows, and he knew that they must be almost at the outskirts by now. Just then, he saw a CITY LIMITS and WELCOME sign flash past. Cousin turned off the highway, and went along for a way on a dirt road that in time turned onto an old oil-stained asphalt street. They passed a few factories and Al thought of dropping off, but he wondered if it might not pay him to stay with the men a while.

Cataract yawned. "What about a game of pool now, boys?" he asked.

So that's what they are, Al thought.

"Say," he said, "I'd like to play too. I ain't very good, but I like the game." He had played exactly three times in his life. Pickles assured him, "We're no good either, that is, I'm no good. You and me can play."

"Yeah," Al said, "it ought to be fun."

Cousin was driving up Milwaukee Avenue now. He turned left, slowing down

very carefully as he did so, although there were no cars in sight.

"That Cousin drives like an old woman," Pickles commented. "I could drive faster going backwards."

Cousin jeered at him. "You couldn't drive my aunt's wheelbarrow. I'm the only guy left who hasn't lost his license," he said, speaking to Al. "It's because I take it easy when I drive a car."

Al said he didn't know much about cars, but he guessed maybe Cousin was right.

The car pulled up in front of a dark gray building on the corner of a long row of old brownstone homes. It was a dark street, and the only evidence that people lived on it was the overflowing garbage and ash cans spaced at irregular intervals in front of the houses. The poolroom itself was down in the cellar, underneath a beauty parlor and a secretarial school. On the steps going down, Al could see penciled scribblings on the walls: some hasty calculation of odds, a woman's telephone number with a comment underneath it, a few bits of profanity, and one very well drawn nude woman.

The foot of the stairs opened right onto the tables, which were strung out in one long narrow line of five. The place was almost dark, only the first table being used, and no lights were on in the back. Pickles stepped over to the counter and started talking to the boss, calling him familiarly, and for some reason annoyingly, by the name Nick. Nick was a short, very broad and sweaty Italian. He and Pickles looked up at Al at the same time, and Pickles motioned to him.

"Nick, this is a pal of mine. I want you to treat him nice if he ever comes in again. Tell thick Nick your name, sweet-face."

"Call me sweet-face," Al said.

"H'lo," Nick said. "Pleased to meet you."

"Where we play?" Al asked. He noticed that Cataract and Cousin had not come down yet.

"Take number four."

"Sweet-face and me on number four," Pickles said. "Got it."

He walked down turning on a few lights. He stopped at the cue rack, and picked one at random. Al followed him, selected one carefully, sighting along it to see if there was any warp, and sprinkling some talc over it. "Should we play a rack for table?" he asked.

"Sure," said Pickles. "You mind if we play straight? I don't know any fancy stuff."

"Me neither."

They tossed a coin, and Al had to break. He shot poorly, hit the wrong ball and scratched. Pickles overshot and splattered balls all over the table. Al sunk two, shooting as well as he could, knowing that Pickles would notice any attempts at faking. They both played sloppily and it took fifteen minutes to clear the table. Al won, eight balls to seven.

"We're pretty close," Pickles said. "What about playing for a couple of bucks this next table?"

He watched Cataract and Cousin who had just come in and were starting to play.

Al could feel the sweat starting up in the small of his back and on his thighs. I can still get out of it, he thought. At least I'll have my buck. The thought of another five dollars, however, was too strong for him. He tried to think of what would happen to him if he didn't get away with it, but he kept remembering how it felt to have money in his hands. He heard himself speaking, feeling that it was not he but someone right in back, or on top of him.

"Make it a buck," he said.

Pickles broke, again shooting too hard. Al watched him flub balls all over the table, slightly overdoing it this time. They finished the rack, Al getting a run of three at the end, to win, ten to five. Pickles handed him a dollar, and placed another on the side of the table. Al covered it with the one he had won. I wonder when he starts winning, Al thought. If I can only quit then. They played for a dollar twice more, Al winning both times. A first drop of perspiration drew together, and raced down his back. He saw Cataract watching them play, juggling two balls in his hand. They played for three dollars, Al winning, after being behind, five to two.

He straightened up, making an almost visible effort to relax.

"That makes six bucks," he said.

"Sure," said Pickles. "Let's make it five this time. I want to win my dough back."

This time Pickles won. Al handed him five dollars, separating the bills with

difficulty, and handing them over painfully.

"Another one for five," Pickles said.

Al looked around him desperately, wondering if he could get out. "Five," he croaked. Cataract was still juggling the balls.

It was the longest game he ever played. After every shot he stopped to wipe his hands. In the middle, he realized that this game was going to be given to him. He couldn't relax, however, because he knew the showdown would merely be delayed for another game or so.

He won, as he knew he would, but immediately the pressure was on again. They played once more for five, and he won. After it was over, he didn't trust himself to stand, and he leaned against the cue rack, trying to draw satisfaction from the money in his pocket. He dreamed of getting out, and having it all to do as he pleased, until he saw Pickles and Cataract looking at each other. Cataract threw a ball up, and closed his fingers too soon, missing it. It came down with a loud shattering crack that made Nick look up from his counter. That's the signal, Al thought.

They were the only ones in the place now.

Pickles stroked his cue, grinning, "Your luck's been too good, sweet-face. I think this is going to be my game. I got twenty bucks left. I'm laying it down."

"No," said Al. "I don't want to."

"Listen, I been losing dough. You're playing."

They all looked at him menacingly.

"I want to quit," Al said.

"I wouldn't try it," Cousin said.

Al looked about him, trapped, thoughts of fighting them mixing with mad ideas of flight.

Cataract stepped toward, holding a cue in his hand.

"All right," Al said, "I'll play."

Pickles broke, making a very beautiful "safe," leaving Al helpless. He bent over his stick to shoot. The balls wavered in front of him, and he could see the tip of the cue shaking up and down. He wiped his face and looked around to loosen his muscles. When he tried again, it was useless. He laid his cue on the table and walked to the back.

"Where you going?" asked Pickles.

"To the can. Want to come along?" He forced a laugh from the very bottom of his throat.

He passed through a small littered room, where old soda boxes were stored. The bathroom was small and filthy; the ceiling higher than the distance from wall to wall. Once inside he bolted the door, and sank down on the floor, whimpering softly.

After a while he quieted and looked around. The only possible exit was a window, high up on the wall facing the door. He looked at it, not realizing its significance, until a chance sound from outside made him realize where he was and what was happening to him. He got up, and looked at the wall, examining its surface for some possible boost. He saw there was none, crouched down, and jumped. His hands just grasped the edge, clung for a fraction of a second, and then scraped off. He knelt again, as close to the wall as he could possibly get, flexed himself, and leaped up. This time his palms grasped hold. He pressed his finger tips against the stone surface and chinned up enough to work his elbows over. He rested a moment, and then squeezed his stomach in and hung there on the ledge against the window, his legs dangling behind. He inched the window open noiselessly and, forgetting he was in the cellar, looked down into blackness. For a moment he was panic-stricken, until he remembered he was in the cellar, and had to look up. He shifted his position, and raised his head. There was a grating at right angles to the window, fixed above a dump heap, much like the one beneath a subway grille. It was very dark outside, but he could make out that it opened into an alley. Overjoyed, he took his money out, almost falling off in the act, kissed it, put it back, and tried to open the grating. He placed his hands under it and pushed up as hard as he could in his cramped position. The grille didn't move. He stuck one foot through the open window, and straddled the ledge, one foot in, one foot out. Bracing himself, he pushed calmly against the grating, trying to dislodge it from the grime embedded in it. Finding his efforts useless, he pushed harder and harder until his arms were almost pushed into his chest and his back and crotch felt as if they would crack. Breathing heavily, he stopped and stared up past the grating. Suddenly, with a cry of desperation, he flung himself up, beating against it with his hands and arms, until the blood ran down. Half

crazy, he gripped the bars and shook, with impassioned groans. His fingers slipped against a little obstruction on one of the end bars. His hand felt it, caressed it, hoping to find some lever point, and discovered it to be a rivet between the foundation and the grille. He sat there, huge sobs torn from him, his eyes gazing hungrily at the sky above. After a bit, he withdrew his leg, wormed his body in again, closed the window, and dropped heavily to the wall. I'll just wait till they come for me, he thought. He could hear someone coming toward the door. Pickles knocked. "Hey, kid," he yelled from the other side of the partition, "hurry up."

Al stood up, a mad flare of hope running through him as he thought of the money he still had. He held his hand to his throat, and struggled to control his voice. "Be right out," he said, managing to hold it through to the end. He heard Pickles walk away, and felt a little stronger. He started to wash himself, to get the blood off. His hands were still bleeding dully, the blood oozing out thickly and sluggishly, but he was able to stop the flow somewhat. He backed away, glanced out the window once more, and took his money out. He held it in his hands, and let the bills slip through his fingers. Gathering them up, he kissed them feverishly, rubbing the paper against his face and arms. He folded them tenderly, let down his pants, and slipped the cash into a little secret pocket, just under the crotch. He flattened out the bump it made, and unlocked the door to get out. His heart was still pounding, but he felt calmer, and more determined.

They were waiting for him impatiently, smoking quickly and nervously.

Al took out one of Cataract's cigarettes and asked for a match. He lit it, sucking deeply and gratefully from it. They glared at him, their nerves almost as tight as his.

"Come on," said Pickles, "it's your turn to shoot."

Al picked up his cue, gripping it hard to make his hand bleed faster. He bent over, made a pretense of sighting, and then laid his cue down, exposing the place where his hand had stained it.

"What's the matter?" Cousin snapped.

"I can't hold a cue," Al said. "I cut my hand in there."

"What do you mean you can't play?" Pickles shouted. "My money's up. You got to play."

"You can't force me. I'm not going to play. It's my money, it's mine see, and you can't make me. You guys can't pull this one on me; you're just trying to work a sucker game."

It was the wrong thing to say. Cataract caught him by the shirt, and shook him. "Grab hold of that stick," he said.

Al wrenched loose. "Go to hell," he said. "I'm quitting."

He picked up his hat, and started walking down past the tables to go out. He had to pass three tables and the counter to get to the stairs. He walked slowly, hoping to bluff his way out. He knew he had no chance if he ran. He could feel the sweat starting up faster this time. His shoulders were twitching, and he was very conscious of the effort of forming each step, expecting something to hit him at every second. His face was wet, and he fought down an agonizing desire to turn and look at them. Behind him, they were silent. He could see Nick at the entrance, watching him walk toward him, his face expressionless. Fascinated, he hung onto Nick's eyes, pleading silently with him. A slight smile grew on Nick's face. It broke into a high unnatural laugh, squeaking off abruptly. Terrified, Al threw a quick glance back, and promptly threw himself on his face. A cue whizzed by, shattering on the far wall with a terrific smash. Before he could get up, they were on him. Cataract turned him on his back, and knelt over him. He brought the heel of his hand down hard on Al's face, knocking his head on the floor. He saw them swirl around him, the pool tables mixed in somewhere, and he shook his head furiously, to keep from going out. Cataract hit him again.

Al struck out with his foot, and hit him in the shin.

"You dirty little bastard," Cataract said. "I'll teach you."

He slammed his knee down into Al's stomach. Al choked and writhed, the fight out of him for a moment. They turned him over, and stripped his pockets, looking for his money. They shook him. "Where is it, sweet-face?" Pickles said.

Al choked for breath.

"I lost it," he said mockingly.

"It's in his pants somewhere," Cousin said. "These rats always got a secret pocket." They tried to open his pants. He fought crazily, kicking, biting, screaming, using his elbows and knees.

"Come on," Cataract commanded, "get it off him."

Al yelled as loud as he could. Nick came over. "Get him out," he said. "The cops'll be dropping in soon. I don't want trouble."

"What'll we do with him?"

"Take him out on the road where no one will hear you. After that, it's your imagination." He squealed with laughter again.

They picked him up, and forced him out. He went with them peacefully, too dazed to care. They shoved him in the car, and Cousin turned it around. Al was in front, Cataract in the back seat, holding his wrist so he couldn't break loose before they started.

Al sat there silently, his head clearing, remembering how slowly Cousin drove. He looked out, watching the ground shoot by, and thought of jumping out. Hopelessly, he looked at the speedometer. They were going around a turn, and Cousin had slowed to less than twenty miles an hour. He had jumped off freight trains going faster than that, but there had been no door in the way, and no one had been holding him. Discouraged, he gave up the idea.

Cousin taunted him. "See that white sign, sweet-face? We turn left there, just around it, and after that it won't be long."

Anger and rebellion surged through him. They were taking away something that he had earned dangerously, and they were going to beat him up, because they had not been as smart as he. It was not fair. He wanted the money more than they did. In a fury, he decided to jump at the turn. The sign was about a hundred yards away; it would be his last chance. He figured it would take seven seconds to reach it.

He turned around to face Cataract, his left elbow resting loosely against the door handle. He had turned the way his wrist was twisted, holding it steady, so that Cataract would not realize the pressure was slackened. One, he counted to himself. "Look," he begged Cataract, "let me off. I ain't got the money, let me off." Maybe thirty yards gone by. Cataract was talking, "Oh, you're a funny boy, sweet-face. I like you, sweet-face." Another twenty. "Yeh, sure I'm funny, I'm a scream," he said. "Oh, I'm so funny." The sign, where is it? We should have reached it. Oh please God, show me the sign, you got to, it's my money, not theirs, oh please. "Goddam you, please," he shouted. "What?" Cataract yelled. Cousin slowed down. The sign slipped by. They started to turn. Al spat full in

Cataract's face, and lashed out with his wrist against the thumb. His elbow kicked the door open, and he yanked his hand loose, whirled about, and leaped out, the door just missing him in its swing back.

His feet were pumping wildly as he hit the ground. He staggered in a broken run for a few steps, before his knees crumpled under him, and he went sprawling in the dust. His face went grinding into it, the dirt mashing up into his cheeks and hands. He lay there stunned for a very long second, and then he pushed hard with his hands against the ground, forcing himself up. The car had continued around the turn, and in the confusion had gone at least a hundred feet before it stopped. Al threw a stone at the men scrambling out, and plunged off into a field. It had stopped raining, but the sky was black and he knew they would never catch him. He heard them in the distance, yelling to each other, and he kept running, his legs dead, his head lolling sideways, his breath coming in long ripping bursts. He stumbled over a weed and fell, his body spreading out on soft wet grass. Exhausted, he lay there, his ear close to the ground, but no longer hearing them, he sat up, plucking weakly at bits of grass, saying over and over again, "Oh, those suckers, those big, dumb, suckers. Oh, those dopes, those suckers. . . ."

At two-thirty, Al Groot, his stomach full, swung off a streetcar near Madison Street, and went into a flophouse. He gave the night man a new dollar bill, and tied the eighty-five cents change in a rag that he fastened to his wrist. He stood over his bed, and lit some matches, moving them slowly over the surface of his mattress. A few bedbugs started out of their burrows, and crept across the bed. He picked them up, and squashed them methodically. The last one he held in his hand, watching it squirm. He felt uneasy for a moment, and impulsively let it escape, whirling his hand in a circle to throw it away from the bed. He stretched himself out, and looked off in the distance for a while, thinking of women, and hamburgers, and billiard balls, and ketchup bottles, and shoes and, most of all, of the thrill of breaking a five-dollar bill. Lighting the last of Cataract's cigarettes, he thought of how different things had been, when he had first palmed them. He smoked openly, not caring if someone should see him, for it was his last. Al smoked happily, tremendously excited, letting each little ache and pain well into the bed. When the cigarette was finished he tried to fall asleep. He felt wide

awake, though, and after some time he propped himself on an elbow, and thought of what he would do the next day. First he would buy a pack of cigarettes, and then he would have a breakfast, and then a clean woman; he would pay a buck if he had to, and then a dinner and another woman. He stopped suddenly, unable to continue, so great was his ecstasy. He lay over his pillow and addressed it.

"By God," Al Groot said, about to say something he had never uttered before, "by God, this is the happiest moment of my life."

<div align="right">1940</div>

TESS GALLAGHER
FROM MOSS-LIGHT
TO HOPPER WITH LOVE

Or as a woman fond of wearing hats opined: "Chic chapeau!"
catching me pensive in the microwave fluorescence
of the pharmacy, buying a pack
of red Trojans, unsure where a certain amour
was heading, but not above precautions. Handy,

a hat under such conditions, to shield the shoe-ward
glance, the muffled smile that hints toward
a bald indiscretion. Being bald yourself,
you would commiserate with the unfurnished apartment
of my eye-to-eye with her, slashed

by a brim of voluptuous gloom where a shadow tranced
my cheekbones. At such moments a hat can make

all the difference, since cat-like, we are creatures invigorated
by notions of dignity. So on film Marie Lloyd
became "an expressive figure" of the British lower classes,

and Ray's stories tore down more than motorcycles
in rented living rooms across America
to announce the sinking middle and working classes.
An expressive figure, you seem to say, lends dignity
to moments alone in the stairwell, or emboldens our solitude

when love, even at one's elbow, is mostly craving
and window-gazing. If dignity were not precarious, we would be
worth less. "There goes my dignity," shrugged the Irish musician
Joe Burke, at O'Toole's one midnight, pulling a drunken mate's foot
out of his accordion. Dazed as I am by hemlock shadow, it

is foreign to encounter the bald intensity of your nearly criminal
sunlight, so white it drives out yellow, the way concrete
in sunlight cousins marble. Daylight, when it is *that* white, is
night's apostasy—as too much loneliness companions itself.
A day with you and I am inwardly shouting: "I suffer like a door!"

for those women in your paintings who could not think to shout,
ignored in train cars or offices at night. Their despair wasn't chic,
then or now. In their behalf we must swing pressure to the moment
because the present is, as you insist, clean and tearing enough to
hold back the overhang of future. But how relieved I am!

to be at the fountain's center with *you*. The gush and sparkle,
so silent here—I am buxomly relieved and clumsily
gorgeous, my haunches at a bay mare sway—as if to say
"Take that, Degas!" And what would you make of the starved-down
magazine waifs of my time, these blitzkrieg-of-the-spirit

inhalations? Aren't we as perishingly alive and nose-to-nose
with the unutterable, as fatal to ourselves as they?
Such a long way from the counter
to the purse
with these red Trojans. My hand so below, so at bottom, so
cloud-worn and muted by . . . solitude trails me off.

You see how easily two puritans slip into the sensual with their
blinds half pulled? A bluish gleam is blushing me
toward you. Could this moment be the calm, desirous darkening
where realism and impressionism overlap? Categories, you see,
like us, my not-so-sweet, are simply errands. To be

fulfilled, yet transitory. And now, my banister, my bald-pated
blank abode, allow me the full gold of this neither-nor in which we
do not meet. This *is* eternity—with my purse snapped shut, its
armory in place. Ah, my glance, my pall-like lids of homage
as I pass you, braced there at the counter above an open book.

Soon, too soon, we will gallop our particles
of "racing electric impulses" under the viaduct. But first,
that tonic blast of your sunlight, a primitive canon
to the heart. Sultry and expectant, I doff my hat to you, unfurling
Modigliani brows.

JAMES SALTER
DUSK

Mrs. Chandler stood alone near the window in a tailored suit, almost in front of the neon sign that said in small, red letters PRIME MEATS. She seemed to be looking at onions, she had one in her hand. There was no one else in the store. Vera Pini sat by the cash register in her white smock, staring at the passing cars. Outside it was cloudy and the wind was blowing. Traffic was going by in an almost continuous flow. "We have some good Brie today," Vera remarked without moving. "We just got it in."

"Is it really good?"

"Very good."

"All right, I'll take some." Mrs. Chandler was a steady customer. She didn't go to the supermarket at the edge of town. She was one of the best customers. Had been. She didn't buy that much anymore.

On the plate glass the first drops of rain appeared. "Look at that. It's started," Vera said.

Mrs. Chandler turned her head. She watched the cars go by. It seemed as if it were years ago. For some reason she found herself thinking of the many times she had driven out herself or taken the train, coming into the country, stepping down onto the long, bare platform in the darkness, her husband or a child there to meet her. It was warm. The trees were huge and black. Hello, darling. Hello, Mummy, was it a nice trip?

The small neon sign was very bright in the greyness, there was the cemetery across the street and her own car, a foreign one, kept very clean, parked near the door, facing in the wrong direction. She always did that. She was a woman who lived a certain life. She knew how to give dinner parties, take care of dogs, enter restaurants. She had her way of answering invitations, of dressing, of being herself. Incomparable habits, you might call them. She was a woman who had read books, played golf, gone to weddings, whose legs were good, who had weathered storms, a fine woman whom no one now wanted.

The door opened and one of the farmers came in. He was wearing rubber boots. "Hi, Vera," he said.

She glanced at him. "Why aren't you out shooting?"

"Too wet," he said. He was old and didn't waste words. "The water's a foot high in a lot of places."

"My husband's out."

"Wish you'd told me sooner," the old man said slyly. He had a face that had almost been obliterated by the weather. It had faded like an old stamp.

It was shooting weather, rainy and blurred. The season had started. All day there had been the infrequent sound of guns and about noon a flight of six geese, in disorder, passed over the house. She had been sitting in the kitchen and heard their foolish, loud cries. She saw them through the window. They were very low, just above the trees.

The house was amid fields. From the upstairs, distant barns and fences could be seen. It was a beautiful house, for years she had felt it was unique. The garden was tended, the wood stacked, the screens in good repair. It was the same inside, everything well selected, the soft, white sofas, the rugs and chairs, the Swedish glasses that were so pleasant to hold, the lamps. The house is my soul, she used to say.

She remembered the morning the goose was on the lawn, a big one with his long black neck and white chinstrap, standing there not fifteen feet away. She had hurried to the stairs. "Brookie," she whispered.

"What?"

"Come down here. Be quiet."

They went to the window and then on to another, looking out breathlessly.

"What's he doing so near the house?"

"I don't know."

"He's big, isn't he?"

"Very."

"But not as big as Dancer."

"Dancer can't fly."

All gone now, pony, goose, boy. She remembered that night they came home from dinner at the Werners' where there had been a young woman, very pure featured, who had abandoned her marriage to study architecture. Rob Chandler had said nothing, he had merely listened, distracted, as if to a familiar kind of news. At midnight in the kitchen, hardly having closed the door, he simply announced it. He had turned away from her and was facing the table.

"What?" she said.

He started to repeat it but she interrupted.

"What are you saying?" she said numbly.

He had met someone else, he said.

"You've what?"

She kept the house. She went just one last time to the apartment on Eighty-second Street with its large windows from which, cheek pressed to glass, you could see the entrance steps of the Met. A year later he remarried. For a while she veered off course. She sat at night in the empty living room, almost helpless, not bothering to eat, not bothering to do anything, stroking her dog's head and talking to him, curled on the couch at two in the morning still in her clothes. A fatal weariness had set in, but then she pulled herself together, began going to church and putting on lipstick again.

Now as she returned to her house from the market, there were great, leaden clouds marbled with light, moving above the trees. The wind was gusting. There

was a car in the driveway as she turned in. For just a moment she felt alarm and then she recognized it. A figure came toward her.

"Hi, Bill," she said.

"I'll give you a hand." He took the biggest bag of groceries from the car and followed her into the kitchen.

"Just put it down on the table," she said. "That's it. Thanks."

Then she added, "It's been a while."

He didn't answer. He was wearing a white shirt, unbuttoned at the collar, and an old sport coat, expensive at one time. The kitchen seemed cold. Far off was the faint pop of guns.

"Come in," she said. "It's chilly out here."

"I just came by to see if you had anything that needed to be taken care of before the cold weather set in."

"Oh, I see. Well," she said, "there's the upstairs bathroom. Is that going to be trouble again?"

"The pipes?"

"They're not going to break again this year?"

"Didn't we stuff some insulation in there?" he said. There was a slight, elegant slur in his speech, back along the edge of his tongue. He had always had it. "It's on the north side, is the trouble."

"Yes," she said. She was searching vaguely for a cigarette. "Why do you suppose they put it there?"

"Well, that's where it's always been," he said.

He was forty but looked younger. There was something hard and hopeless about him, something that was preserving his youth. All summer on the golf course, sometimes into December. Even there he seemed indifferent, dark hair blowing—even among companions, as if he were killing time. There were a lot of stories about him. He was a fallen idol. His father had a real estate agency in a cottage on the highway. Lots, farms, acreage. They were an old family in these parts. There was a lane named after them.

"There's a bad faucet. Do you want to take a look at that?"

"What's wrong with it?"

"It drips," she said. "I'll show you."

She led the way upstairs. "There," she said, pointing toward the bathroom. "You can hear it."

He casually turned the water on and off a few times and felt under the tap. He was doing it at arm's length with a slight, careless movement of the wrist. She could see him from the bedroom. He seemed to be examining other things on the counter.

She turned on a light and sat down. It was nearly dusk and the room immediately became cozy. The walls were papered in a blue pattern and the rug was a soft white. The polished stone of the hearth gave a sense of order. Outside, the fields were disappearing. It was a serene hour, one she shrank from. Sometimes, looking toward the ocean, she thought of her son, although that had happened in the sound and long ago. She no longer found she returned to it every day. They said it got better after a time but that it never really went away. As with so many other things, they were right. He had been the youngest and very spirited though a little frail. She prayed for him every Sunday in church. She prayed just a simple thing: O Lord, don't overlook him, he's very small. . . . Only a little boy, she would sometimes add. The sight of anything dead, a bird scattered in the road, the stiff legs of a rabbit, even a dead snake, upset her.

"I think it's a washer," he said. "I'll try and bring one over sometime."

"Good," she said. "Will it be another month?"

He stood looking at the floor. Then he looked up.

"So," she said, "how've you been?"

"I've been all right. You know Marian and I are back together again. Did you know that?"

"Oh, I see." She gave a slight, involuntary sigh. She felt strange. "I, uh . . ." What weakness, she thought later! "When did it happen?"

"A few weeks ago."

"That didn't take long."

"It's been over a year."

After a bit she stood up. "Shall we go downstairs?"

She could see their reflections passing the stairway window. She could see her apricot-colored shirt go by. The wind was still blowing. A bare branch was scraping the side of the house. She often heard that at night.

"Do you have time for a drink?" she asked.

"I'd better not."

She poured some Scotch and went into the kitchen to get some ice from the refrigerator and add a little water. "I suppose I won't see you for a while."

It hadn't been that much. Some dinners at the Lanai, some improbable nights. It was just the feeling of being with someone you liked, someone easy and incongruous. "I . . ." She tried to find something to say.

"You wish it hadn't happened."

"Something like that."

He nodded. He was standing there. His face had become a little pale, the pale of winter.

"And you?" she said.

"Oh, hell." She had never heard him complain. Only about certain people. "I'm just a caretaker. She's my wife. What are you going to do, come up to her sometime and tell her everything?"

"I wouldn't do that."

"I hope not," he said.

When the door closed she did not turn. She heard the car start outside and saw the reflection of the headlights. She stood in front of the mirror and looked at her face coldly. Forty-six. It was there in her neck and beneath her eyes. She would never be any younger. She should have pleaded, she thought. She should have told him all she was feeling, all that suddenly choked her heart. The summer with its hope and long days was gone. She had the urge to follow him, to drive past his house. The lights would be on. She would see someone through the windows.

That night she heard the branches tapping against the house and the window frames rattle. She sat alone and thought of the geese, she could hear them out there. It had gotten cold. The wind was blowing their feathers. They lived a long time, ten or fifteen years, they said. The one they had seen on the lawn might still be alive, settled back into the fields with the others, in from the ocean where they went to be safe, the survivors of bloody ambushes. Somewhere in the wet grass, she imagined, lay one of them, dark sodden breast, graceful neck still extended, great wings striving to beat, bloody sounds coming from the holes in its beak. She went around and turned on lights. The rain was coming down, the sea was crashing, a comrade lay dead in the whirling darkness.

JOHN HOLLANDER
SUN IN AN EMPTY ROOM

Early sunlight, even if at a late
Time, enters and plasters itself in the trapezoids
Outlined in shadow—as if given substance thereby—
Along a reach of wall, then significantly echoed
Again, in small, along a larger
Reach—as if in memory or in afterthought
Or in some mode of light's picturing of light as it
Composes a picture of the way we know
And remember and represent. It may recall
An earlier glimpse of emptiness, a corner
Of a room by the sea, opening seemingly
Onto an uncontainable expanse of ocean.
If so, it is almost to call up and purify
Such a recollection that this place

Is full, so full, of vacancy. No doubt,

A mind can be preoccupied with light

Like that which occupies a room on a daily basis;

And to look at the most uneventful morning's slow spectacle

—As through those aids to vision that used to be called

Spectacles themselves—can be to dwell

On the way light can know a room even

As Adam knew Eve in the first room that was all

Outdoors, and full of sufficiency, empty

Of the furniture by which culture copes with nature.

Perhaps sheer room had taught us "thus to ruminate,

That time will come" and take our light away, of course; but more:

That the extraordinary can be something less

Than is provided by the clutter of incident.

That it can dwell in the traces of meaningfulness,

Those trapezoids, signs of the light by which we see

The light we see—"*in lumine tuo videbimus*

Lumen"—(as we might say to the fathering sun what we had once

Sung to the fostering mother of wisdom,

"In thy radiance we see light.")

But for now, we acknowledge

The light of the world into which it has itself been

Thrown. And to ask our selves what we are *doing*

In this space—invading it with our inquiry,

Occupying ourselves not in the painted fiction of space,

But with a place of contemplation—

We may finally say that, like the painter,

It was ourselves that we were after,

Filled with the minding of the light that dwells

In the inexhaustible flatness of painted

Room, of what we stand before.

WILLIAM KENNEDY
FRANCIS IN THE JUNGLE

As Old Shoes' car moved north on Erie Boulevard, where the Erie Canal used to flow, Francis remembered Emmett Daugherty's face: rugged and flushed beneath wavy gray hair, a strong, pointed nose truly giving him the look of the Divine Warrior, which is how Francis would always remember him, an Irishman who never drank more than enough, a serious and witty man of control and high purpose, and with an unkillable faith in God and the laboring man. Francis had sat with him on the slate step in front of Iron Joe's Wheelbarrow and listened to his endless talk of the days when he and the country were young, when the riverboats brought the greenhorns up the Hudson from the Irish ships. When the cholera was in the air, the greenhorns would be taken off the steamboats at Albany and sent west on canal boats, for the city's elders had charged the government with keeping the pestilential foreigners out of the city.

Emmett rode up from New York after he got off the death ship from Cork, and at the Albany basin he saw his brother Owen waving frantically to him. Owen followed the boat to the North Albany lock, ran along the towpath yelling advice to Emmett, giving him family news, telling him to get off the boat as soon as they'd let him, then to write saying where he was so Owen could send him money to come back to Albany by stagecoach. But it was days before Emmett got off that particular packet boat, got off in a place whose name he never learned, and the authorities there too kept the newcomers westering, under duress.

By the time Emmett reached Buffalo he had decided not to return to such an inhospitable city as Albany, and he moved on to Ohio, where he found work building streets, and then with the railroads, and in time went all the way west on the rails and became a labor organizer, and eventually a leader of the Clann na Gael, and lived to see the Irish in control of Albany, and to tell his stories and inspire Francis Phelan to throw the stone that changed the course of life, even for people not yet born.

That vision of the packet moving up the canal and Owen running alongside it telling Emmett about his children was as real to Francis, though it happened four decades before he was born, as was Old Shoes' car, in which he was now bouncing ever northward toward the precise place where the separation took place. He all but cried at the way the Daugherty brothers were being separated by the goddamned government, just as he was now being separated from Billy and the others. And by what? What and who were again separating Francis from those people after he'd found them? It was a force whose name did not matter, if it had a name, but whose effect was devastating. Emmett Daugherty had placed blame on no man, not on the cholera inspectors or even the city's elders. He knew a larger fate had moved him westward and shaped in him all that he was to become; and that moving and shaping was what Francis now understood, for he perceived the fugitive thrust that had come to be so much a part of his own spirit. And so he found it entirely reasonable that he and Emmett should be fused in a single person: the character of the hero of the play written by Emmett's son, Edward Daugherty the playwright: Edward (husband of Katrina, father of Martin), who wrote *The Car Barns*, the tale of how Emmett radicalized Francis by telling

his own story of separation and growth, by inspiring Francis to identify the enemy and target him with a stone. And just as Emmett truly did return home from the west as a labor hero, so also did the playright conjure an image of Francis returning home as underground hero for what that stone of his had done.

For a time Francis believed everything Edward Daugherty had written about him: liberator of the strikers from the capitalist beggars who owned the trolleys, just as Emmett had helped Paddy-with-a-shovel straighten his back and climb up out of his ditch in another age. The playright saw them both as Divine Warriors, sparked by the socialistic gods who understood the historical Irish need for aid from on high, for without it (so spoke Emmett, the golden-tongued organizer of the play), "how else would we rid ourselves of those Tory swine, the true and unconquerable devils of all history?"

The stone had (had it not?) precipitated the firing by the soldiers and the killing of the pair of bystanders. And without that, without the death of Harold Allen, the strike might have continued, for the scabs were being imported in great numbers from Brooklyn, greenhorn Irish the likes of Emmett on the packet boat, some of them defecting instantly from the strike when they saw what it was, others bewildered and lost, lied to by men who hired them for railroad work in Philadelphia, then duped them into scabbery, terror, even death. There were even strikers from other cities working as scabs, soulless men who rode the strike trains here and took these Albany men's jobs, as other scabs were taking theirs. And all of that might have continued had not Francis thrown the first stone. He was the principal hero in a strike that created heroes by the dozen. And because he was, he lived all his life with guilt over the deaths of the three men, unable to see any other force at work in the world that day beyond his own right hand. He could not accept, though he knew it to be true, that other significant stones had flown that day, that the soldiers' fusillade at the bystanders had less to do with Harold Allen's death than it did with the possibility of the soldiers' own, for their firing had followed not upon the release of the stone by Francis but only after the mob's full barrage had flown at the trolley. And then Francis, having seen nothing but his own act and what appeared to be its instant consequences, had fled into heroism and been suffused further, through the written word of Edward Daugherty, with the hero's most splendid guilt.

But now, with those events so deeply dead and buried, with his own guilt having so little really to do with it, he saw the strike as simply the insanity of the Irish, poor against poor, a race, a class divided against itself. He saw Harold Allen trying to survive the day and the night at a moment when the frenzied mob had turned against him, just as Francis himself had often had to survive hostility in his flight through strange cities, just as he had always had to survive his own worst instincts. For Francis knew now that he was at war with himself, his private factions mutually bellicose, and if he was ever to survive, it would be with the help not of any socialistic god but with a clear head and a steady eye for the truth; for the guilt he felt was not worth the dying. It served nothing except nature's insatiable craving for blood. The trick was to live, to beat the bastards, survive the mob and that fateful chaos, and show them all what a man can do to set things right, once he sets his mind to it.

Poor Harold Allen.

"I forgive the son of a bitch," Francis said.

"Who's that?" Old Shoes asked. Rudy lay all but blotto across the backseat, holding the whiskey and wine bottles upright on his chest with both tops open in violation of Old Shoes' dictum that they stay closed, and not spilling a drop of either.

"Guy I killed. Guy named Allen."

"You killed a guy?"

"More'n one."

"Accidental, was it?"

"No. I tried to get that one guy, Allen. He was takin' my job."

"That's a good reason."

"Maybe, maybe not. Maybe he was just doin' what he had to do."

"Baloney," Old Shoes said. "That's what everybody does, good, bad, and lousy. Burglars, murderers."

And Francis fell quiet, sinking into yet another truth requiring handling.

The jungle was maybe seven years old, three years old, a month old, days old. It was an ashpit, a graveyard, and a fugitive city. It stood among wild sumac bushes and river foliage, all fallen dead now from the early frost. It was a hap-

hazard upthrust of tarpaper shacks, lean-tos, and impromptu constructions describable by no known nomenclature. It was a city of essential transiency and would-be permanency, a resort of those for whom motion was either anathema or pointless or impossible. Cripples lived here, and natives of this town who had lost their homes, and people who had come here at journey's end to accept whatever disaster was going to happen next. The jungle, a visual manifestation of the malaise of the age and the nation, covered the equivalent of two or more square city blocks between the tracks and the river, just east of the old carbarns and the empty building that once housed Iron Joe's saloon.

Francis's friend in the jungle was a man in his sixties named Andy, who had admitted to Francis in the boxcar in which they both traveled to Albany that people used to call him Andy Which One, a name that derived from his inability, until he was nearly twenty, to tell his left hand from his right, a challenge he still faced in certain stressful moments. Francis found Andy Which One instantly sympathetic, shared the wealth of cigarettes and food he was carrying, and thought instantly of him again when Annie handed him two turkey sandwiches and Peg slipped him a hefty slice of plum pudding, all three items wrapped in waxed paper and intact now in the pockets of his 1916 suitcoat.

But Francis had not seriously thought of sharing the food with Andy until Rudy had begun singing of the jungle. On top of that, Francis almost suffocated seeing his own early venom and self-destructive arrogance reembodied in Little Red, and the conjunction of events impelled him to quit the flop and seek out something he could value; for above all now, Francis needed to believe in simple solutions. And Andy Which One, a man confused by the names of his own hands, but who survived to dwell in the city of useless penitence and be grateful for it, seemed to Francis a creature worthy of scrutiny. Francis found him easily when Old Shoes parked the car on the dirt road that bordered the jungle. He roused Andy from shallow sleep in front of a fading fire, and handed him the whiskey bottle.

"Have a drink, pal. Lubricate your soul."

"Hey, old Francis. How you makin' out there, buddy?"

"Puttin' one foot in front of the other and hopin' they go somewheres," Francis said. "The hotel open here? I brought a couple of bums along with me. Old

Shoes here, he says he ain't a bum no more, but that's just what he says. And Rudy the Cootie, a good ol' fella."

"Hey," said Andy, "just settle in. Musta known you was comin'. Fire's still goin', and the stars are out. Little chilly in this joint. Lemme turn up the heat."

They all sat down around the fire while Andy stoked it with twigs and scraps of lumber, and soon the flames were trying to climb to those reaches of the sky that are the domain of all fire. The flames gave vivid life to the cold night, and the men warmed their hands by them.

A figure hovered behind Andy and when he felt its presence he turned and welcomed Michigan Mac to the primal scene.

"Glad to meet ya," Francis said to Mac. "I heard you fell through a hole the other night."

"Coulda broke my neck," Mac said.

"Did you break it?" Francis asked.

"If I'da broke my neck I'd be dead."

"Oh, so you're livin', is that it? You ain't dead?"

"Who's this guy?" Mac asked Andy.

"He's an all-right guy I met on the train," Andy said.

"We're all all right," Francis said. "I never met a bum I didn't like."

"Will Rogers said that," Rudy said.

"He did like hell," Francis said. "I said it."

"All I know. That's what he said. All I know is what I read in the newspapers," Rudy said.

"I didn't know you could read," said Francis.

"James Watt invented the steam engine," Rudy said. "And he was only twenty-nine years old."

"He was a wizard," Francis said.

"Right. Charles Darwin was a very great man, master of botany. Died in nineteen-thirty-six."

"What's he talkin' about?" Mac asked.

"He ain't talkin' about nothin'," Francis said. "He's just talkin'."

"Sir Isaac Newton. You know what he did with the apple?"

"I know that one," Old Shoes said. "He discovered gravity."

"Right. You know when that was? Nineteen-thirty-six. He was born of two midwives."

"You got a pretty good background on these wizards," Francis said.

"God loves a thief," Rudy said. "I'm a thief."

"We're all thieves," Francis said. "What'd you steal?"

"I stole my wife's heart," Rudy said.

"What'd you do with it?"

"I gave it back. Wasn't worth keepin'. You know where the Milky Way is?"

"Up there somewheres," Francis said, looking up at the sky, which was as full of stars as he'd ever seen it.

"Damn, I'm hungry," Michigan Mac said.

"Here," said Andy. "Have a bite." And from a coat pocket he took a large raw onion.

"That's an onion," Mac said.

"Another wizard," Francis said.

Mac took the onion and looked at it, then handed it back to Andy, who took a bite out of it and put it back in his pocket.

"Got it at a grocery," Andy said. "Mister, I told the guy, I'm starvin', I gotta have somethin'. And he gave me two onions."

"You had money," Mac said. "I told ya, get a loaf of bread, but you got a pint of wine."

"Can't have wine and bread too," Andy said. "What are you, a Frenchman?"

"You wanna buy food and drink," said Francis, "you oughta get a job."

"I caddied all last week," Mac said, "but that don't pay, that shit. You slide down them hills. Them golf guys got spikes on their shoes. Then they tell ya: Go to work, ya bum. I like to, but I can't. Get five, six bucks and get on the next train. I'm no bum, I'm a hobo."

"You movin' around too much," Francis said. "That's why you fell through that hole."

"Yeah," said Mac, "but I ain't goin' back to that joint. I hear the cops are pickin' the boys outa there every night. That pot is hot. Travel on, Avalon."

"Cops were here tonight earlier, shinin' their lights," Andy said. "But they didn't pick up anybody."

Rudy raised up his head and looked over all the faces in front of the fire. Then

he looked skyward and talked to the stars. "On the outskirts," he said, "I'm a restless person, a traveler."

They passed the wine among them and Andy restoked the fire with wood he had stored in his lean-to. Francis thought of Billy getting dressed up in his suit, topcoat, and hat, and standing before Francis for inspection. You like the hat? he asked. I like it, Francis said. It's got style. Lost the other one, Billy said. First time I ever wore this one. It look all right? It looks mighty stylish, Francis said. All right, gotta get downtown, Bill said. Sure, said Francis. We'll see you again, Billy said. No doubt about it. Francis said. You hangin' around Albany or movin' on? Billy asked. Couldn't say for sure, said Francis. Lotta things that need figurin' out. Always is, said Billy, and then they shook hands and said no more words to each other.

When he himself left an hour and a little bit later, Francis shook hands also with George Quinn, a quirky little guy as dapper as always, who told bad jokes (Let's all eat tomatoes and catch up) that made everybody laugh, and Peg threw her arms around her father and kissed him on the cheek, which was a million-dollar kiss, all right, all right, and then Annie said when she took his hand in both of hers: You must come again. Sure, said Francis. No, said Annie, I mean that you must come so that we can talk about the things you ought to know, things about the children and about the family. There's a cot we could set up in Danny's room if you wanted to say over next time. And then she kissed him ever so lightly on the lips.

"Hey Mac," Francis said, "you really hungry or you just mouthin' off for somethin' to say?"

"I'm hungry," Mac said. "I ain't et since noon. Goin' on thirteen, fourteen hours, whatever it is."

"Here," Francis said, unwrapping one of his turkey sandwiches and handing Mac a half, "take a bite, take a couple of bites, but don't eat it all."

"Hey all right," Mac said.

"I told you he was a good fella," Andy said.

"You want a bite of sandwich?" Francis asked Andy.

"I got enough with the onion," Andy said. "But the guy in the piano box over there, he was askin' around for something awhile back. He's got a baby there."

"A baby?"

"Baby and a wife."

Francis snatched the remnants of the sandwich away from Michigan Mac and groped his way in the firelight night to the piano box. A small fire was burning in front of it and a man was sitting cross-legged, warming himself.

"I hear you got a kid here," Francis said to the man, who looked up at Francis suspiciously, then nodded and gestured at the box. Francis could see the shadow of a woman curled around what looked to be the shadow of a swaddled infant.

"Got some stuff here I can't use," Francis said, and he handed the man the full sandwich and the remnant of the second one. "Sweet stuff too," he said and gave the man the plum pudding. The man accepted the gifts with an upturned face that revealed the incredulity of a man struck by lightning in the rainless desert; and his benefactor was gone before he could even acknowledge the gift. Francis rejoined the circle at Andy's fire, entering into silence. He saw that all but Rudy, whose head was on his chest, were staring at him.

"Give him some food, did ya?" Andy asked.

"Yeah. Nice fella. I ate me a bellyful tonight. How old's the kid?"

"Twelve weeks, the guy said."

Francis nodded. "I had a kid. Name of Gerald. He was only thirteen days old when he fell and broke his neck and died."

"Jeez, that's tough," Andy said.

"You never talked about that," Old Shoes said.

"No, because it was me that dropped him. Picked him up with the diaper and he slid out of it."

"Goddamn," said Old Shoes.

"I couldn't handle it. That's why I run off and left the family. Then I bumped into one of my other kids last week and he tells me the wife never told nobody I did that. Guy drops a kid and it dies and the mother don't tell a damn soul what happened. I can't figure that out. Woman keeps a secret like that for twenty-two years, protectin' a bum like me."

"You can't figure women," Michigan Mac said. "My old lady used to peddle her tail all day long and then come home and tell me I was the only man ever

touched her. I come in the house one day and found her bangin' two guys at once, first I knew what was happenin'."

"I ain't talkin' about that," Francis said. "I'm talkin' about a woman who's a real woman. I ain't talkin' about no trashbarrel whore."

"My wife was very good-lookin', though," Mac said. "And she had a terrific personality."

"Yeah," said Francis. "And it was all in her ass."

Rudy raised up his head and looked at the wine bottle in his hand. He held it up to the light.

"What makes a man a drunk?" he asked.

"Wine," Old Shoes said. "What you got in your hand."

"You ever hear about the bears and the mulberry juice?" Rudy asked. "Mulberries fermented inside their stomachs."

"That so?" said Old Shoes. "I thought they fermented before they got inside."

"Nope. Not with bears," Rudy said.

"What happened to the bears and the juice?" Mac asked.

"They all got stiff and wound up with hangovers," Rudy said, and he laughed and laughed. Then he turned the wine bottle upside down and licked the drops that flowed onto his tongue. He tossed the bottle alongside the other two empties, his own whiskey bottle and Francis's wine that had been passed around.

"Jeez," Rudy said. "We got nothin' to drink. We on the bum."

In the distance the men could hear the faint hum of automobile engines, and then the closing of car doors.

Francis's confession seemed wasted. Mentioning Gerald to strangers for the first time was a mistake because nobody took it seriously. And it did not diminish his own guilt but merely cheapened the utterance, made it as commonplace as Rudy's brainless chatter about bears and wizards. Francis concluded he had made yet another wrong decision, another in a long line. He concluded that he was not capable of making a right decision, that he was as wrongheaded a man as ever lived. He felt certain now that he would never attain the balance that allowed so many other men to live peaceful, nonviolent, nonfugitive lives, lives that spawned at least a modicum of happiness in old age.

He had no insights into how he differed in this from other men. He knew he was somehow stronger, more given to violence, more in love with the fugitive dance, but this was all so for reasons that had nothing to do with intent. All right, he had wanted to hurt Harold Allen, but that was so very long ago. Could anyone in possession of Francis's perspective on himself believe that he was responsible for Rowdy Dick, or the hole in the runt's neck, or the bruises on Little Red, or the scars on other men long forgotten or long buried?

Francis was now certain only that he could never arrive at any conclusions about himself that had their origin in reason. But neither did he believe himself incapable of thought. He believed he was a creature of unknown and unknowable qualities, a man in whom there would never be an equanimity of both impulsive and premeditated action. Yet after every admission that he was a lost and distorted soul, Francis asserted his own private wisdom and purpose: he had fled the folks because he was too profane a being to live among them; he had humbled himself willfully through the years to counter a fearful pride in his own ability to manufacture the glory from which grace would flow. What he was was, yes, a warrior, protecting a belief that no man could ever articulate, especially himself; but somehow it involved protecting saints from sinners, protecting the living from the dead. And a warrior, he was certain, was not a victim. Never a victim.

In the deepest part of himself that could draw an unutterable conclusion, he told himself: My guilt is all that I have left. If I lose it, I have stood for nothing, done nothing, been nothing.

And he raised his head to see the phalanx of men in Legionnaires' caps advancing into the firelight with baseball bats in their hands.

The men in caps entered the jungle with a fervid purpose, knocking down everything that stood, without a word. They caved in empty shacks and toppled lean-tos that the weight of weather and time had already all but collapsed. One man who saw them coming left his lean-to and ran, calling out one word: "Raiders!" and rousing some jungle people, who picked up their belongings and fled behind the leader of the pack. The first collapsed shacks were already burning when the men around Andy's fire became aware that raiders were approaching.

"What the hell's doin'?" Rudy asked. "Why's everybody gettin' up? Where you goin', Francis?"

"Get on your feet, stupid," Francis said, and Rudy got up.

"What the hell did I get myself into?" Old Shoes said, and he backed away from the fire, keeping the advancing raiders in sight. They were half a football field away but Michigan Mac was already in heavy retreat, bent double like a scythe as he ran for the river.

The raiders moved forward with their devastation clubs and one of them flattened a lean-to with two blows. A man following them poured gasoline on the ruins and then threw a match on top of it all. The raiders were twenty yards from Andy's lean-to by then, with Andy, Rudy, and Francis still immobilized, watching the spectacle with disbelieving eyes.

"We better move it," Andy said.

"You got anything in that lean-to worth savin'?" Francis asked.

"Only thing I own that's worth anything's my skin, and I got that with me."

The three men moved slowly back from the raiders, who were clearly intent on destroying everything that stood. Francis looked at the piano box as he moved past it and saw it was empty.

"Who are they?" Rudy asked Francis. "Why they doin' this?"

But no one answered.

Half a dozen lean-tos and shacks were ablaze, and one had ignited a tall, leafless tree, whose flames were reaching high into the heavens, far above the level of the burning shacks. In the wild firelight Francis saw one raider smashing a shack, from which a groggy man emerged on hands and knees. The raider hit the crawling man across the buttocks with a half swing of the bat until the man stood up. The raider poked him yet again and the man broke into a limping run. The fire that rose from the running man's shack illuminated the raider's smile.

Francis, Rudy, and Andy turned to run then too, convinced at last that demons were abroad in the night. But as they turned they confronted a pair of raiders moving toward them from their left flank.

"Filthy bums," one raider said, and swung his bat at Andy, who stepped deftly out of range, ran off, and was swallowed up by the night. The raider reversed his swing and caught the wobbling Rudy just above neck level, and Rudy yelped

and went down. Francis leaped on the man and tore the bat from him, then scrambled away and turned to face both raiders, who were advancing toward him with a hatred on their faces as anonymous and deadly as the exposed fangs of rabid dogs. The raider with the bat raised it above his own head and struck a vertical blow at Francis, which Francis sidestepped as easily as he once went to his left for a fast grounder. Simultaneously he stepped forward, as into a wide pitch, and swung his own bat at the man who had struck Rudy. Francis connected with a stroke that would have sent any pitch over any center-field fence in any ball park anywhere, and he clearly heard and truly felt bones crack in the man's back. He watched with all but orgasmic pleasure as the breathless man twisted grotesquely and fell without a sound.

The second attacker charged Francis and knocked him down, not with his bat but with the weight and force of his moving body. The two rolled over and over, Francis finally separating himself from the man by a glancing blow to the throat. But the man was tough and very agile, fully on his feet when Francis was still on his knees, and he was raising his arms for a horizontal swing when Francis brought his own bat full circle and smashed the man's left leg at knee level. The knee collapsed inward, a hinge reversed, and the raider toppled crookedly with a long howl of pain.

Francis lifted Rudy, who was mumbling incoherent sounds, and threw him over his shoulder. He ran, as best he could, toward the dark woods along the river, and then moved south along the shore toward the city. He stopped in tall weeds, all brown and dead. No one was following. He looked back at the jungle through the barren trees and saw it aflame in widening measure. The moon and the stars shone on the river, a placid sea of glass beside the sprawling, angry fire.

Francis found he was bleeding from the cheek and he went to the river and soaked his handkerchief and rinsed off the blood. He drank deeply of the river, which was icy and shocking and sweet. He blotted the wound, found it still bleeding, and pressed it with the handkerchief to stanch it.

"Who were they?" Rudy asked when he returned.

"They're the guys on the other team," Francis said. "They don't like us filthy bums."

"You ain't filthy," Rudy said hoarsely. "You got a new suit."

"Never mind my suit, how's your head?"

"I don't know. Like nothin' I ever felt before." Francis touched the back of Rudy's skull. It wasn't bleeding but there was one hell of a lump there.

"Can you walk?"

"I don't know. Where's Old Shoes and his car?"

"Gone, I guess. I think that car is hot. I think he stole it. He used to do that for a livin'. That and peddle his ass."

Francis helped Rudy to his feet, but Rudy could not stand alone, nor could he put one foot in front of the other. Francis lifted him back on his shoulder and headed south. He had Memorial Hospital in mind, the old Homeopathic Hospital on North Pearl Street, downtown. It was a long way, but there wasn't no other place in the middle of the damn night. And walking was the only way. You wait for a damn bus or a trolley at this hour, Rudy'd be dead in the gutter.

Francis carried him first on one shoulder, then on the other, and finally piggyback when he found Rudy had some use of both arms and could hold on. He carried him along the river road to stay away from cruising police cars, and then down along the tracks and up to Broadway and then Pearl. He carried him up the hospital steps and into the emergency room, which was small and bright and clean and empty of patients. A nurse wheeled a stretcher away from one wall when she saw him coming, and helped Rudy to slide off Francis's back and stretch out.

"He got hit in the head," Francis said. "He can't walk."

"What happened?" the nurse asked, inspecting Rudy's eyes.

"Some guy down on Madison Avenue went nuts and hit him with a brick. You got a doctor can help him?"

"We'll get a doctor. He's been drinking."

"That ain't his problem. He's got a stomach cancer too, but what ails him right now is his head. He got rocked all to hell, I'm tellin' you, and it wasn't none of his fault."

The nurse went to the phone and dialed and talked softly.

"How you makin' it, pal?" Francis asked.

Rudy smiled and gave Francis a glazed look and said nothing. Francis patted him on the shoulder and sat down on a chair beside him to rest. He saw his own

image in the mirror door of a cabinet against the wall. His bow tie was all cock-eyed and his shirt and coat were spattered with blood where he had dripped before he knew he was cut. His face was smudged and his clothes were covered with dirt. He straightened the tie and brushed off a bit of the dirt.

After a second phone call and a conversation that Francis was about to interrupt to tell her to get goddamn busy with Rudy, the nurse came back. She took Rudy's pulse, went for a stethoscope, and listened to his heart. Then she told Francis Rudy was dead. Francis stood up and looked at his friend's face and saw the smile still there. Where the wind don't blow.

"What was his name?" the nurse asked. She picked up a pencil and a hospital form on a clipboard.

Francis could only stare into Rudy's glassy-eyed smile. Isaac Newton of the apple was born of two midwives.

"Sir, what was his name?" the nurse said.

"Name was Rudy."

"Rudy what?"

"Rudy Newton," Francis said. "He knew where the Milky Way was."

It would be three-fifteen by the clock on the First Church when Francis headed south toward Palombo's Hotel to get out of the cold, to stretch out with Helen and try to think about what had happened and what he should do about it. He would walk past Palombo's night man on the landing, salute him, and climb the stairs to the room he and Helen always shared in this dump. Looking at the hallway dirt and the ratty carpet as he walked down the hall, he would remind himself that this was luxury for him and Helen. He would see the light coming out from under the door, but he would knock anyway to make sure he had Helen's room. When he got no answer he would open the door and discover Helen on the floor in her kimono.

He would enter the room and close the door and stand looking at her for a long time. Her hair would be loose, and fanned out, and pretty.

He would, after a while, think of lifting her onto the bed, but decide there was no point in that, for she looked right and comfortable just as she was. She looked as if she were sleeping.

He would sit in the chair looking at her for an amount of time he later would not be able to calculate, and he would decide that he had made a right decision in not moving her.

For she was not crooked.

He would look in the open suitcase and would find his old clippings and put them in his inside coat pocket. He would find his razor and his penknife and Helen's rhinestone butterfly, and he would put these in his coat pockets also. In her coat hanging in the closet he would find her three dollars and thirty-five cents and he would put that in his pants pocket, still wondering where she got it. He would remember the two dollars he left for her and that she would never get now, nor would he, and he would think of it as a tip for old Donovan. Helen says thank you.

He would then sit on the bed and look at Helen from a different angle. He would be able to see her eyes were closed and he would remember how vividly green they were in life, those gorgeous emeralds. He would hear the women talking together behind him as he tried to peer beyond Helen's sheltered eyes.

Too late now, the women would say. Too late now to see any deeper into Helen's soul. But he would continue to stare, mindful of the phonograph record propped against the pillow; and he would know the song she'd bought, or stole. It would be "Bye Bye Blackbird," which she loved so much, and he would hear the women singing it softly as he stared at the fiercely glistening scars on Helen's soul, fresh and livid scars whitening among the old, the soul already purging itself of all wounds of the world, flaming with the green fires of hope, but keeping their integrity too as welts of insight into the deepest secrets of Satan.

Francis, this twofold creature, now an old man in a mortal slouch, now again a fledgling bird of uncertain wing, would sing along softly with the women: Here I go, singin' low, the song revealing to him that he was not looking into Helen's soul at all but only into his own repetitive and fallible memory. He knew that right now both Rudy and Helen had far more insight into his being than he himself ever had, or would have, into either of theirs.

The dead, they got all the eyes.

He would follow the thread of his life backward to a point well in advance of the dying of Helen and would come to a vision of her in this same Japanese

kimono, lying beside him after they had made sweet love, and she saying to him: All I want in the world is to have my name put back among the family.

And Francis would then stand up and vow that he would one day hunt up Helen's grave, no matter where they put her, and would place a stone on top of it with her named carved deeply on its face. The stone would say: *Helen Marie Archer, a great soul.*

Francis would remember then that when great souls were being extinguished, the forces of darkness walked abroad in the world, filling it with lightning and strife and fire. And he would realize that he should pray for the safety of Helen's soul, since that was the only way he could now help her. But because his vision of the next world was not of the court of heaven where the legion of souls in grace venerate the Holy Worm, but rather of a foul mist above a hole in the ground where the earth itself purges away the stench of life's rot, Francis saw a question burning brightly in the air: How should this man pray?

He would think about this for another incalculably long moment and decide finally there was no way for him to pray: not for Helen, not even for himself.

He would then reach down and touch Helen on the top of the head and stroke her skull the way a father strokes the soft fontanel of his newborn child, stroke her gently so as not to disturb the flowing fall of her hair.

Because it was so pretty.

Then he would walk out of Helen's room, leaving the light burning. He would walk down the hall to the landing, salute the night clerk, who would be dozing in his chair, and then he would reenter the cold and living darkness of the night.

By dawn he would be on a Delaware & Hudson freight heading south toward the lemonade springs. He would be squatting in the middle of the empty car with the door partway open, sitting a little out of the wind. He would be watching the stars, whose fire seemed so unquenchable only a few hours before, now vanishing from an awakening sky that was between a rose and a violet in its early hue.

It would be impossible for him to close his eyes, and so he would think of all the things he might now do. He would then decide that he could not choose among all the possibilities that were his. By now he was sure only that he lived in a world where events decided themselves, and that all a man could do was to

stay one jump into their mystery.

He had a vision of Gerald swaddled in the silvery web of his grave, and then the vision faded like the stars and he could not even remember the color of the child's hair. He saw all the women who became three, and then their impossible coherence also faded and he saw only the glorious mouth of Katrina speaking words that were little more than silent shapes; and he knew then that he was leaving behind more than a city and a lifetime of corpses. He was also leaving behind even his vivid memory of the scars on Helen's soul.

Strawberry Bill climbed into the car when the train slowed to take on water, and he looked pretty good for a bum that died coughin'. He was all duded up in a blue seersucker suit, straw hat, and shoes the color of a new baseball.

"You never looked that good while you was livin'," Francis said to him. "You done well for yourself over there."

Everybody gets an Italian tailor when he checks in, Bill said. But say, pal, what're you runnin' from this time?

"Same old crowd," Francis said. "The cops."

Ain't no such things as cops, said Bill.

"Maybe they ain't none of 'em got to heaven yet, but they been pesterin' hell outa me down here."

No cops chasin' you, pal.

"You got the poop?"

Would I kid a fella like you?

Francis smiled and began to hum Rudy's song about the place where the blue-bird sings. He took the final swallow of Green River whiskey, which tasted sweet and cold to him now. And he thought of Annie's attic.

That's the place, Bill told him. They got a cot over in the corner, near your old trunk.

"I saw it," said Francis.

Francis walked to the doorway of the freight car and threw the empty whiskey bottle at the moon, an outshoot fading away into the rising sun. The bottle and the moon made music like a soulful banjo when they moved through the heavens, divine harmonies that impelled Francis to leap off the train and seek sanctuary under the holy Phelan eaves.

"You hear that music?" Francis said.

Music? said Bill. Can't say as I do.

"Banjo music. Mighty sweet banjo. That empty whiskey bottle's what's makin' it. The whiskey bottle and the moon."

If you say so, said Bill.

Francis listened again to the moon and his bottle and heard it clearer than ever. When you heard that music you didn't have to lay there no more. You could get right up off'n that old cot and walk over to the back window of the attic and watch Jake Becker lettin' his pigeons loose. They flew up and around the whole damn neighborhood, round and round, flew in a big circle and got themselves all worked up, and then old Jake, he'd give 'em the whistle and they'd come back to the cages. Damnedest thing.

"What can I make you for lunch?" Annie asked him.

"I ain't fussy. Turkey sandwich'd do me fine."

"You want tea again?"

"I always want that tea," said Francis.

He was careful not to sit by the window, where he could be seen when he watched the pigeons or when, at the other end of the attic, he looked out at the children playing football in the school athletic field.

"You'll be all right if they don't see you," Annie said to him. She changed the sheets on the cot twice a week and made tan curtains for the windows and bought a pair of black drapes so he could close them at night and read the paper.

It was no longer necessary for him to read. His mind was devoid of ideas. If an idea entered, it would rest in the mind like the morning dew on an open field of stone. The morning sun would obliterate the dew and only its effect on the stone would remain. The stone needs no such effect.

The point was, would they ever know it was Francis who had broken that fellow's back with the bat? For the blow, indeed, had killed the murdering bastard. Were they looking for him? Were they pretending not to look for him? In his trunk he found his old warm-up sweater and he wore that with the collar turned up to shield his face. He also found George Quinn's overseas cap, which gave him a military air. He would have earned stripes, medals in the military. Regimentation always held great fascination for him. No one would ever think of looking

for him wearing George's overseas cap. It was unlikely.

"Do you like Jell-O, Fran?" Annie asked him. "I can't remember ever making Jell-O for you. I don't remember if they had Jell-O back then."

If they were on to him, well that's all she wrote. Katie bar the door. Too wet to plow. He'd head where it was warm, where he would never again have to run from men or weather.

The empyrean, which is not spatial at all, does not move and has no poles. It girds, with light and love, the primum mobile, the utmost and swiftest of the material heavens. Angels are manifested in the primum mobile.

But if they weren't on to him, then he'd mention it to Annie someday (she already had the thought, he could tell that) about setting up the cot down in Danny's room, when things got to be absolutely right, and straight.

That room of Danny's had some space to it.

And it got the morning light too.

It was a mighty nice little room.

GAIL LEVIN
EDWARD HOPPER
HIS LEGACY FOR ARTISTS

The impressions on the imagination make the great days of life: the
book, the landscape or the personality which did not stay on the
surface of the eye or ear but penetrated to the inward sense, agi-
tates us, and is not forgotten. . . . The term "genius," when used
with emphasis, implies imagination; use of symbols, figurative
speech. A deep insight will always, like Nature, ultimate its thought
in a thing.
—Ralph Waldo Emerson[1]

Edward Hopper read Emerson assiduously and sought to express the Emerson-
ian vision by transforming reality into art.[2] Hopper insisted upon the necessity
of imagination: "No amount of skillful invention can replace the essential element
of imagination. One of the weaknesses of much abstract painting is the attempt
to substitute the inventions of the intellect for a pristine imaginative conception."[3]

No imagination seems more "American" than Hopper's. His images often serve
to embody America in Europe and are regularly reproduced on the jackets of
translated American novels. A popular poster of 1987 (titled *Boulevard of Broken
Dreams*) by Austrian artist Gottfried Helnwein parodies Hopper's *Nighthawks*

(1942), replacing the anonymous figures with Elvis Presley, James Dean, Humphrey Bogart, and Marilyn Monroe. Although Hopper's signature piece dates from 1942, its desolate mood suggested to Helnwein the American cinema of the 1950s and the tragic fate of the decade's best-loved celebrities. In Berlin, across from the great museum of classical art near the historic Unter den Linden, an entire wall of the new American-style Lucky Strike Café features a billboard-size *Nighthawks*, in which the cigarette trademark replaces Hopper's "Phillies Cigar" sign. Set in the old cultural center and recent zone of oppression, Hopper's image stamps the new age as American.

The excitement over Hopper does not stop with Europe. When least expected, his fans turn up among artists of diverse nationalities, ages, and styles—from folk artists to avant-garde conceptualists. My involvement with Hopper's work for nearly twenty years, as researcher, writer, and curator, has brought me into contact with a wide variety of contemporary artists who have found something in Hopper to admire, emulate, or even appropriate. After organizing the 1980 Hopper retrospective at the Whitney Museum, I came upon Richard Diebenkorn viewing the exhibition. He was scrutinizing Hopper's *Hotel Room* (1931), with its austerely organized planes of color that many abstract painters admire. Long a Hopper enthusiast, Diebenkorn in his formative years had painted *Palo Alto Circle* (1943), a Hopperesque slice of empty cityscape. More than a decade later, the seated female looking away through a window in Diebenkorn's *Woman in a Window* (1957) recalls Hopper's *Eleven A.M.* (1926), while the pale simplified planes evoke *Morning Sun* (1952). Diebenkorn shared with Hopper a love for strong sunlight and shadow, which continued to animate his later abstract compositions.

Many other abstract painters appreciated Hopper's style, even though he never returned the compliment. His admirers included Willem de Kooning, Mark Rothko, and Mark Tobey.[4] "Hopper is the only American I know who could paint the Merritt Parkway," said de Kooning, discussing his own picture of the famous Connecticut road.[5] De Kooning saw Hopper's *Cape Cod Morning* (1950) at the Whitney and praised it: "The forest looks real, like a forest; like you turned on it and there it is; like you turn and actually see it."[6] Rothko remarked, "I hate diagonals, but I like Hopper's diagonals. They're the only diagonals I like."[7]

Alex Katz was challenged by the Abstract Expressionism Hopper scorned. Yet

Katz could not ignore Hopper. He had studied with two of Hopper's strongest advocates and closest friends—Morris Kantor at Cooper Union during the late 1940s and, upon graduation, for two summers with Henry Varnum Poor at the Skowhegan School in Maine.[8] Eventually Katz retained the ambitious scale of the Abstract Expressionists, although, like Hopper, he sought sources for his work in realist painting, popular movies, and commercial art. Katz's *Folding Chair* (1959), with its window view of urban rooftops and an empty floor dominating the composition, suggests his familiarity with Hopper's *Room in Brooklyn* (1932).[9]

By the 1960s, many younger American artists were seeking to break away from Abstract Expressionism, which had been the dominant style of the 1950s. By the time of Hopper's death in 1967 (just before his eighty-fifth birthday), his example had already given these restless artists a way of looking that discounted abstraction. Hopper's importance for the new generation was underlined by the United States exhibition at the São Paulo Bienal in 1967, which featured a group of his paintings along with recent work by twenty-one younger artists, among them most of those identified with Pop Art.[10]

Pop artists were among the first to turn to Hopper's art for support in their rejection of abstract art. In 1963, Jim Dine declared: "I love the eccentricity of Edward Hopper, the way he puts skies in. For me he's more exciting than Magritte as a Surrealist. He is also like a Pop artist—gas stations and Sunday mornings and rundown streets, without making it Social Realism. . . .It seems to me that those who like Hopper would be involved with Pop somehow."[11]

That same year Claes Oldenburg produced the environmental sculpture *Bedroom Ensemble* and commented: "Bedroom, my little gray geometric home in the West, is two-stepping with Edward Hopper. To complete the story, I should mention that the Bedroom is based on a famous motel along the shore road to Malibu. . . ."[12] Oldenburg must have had in mind the abstract quality of Hopper's realist paintings as well as the specific theme of *Western Motel* (1957), which Hopper painted in California while a guest of the Huntington Hartford Foundation. Oldenburg explained: "Bedroom might have been called composition for (rhomboids) columns and disks. Using names for things may underline the 'abstract' nature of the subject. . . . Subject matter is not necessarily an obstacle to seeing 'pure' form and color."[13] In fact, the angularity of the bed in Hopper's

composition anticipates Oldenburg's resolution of the problem in three dimensions. Both artists relish the paradox of importing vernacular and willfully banal subject matter into the precincts of high art.

Other Pop artists immediately seized upon Hopper's emblematic use of popular American culture. His advertising images, such as the Phillies cigar sign in *Nighthawks*, the Ex-Lax advertisement in *Drug Store* (1927), and the flying red Pegasus from the Mobil Oil stations of *Gas* (1940) and *Four Lane Road* (1956) reverberate throughout Pop works by such artists as George Segal, Andy Warhol, and Tom Wesselmann.

Wesselmann identified Hopper as "a favorite painter" and cited the etching *Evening Wind* (1921) as inspiration for the "blowing curtain" he introduced into the Bedroom series that he began painting in 1967.[14] Wesselmann's *Great American Nude #48* (1963), with its urban window view and conventional interior furniture, parodies Hopper's characteristic paintings of figures in interiors such as *Room in Brooklyn* or *Morning in a City* (1944).

George Segal, who stressed that his "teachers were Abstract Expressionist painters," once told me:

> I became interested in realism . . . as a corrective to some of the teaching that I got that said, "Purge any trace of figurative elements out of your painting." I thought that someone was throwing the baby away with the dirty bath water. . . . The only honest way that I know to arrive at an abstraction, or a piece of poetry, or a perception, or an insight is to deal with my own response to the real world. . . . And what I like about Hopper is how far poetically he went, away from the real world.[15]

Several of Segal's sculptures of the 1960s and 1970s, with their life-size cast plaster figures, have a sense of isolation that strongly recalls the solitude in many of Hopper's pictures. The spare settings in which Segal placed his figures resurrect the everyday world of Hopper's gas stations, restaurants, diners, and cinemas. Segal's *The Diner* (1964–66) is reminiscent of *Nighthawks*, especially in the psychological tension created between the figures and their surroundings and in the atmosphere of loneliness and alienation. In *The Parking Garage* (1968), the mood and pose of the glum solitary figure evoke the man seated on the curb in

Hopper's *Sunday* (1926). The tense bedroom scene in Hopper's *Summer in the City* (1949) prefigured the couple in Segal's *Blue Girl on Black Bed* (1976), although in the sculpture the man seems more relaxed than Hopper's and only the woman appears downcast.

In 1968, one critic wrote: "like Hopper, Segal is not an American Social-Realist, but a poetic-realist."[16] Later, some critics felt it necessary to deny that Segal was "directly influenced by Hopper." Graham Beal went so far as to argue that "Segal's environments owe nothing to Hopper. They are the result of his own need to combine his experience of the physical world with the overwhelming visual impact of a painting by de Kooning or Rothko."[17] Segal himself boasted that Mark Rothko said of his work, "It looks like a walk-in Hopper."[18]

Hopper's gas stations triggered a response in the Southern California painter Edward Ruscha. In 1963, he produced *Twentysix Gasoline Stations*, a book of photographs, and an oil painting, *Standard Station, Amarillo, Texas*. The canvas evoked Hopper's work in both its theme and severe reduction of detail. Ruscha's immense painting, *Large Trademark with Eight Spotlights* (1962), which spells out "20th Century Fox," recalls Hopper's fascination with the cinema and the movie house marquee. Ruscha's subsequent depictions of Los Angeles architecture, in which he omitted figures and cropped his compositions abruptly, likewise speak for a familiarity with Hopper's compositional style.[19]

The British artist David Hockney, also in Los Angeles, called Hopper "the greatest American realist painter of the twentieth century" and publicly insisted that The Tate Gallery in London purchase one of Hopper's canvases.[20] The sense of aloneness in Hockney's *A Bigger Splash* (1967) and his focus on the psychological implications of a figure in an interior both reflect the influence of Hopper.[21] Hockney's close friend, the American expatriate R.B. Kitaj, has also spoken of his admiration for Hopper. Kitaj praised *Automat* (1927) as his favorite work in the large survey of twentieth-century American art recently shown in London.[22] In 1970, Kitaj produced *Edward Hopper*, a color screenprint and a Pop replica of the cover of Lloyd Goodrich's 1949 paperback for Penguin Books in England.

Nighthawks is one of Chicago Imagist Roger Brown's favorite works at The Art Institute.[23] Brown transformed its nocturnal view into an all-night diner in

a stylized 1969 canvas: "*Puerto Rican Wedding* is a kind of neighborhood corner view," says Brown. "Of course another part of it is, I think a kind of reference to Edward Hopper's *Nighthawks*. One side of the painting is sort of a café view which isn't really like or isn't set up like an imitation of *Nighthawks*, but still refers to it very much."[24] Brown has painted other themes identified with Hopper, including theater interiors (*Untitled*, 1968) and lonely urban streets at night (*Central City*, 1970).

By the late 1960s, several of the emerging Photo-Realists also pursued urban imagery that was closely associated with Hopper's work. Richard Estes, whose paintings most often seem Hopperesque, studied for four years at The Art Institute of Chicago, where he too came to know *Nighthawks* well. He has spoken of his admiration for three artists—Hopper, along with Degas and Eakins, who were Hopper's two favorite painters.[25] Estes moved to New York in 1959 and began to paint the city with increasing sharpness of focus. Several of his paintings give Hopper's themes a contemporary look: *Welcome to 42nd St. (Victory Theater)* (1968) recalls Hopper's *The Circle Theatre* (1936), and *Drugs* (1970) up-

Roger Brown, *Puerto Rican Wedding*, 1969. Oil on canvas, 30⅛ x 36⅛ inches. Collection of Don Baum

dates Hopper's *Drug Store* (1927).[26] In *People's Flowers* (1971), Estes painted a corner shop with a view through the window to the buildings across the street, reiterating the compositional device of *Nighthawks*; yet his own concern was with the spectacle of daylight reflection rather than nocturnal urban disquiet.

Ivan Karp, an early dealer of Photo-Realist art, wrote in 1972: "Estes will be related and compared to Hopper, with whom he may eventually be equal. Both concern themselves with 'secondary' sights: anonymous facades and static atmosphere, a strictly American regalia. Estes' shadowy figures interact among his places and objects and have no 'presence' as in Hopper. The *Subway Car* painting commands an existential emptiness and may never win nostalgia."[27] The critic Barbara Rose, reviewing a 1974 Estes show, complained that his paintings were "crammed with an incredible number of nostalgia-evoking details" and "like a visual soap opera. Obsessed with the pathos of everyday, Estes is the Paddy Chayefsky of painting."[28] While she had earlier praised Hopper's empty cityscapes, citing his ability to refine "his style to fit the needs of his subject," Rose protested that in the absence of human presence, Estes appeared to comment on "the deadness and alienation of contemporary life."[29] Ironically, she missed just how close she placed Estes' work to Hopper: the low-budget film *Marty*, based on a Chayefsky screenplay, was one of Hopper's favorite movies.[30]

Other Photo-Realists also looked at Hopper. During the 1970s, Ralph Goings painted many diners reminiscent of *Nighthawks*. John Baeder's *Tony's Trailer Court* (1980) suggests Hopper's gas stations in both its theme and treatment of light. Idelle Weber, whose New York painting *Leonard's Bakery* (1970) relates to Hopper's *Tables for Ladies* (1930), explained that "like Hopper, I enjoyed looking into interiors that were separated or distanced from the viewer by some architectural element—walls, windows, or glass."[31] Before she became a Photo-Realist, Weber had painted Pop images of office workers, another theme inspired by Hopper works such as *Office at Night* (1940) and *Conference at Night* (1949).

Many contemporary painters work on Hopperesque themes in a realist style that he would have respected. Cape Cod scenes by both Philip Koch and John Dowd have been compared to Hopper's work;[32] literature for Koch's current show boasts that his pictures "echo the work of Edward Hopper."[33] Walter Hatke's *Room of the Sun* (1979) was one of many pictures in which he explored painting

Idelle Weber, *Leonard's Bakery*, 1970. Oil on canvas, 40¼ x 32⅛ inches. Collection of Suzanne Weber

sunlight in interiors in a way suggestive of Hopper's focus on light, particularly in the latter's celebrated *Sun in an Empty Room* (1963). Hopper's themes reappear in the gas stations, street corners, and trains by George Nick, who studied with Hopper's friend and admirer Edwin Dickinson, although his compositions have been called more open and accessible than Hopper's.[34]

Much more specific references to Hopper's work began to appear during the 1970s; eventually, the term appropriation came into fashion to describe such direct quotations. The French painter Jacques Monory first discovered Hopper in 1963 through reproductions. On a visit to The Museum of Modern Art in 1969, when Minimalism prevailed in New York, he saw Hopper's *House by the Railroad* (1925). In response, Monory painted *Hommage à Edward Hopper* (1971), which reproduces Hopper's picture in monochrome, like an old black-and-white movie. Pleased with his tribute, which he later turned into a serigraph, Monory explained: "Hopper's art is part of my fascination with 'romans noirs,' thrillers, and other expressions of contemporary solitude."[35] Monory, who saw *Nighthawks* in

1976 on a pilgrimage to Chicago, became the first French artist to reciprocate Hopper's intense early involvement with France and French art.[36]

The German Dieter Hacker first referred to Hopper in his Conceptual project entitled *The Myth of Painting* (1979). Consisting of approximately eighty small reproductions of famous works of art and ten extensive text panels quoting such luminaries as Matisse, Heidegger, and Dumas, this project included a postcard size reproduction of Hopper's *Office in a Small City* (1953), one of Hacker's favorite pictures. Several years later, I wrote to Hacker about a Hopper exhibition I was preparing, entitled "Homage to Edward Hopper: Quoting the American Realist" (see note 2). Short ly after, he produced *Weisse Strasse [White Street]*, subtitled *Hommage à Edward Hopper* (1987). This Neo-Expressionist painting refers to *Night Shadows* (1921), one of Hopper's best-known etchings, where a lone man is seen walking in the deserted city at night. In both compositions, our view is from high above, creating a sense of tension that is almost cinematic in its effect.

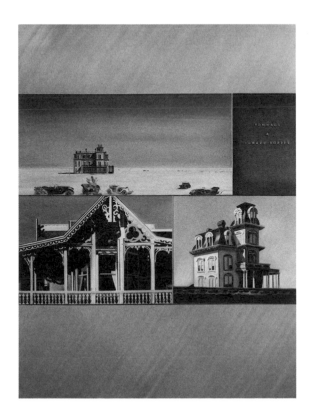

Jacques Monory, *Hommage à Edward Hopper*, 1971. Oil on canvas, 57½ x 35 inches. Whereabouts unknown

Early references to Hopper occur in realist still lifes by the American painter Lawrence Faden. *Matisse* (1979) is named after a poster on the wall behind an elaborate still-life setup with skulls, Japanese masks, exotic textiles, and other objects, and a reproduction of Hopper's *French Six-Day Bicycle Rider* (1937) pinned on another wall. Hopper's painting, with its furled tricolors, may depict a French event, but the nationality of the artist adds an American note to the cosmopolitan array. (In fact, Hopper sketched the scene at Madison Square Garden, although this was not common knowledge at the time Faden completed his work.)

If inveterate admirers of Hopper such as Diebenkorn, de Kooning, and Segal needed no new stimulus, there were countless younger and foreign artists for whom the major retrospective at the Whitney Museum in 1980–81 was a revelation. The show traveled from the Whitney to London, Amsterdam, and Düsseldorf, and then across the United States to San Francisco and Chicago. This exhibition for the first time brought together Hopper's mature paintings with the art of his formative years and a selection of his working drawings. All at once, it became possible to look behind the scenes and track Hopper's development and creative process. The reception in Europe, where Hopper had been little known, was so enthusiastic that a German critic referred to him as a cult figure.[37]

Typical of the artists who took notice for the first time is Randall Deihl, whose *Sweets* (1980) depicted a reproduction of Hopper's *New York Movie* (1939) on the wall above a refreshment stand in a movie theater, treating Hopper as the quintessential painter of the cinema. Also in 1980, Red Grooms poked lighthearted fun in his drawing *Nighthawks Revisited,* adding a car, trash, cats, and figures, including a caricature of Hopper, plunked down at the counter, glowering at us. The short-order cook who scurries to serve this irascible customer has the profile and red hair of Grooms himself. Garbage cans spill over in the foreground, ironically associating Hopper's realism with that of the early twentieth-century Ashcan School, although Hopper, in his quest to be known, as he put it, as a "great world painter," sought to distance himself from those artists.

Eric Fischl settled in New York in 1978 and visited both the 1979 Whitney Museum show of Hopper's prints and illustrations and the 1980 retrospective. Looking for a way around the "Painting is dead" maxim of the late sixties, Fischl had been searching for a viable means of representational painting while

teaching art in Nova Scotia. "I was trying to put content back into painting," he explained.[38] "The thing that's interesting about Hopper is he's such an American artist. . . . he's puritanical . . . the American sensibility. . . . there is an essential discomfort with the physicality of the body. . . . His color transcends the repressive nature of his figures. It's a compelling contradiction."

Fischl's experiments in grisaille painting, such as *Digging Children* (1981) or *The Catch* (1981), suggest a response to Hopper's grisaille illustrations on canvas, which were exhibited for the first time in the 1979 show. (They had been published in *Everybody's* magazine in 1921 and 1922 to illustrate Stephen French Whitman's serial story "Sacrifice."[39]). Two of Hopper's grisailles depict African figures grimacing and gesticulating.[40] This same heightened drama recurs in Fischl's grisaille paintings, begun just months after the show of Hopper's illustrations. Fischl himself does not recall seeing Hopper's images of Africans. Instead, he remembers beginning to look at a book on African voodoo about this time. The frenzied action of Hopper's African scenes again appears in Fischl's

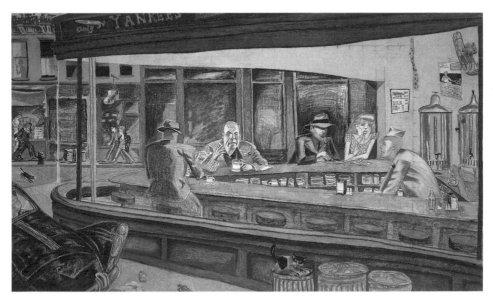

Red Grooms, *Nighthawks Revisited*, 1980. Colored pencil on paper, 44½ x 75⁹⁄₁₆ inches. Collection of the artist; courtesy Marlborough Gallery, New York © 1995 Red Grooms/ARS, NY

Edward Hopper, illustration for Stephen French Whitman, "Sacrifice," part 5, *Everybody's*, 46 (January 1992). Whitney Museum of American Art, New York; Josephine N. Hopper Bequest 70.1167

Eric Fischl, *A Visit To/ A Visit From/ The Island*, 1983. Oil on canvas, 84 x 168 inches. Whitney Museum of American Art, New York; Purchase, with funds from the Louis and Bessie Adler Foundation, Inc., Seymour M. Klein, President 83.17a-b

powerful canvas entitled *A Visit To/A Visit From/The Island* (1983), where the right half calls to mind the illustration for Whitman's story.

Nonetheless, Fischl admires Hopper's ability "to bring a powerful level of content to the intimate and daily life of people; . . . you always sense that everything in the paintings is there for a reason. . . . There's a significance to it." He considers Hopper's *New York Movie* (1939) to be "one of the all-time great modern paintings; it speaks to the duality of experience, the perception of duality as an experience in itself. It's about the reality of fantasy and the fantasy of reality. It's a strictly modern environment." His own quest for drama, for theater, is the element that links Fischl most directly to Hopper's aspirations.

The 1980 Hopper retrospective at the Whitney was also significant for Ushio Shinohara, the Japanese Neo-Dada artist who had moved to New York in 1969. He visited the show many times and later told me that Hopper's work epitomized America as he experienced it. Discovering in Hopper the same sense of isolation he had experienced on his arrival in the United States, Shinohara explained that for him, "Hopper is like Haiku—small words but big meaning."[41] Beginning in 1982, he produced a number of drawings, such as *Samurai Take a Walk to Hopper's Gas Station* or *Japanese Ghost Appears at Gas Stand*, which employ brilliantly colored ink, collaged shiny colored paper, and glitter. Shinohara easily combined images from Hopper's paintings with the figure of a dynamic samurai, as well as popular heroes from the comic books that his American-born son was reading: Batman's pal Robin, Wonder Woman, and the Incredible Hulk.

Shinohara's *Flower Viewing* of 1982 and *Seven Hoppers in Bermuda Island* of 1987 contain multiple quotations of figures and architecture from paintings such as *Second Story Sunlight* (1960) and *Four Lane Road*, in the former, and *Summertime* (1943), *Chop Suey* (1929), *Four Lane Road*, and *Sea Watchers* (1952), in the latter—all recast through the drama of Kabuki and tea ceremonies. The artist's diverse experiences, including travel to Bermuda and the study of traditional Japanese painting, are merged with Hopper's images, recreated with vivid fluorescent color and acrylic powder paints. Shinohara thinks that "Hopper is like theater" and freely puts his own actors on Hopper's stage, among them a typical Japanese noodle waitress, as well as rabbits and frogs from a famous thirteenth-century Japanese scroll painting, the *Choju Giga*. Shinohara simultaneously ad-

Ushio Shinohara, *Flower Viewing*, 1982. Acrylic on canvas, 93½ x 89⅜ inches. Private collection

mired and transformed Hopper through his unique East-West perspective.

An entirely different view of Hopper comes from Victor Burgin, the British Conceptual artist. In his photo-text piece of 1985–86, Burgin examined *Office at Night* (1940) in postmodernist terms deriving from semiotics, psychoanalysis, and feminism. He defined Hopper's image, with its female secretary and male boss, as "the organization of sexuality *for* capitalism." Burgin's work on *Office at Night* was exhibited with a large text panel explaining his theoretical interest: "In Hopper's painting, 'secretary' and 'boss' are at once the image of a particular bureaucratic dyad, and an iconogram serving to represent all such relations of subordination in the (re)production of wealth. The inscription of the power relation across the gender divide respects a patriarchal polarity." Burgin also reveled in personal associations with Hopper's picture: "Hopper painted *Office at Night* in the same year I was conceived. As a small child I was given a book which contained a picture of a businessman in a suburban street; he is unaware of the brutal and threatening Neanderthals who are shown crouched in a ditch by the road, waiting for night. I understood nothing of this image and accepted it totally."[42]

While Shinohara added Japanese icons to Hopper, Mark Kostabi added tokens of contemporary American life: television sets, telephones, and hulking skyscrapers. He replaced Hopper's generic figures with his own faceless humanoids in an extensive number of paintings with compositions lifted from Hopper. He also enlarged Hopper's scale—his initial version of *Nighthawks*, called *Greenwich Avenue* (1986), is 17 feet in length—and switched the palettes to either garish electric colors or monochrome. In *Summer Night* (1986), Kostabi added a TV set

on the floor and a bottle of wine to Hopper's *Summer in the City*. Employing a silkscreen process and a staff of artists in a factorylike setting, Kostabi has continued to make variations of this work.

A number of painters have produced humorous tributes to Hopper, often as part of a series of works that appropriate different parts from famous artists. George Deem's *School of Hopper* (1985) presents a classroom populated by several Hopper figures and views: *Nighthawks, Eleven A.M., Morning in a City, Chop Suey,* and *Hotel by a Railroad* (1952). *Office in a Small City,* and *Early Sunday Morning* (1930) provide the views out the classroom windows; in a kind of double play of reality levels, a painting of *Early Sunday Morning* stands on a tabletop easel. *Nighthawks* is also visible on the jacket of a book resting on a desktop.

In *Vincent Bar Hopping Early Sunday Morning* (1982–83), Greg Constantine created a fantasy encounter between two of his favorite painters. He pursued a similar but more complex fiction in *Nighthawk Alley* (1986); these images were part of his illustrated narratives *Vincent Van Gogh Visits New York* and *Picasso Visits Chicago*.[43] Constantine also produced a drawing, *Hopper Slices* (1984), which he followed with a painting, *Hopper's Greatest Hits* (1986), each composed of pie-shaped slices of various Hopper paintings.

Recent sculptors have also been Hopper aficionados. The abstract sculptor Christopher Wilmarth told me that he loved Hopper's work for its light and wrote a song based on Hopper's *Western Motel*.[44] Other sculptors working in

Victor Burgin, *Office at Night #6*, 1985-86. Photographic prints and plastic film on board, 48 x 120 inches. Private collection

George Deem, *School of Hopper*, 1985. Oil on canvas, 40 x 50 inches. Private collection

miniature scale have translated favorite Hopper images into three-dimensional works. In New York, Jim Barden recreated *Early Sunday Morning* in painted cardboard in 1975. In California, Chris Unterseher precisely rendered the architecture from Hopper's *Gas* (1940) in porcelain in 1979 and again in 1982. The same year Bruce Houston produced an untitled assemblage featuring a postcard of Hopper's *City Sunlight* (1954). By placing a figure aiming a movie camera at the seated woman in Hopper's painting, Houston joined the ranks of those responding to the cinematic quality of much of Hopper's art, where the movies serve as both subject and aesthetic inspiration. Susan Leopold created *Still in Brooklyn* (1986), a tiny, illuminated Hopperesque interior viewed through a peephole; it is empty, yet very evocative, suggesting Hopper's *Room in Brooklyn* (1932) without the solitary figure. The next year, Claudia DeMonte modeled figures of the lonely women who appear in Hopper's *Eleven A.M.* and *Morning Sun*.

The Swedish artist Karin Ägren, who spent 1990–91 working in New York, painted several Minimalist canvases that include circular sections of *Early Sun-*

day Morning, as if seen through a peephole: *Portrait of a SUN-DAY* (1990) and *150 Hopper on Gold* (1991), where Hopper's famous scene is repeated in rows.

The vantage point, unusual perspective, and strange trapezoidal forms of Hopper's *City Roofs* (1932) inspired Ellen K. Levy's recent series of abstract paintings (1993–94), based on the collapse of the Hartford Civic Center roof under heavy snow on the night of January 18, 1978. Beyond Hopper's forms, she finds the psychological power of his pictures compelling.[45]

Jack Pierson, a Neo-Beat artist, who organized a joint show of Hopper and himself at the Whitney in 1994, commented: "When the Whitney first presented the title 'American Dreaming' to me, I thought of the first summer I spent in Provincetown in 1980. . . . I loved it there, but my mood traveled—became entranced by Somewhere Else. In this way, I feel more like the subject of a Hopper painting than a latter-day artist."[46] Pierson interspersed his own post-Conceptual images with works by Hopper, but his collage of old magazine clippings of James Dean, while from Hopper's era, suggests Gottfried Helnwein's spoof rather than Hopper himself. *Without You*, Pierson's installation of a shabby hotel room, vaguely recalls the filmic quality of a Hopper interior, but is even more reminiscent of George Segal's sculpture, without the figures.

All these artists' references to Hopper suggest the continuing and growing appeal of Hopper's art to shifting tastes and contemporary concerns. A pioneer in borrowing from vernacular culture to make "high" art, Hopper was a modernist who eschewed abstraction, the dominant mode of modernism. Instead, through the force of his imagination, he found his own means to respond to contemporary life. Although the style he chose was traditional, his radical content powerfully expresses an alienation from much of modern life, which makes his work quintessentially modern. It should not surprise us that Hopper's art resonates ever more strongly for successive generations of artists, for he fulfills the Emersonian description of the genius whose imagination provides the "deep insight" and "symbols" that inspire and spur others.

Nor has the appropriation of Hopper's work been limited to the fine arts. Besides the innumerable cartoons that continue to appear, his images are frequently recycled for advertisements, posters, T-shirts, record jackets, and greeting cards. Novelists and poets refer to his art, and choreographers, composers, filmmakers,

and playwrights have added their tributes. These adaptations and appropriations are most often based upon *Nighthawks*, which has been replicated, reconstructed, and animated. By now we are also used to seeing Hopper's morose all-night diner repopulated with Santa and his reindeer, the characters from *Peanuts*, or a group of rabbits cast as "hoppers." No doubt the artist who hated the years he had to earn his living as a commercial illustrator would detest the transformation of his paintings into so many commercial objects. Yet he himself described another kind of fate near the end of his life, remarking of artists in general: "Ninety per cent of them are forgotten ten minutes after they're dead."[47] Edward Hopper, however, has become a cultural icon, increasingly alive, ensconced in popular fancy, even while his uncanny and uncompromising vision continues to quicken and renew the imaginative enterprise of art.

Installation view of "Edward Hopper and Jack Pierson: American Dreaming" at the Whitney Museum of American Art, Summer 1994

NOTES

1. "Poetry and Imagination," in *Letters and Social Aim, Works of Ralph Waldo Emerson*, vol. 4 (Boston: Houghton, Osgood and Company, 1879), pp. 18-20.

2. For Hopper's interest in Emerson, see Gail Levin, *Edward Hopper: An Intimate Biography* (New York: Alfred A. Knopf, in press). Most of the Hopper-derived images in this essay and examples of references to Hopper in cartoons, films, advertisements, poetry, fiction, and the performing arts were featured in "Homage to Edward Hopper: Quoting the American Realist," an exhibition organized by the author for the Baruch College Gallery, New York, November 3–December 23, 1988.

3. Edward Hopper, "Statements by Four Artists," *Reality*, 1 (June 1953), p. 8.

4. See Levin, *Edward Hopper: An Intimate Biography*, for de Kooning and Tobey as well as a discussion of Hopper's disdain for the Abstract Expressionists.

5. De Kooning's remark, made in 1959, is published in Irving Sandler, "Conversations with de Kooning," *Art Journal*, 48 (Fall 1989), p. 217. The Merritt Parkway connects Fairfield County, Connecticut, with New York State; completed in 1940, it was one of the earliest attempts to contend with America's new fixation on the automobile.

6. Ibid., p. 217.

7. Quoted in Brian O'Doherty, *American Masters: The Voice and the Myth* (New York: Universe Books, 1988), p. 24.

8. For Hopper's friendships, see Levin, *Edward Hopper: An Intimate Biography*.

9. In conversations that began in 1979 (at the time Hopper's illustrations were first shown) and continued while I posed for a portrait in 1983, Katz frequently discussed Hopper with me and more than once recounted his own early work as a commercial illustrator.

10. William C. Seitz, *São Paulo 9*, exh. cat. (Washington, D.C.: International Art Program, National Collection of Fine Arts, 1967).

11. Quoted in G.R. Swenson, "'What Is Pop Art?' Answers from 8 Painters" (1963), reprinted in Ellen H. Johnson, *American Artists on Art from 1940 to 1980* (New York: Harper & Row Publishers, 1980), p. 81.

12. Quoted in Seitz, *São Paulo 9*, p. 92.

13. Ibid.

14. Slim Stealingworth [Tom Wesselmann], *Tom Wesselmann* (New York: Abbeville Press, 1980), p. 58.

15. Quoted in Gail Levin, ed., "Artists' Panel: Joel Meyerowitz, George Segal, William Bailey, with Gail Levin, Moderator," *Art Journal*, 41 (Summer 1981), p. 154.

16. John Perreault, "Plaster Caste," *Art News*, 67 (November 1968), p. 75.

17. Graham W.J. Beal, "Realism at a Distance," in Martin Friedman and Graham W.J. Beal, *George Segal: Sculptures*, exh. cat. (Minneapolis: Walker Art Center, 1978), p. 68.

18. Segal, quoting Rothko, in Levin, ed., "Artists' Panel," p. 150.

19. See Peter Plagens, "Ed Ruscha, Seriously," in *The Works of Edward Ruscha*, exh. cat. (San Francisco: San Francisco Museum of Modern Art, 1982), pp. 33–35.

20. "No Joy at the Tate: David Hockney Talks to Miriam Gross," *The Observer*, March 4, 1979.

21. Marco Livingstone, *David Hockney* (New York: Holt, Rinehart and Winston, 1981), pp. 106, 108.

22. "The Best of America: Favorite Works from the Art Show of the Season," *Telegraph Magazine*,

September 11, 1993, pp. 36–37.

23. See Sidney Lawrence, *Roger Brown* (New York: George Braziller, 1987), p. 102.

24. From a 1983 videotape interview produced by Dennis Barrie and directed by Charles Cirgenski, Archives of American Art.

25. Estes, in an interview with John Arthur, in *Richard Estes: The Urban Landscape*, exh. cat. (Boston: Museum of Fine Arts, 1978), p. 18. For Hopper on Eakins and Degas, see Levin, *Edward Hopper: An Intimate Biography*.

26. Hopper made sketches for his painting *Girlie Show* (1941) inside the Victory Theater, although Estes could not have known this in 1968.

27. Ivan Karp, "Rent Is the Only Reality, or the Hotel Instead of the Hymns," *Arts Magazine*, 46 (December–January 1972); reprinted in Gregory Battcock, ed., *Super Realism: A Critical Anthology* (New York: E.P. Dutton & Co., 1975), p. 27.

28. Barbara Rose, "Treacle and Trash," *New York*, May 27, 1974, p. 80.

29. Barbara Rose, *American Art Since 1900* (New York: Frederick A. Praeger, 1967), p. 125.

30. Hopper saw *Marty* in 1956; see Levin, *Edward Hopper: An Intimate Biography*.

31. Interview with the author, August 21, 1994.

32. Marsha Gordon, "Provincetown Prodigy: John Dowd, Hell's Kitchen's Hot Young Artist," *Cape Cod Life* (Fall 1986), pp. 126–29.

33. Cedar Rapids Museum of Art, press release, Summer 1994.

34. Bonnie L. Grad, "George Nick's Realism," in *George Nick: A Retrospective*, exh. cat. (Boston: Massachusetts College of Art, 1993), n.p.

35. Letter to the author, April 27, 1979; author's translation from the French.

36. See Gail Levin, "Edward Hopper: Francophile," *Arts Magazine*, 53 (June 1979), pp. 114-21.

37. Karl-Heinz Bohrer, "Die neue Kultfigur: Edward Hopper," *Frankfurter Allgemeine Zeitung*, March 30, 1981, p. 25.

38. Interview with the author, August 23, 1994. The quotations following in the paragraph are from this interview.

39. See Gail Levin, *Edward Hopper as Illustrator* (New York: W.W. Norton & Company in association with the Whitney Museum of American Art, 1979), figs. 17–26.

40. Ibid., figs. 26a, 26b.

41. Interview with the author, October 1987.

42. For this and preceding text, see Victor Burgin, *Between* (London: Basil Blackwell, 1986), pp. 182, 183.

43. Greg Constantine, *Vincent Van Gogh Visits New York* (New York: Alfred A. Knopf, 1983), p. 20, and Constantine, *Picasso Visits Chicago* (Chicago: Chicago Review Press, 1986), pp. 18–19.

44. Christopher Wilmarth, letter to the author, August 1987, enclosing the song.

45. See Gail Levin, *The Collapse of Postmodernism: New Work by Ellen K. Levy*, exh. cat. (Trenton: New Jersey State Museum, 1994).

46. Jack Pierson, quoted in "Collection in Context. Edward Hopper and Jack Pierson: American Dreaming," press release from the Whitney Museum of American Art, May 1994.

47. Quoted in O'Doherty, *American Masters*, p. 1.

PLATES

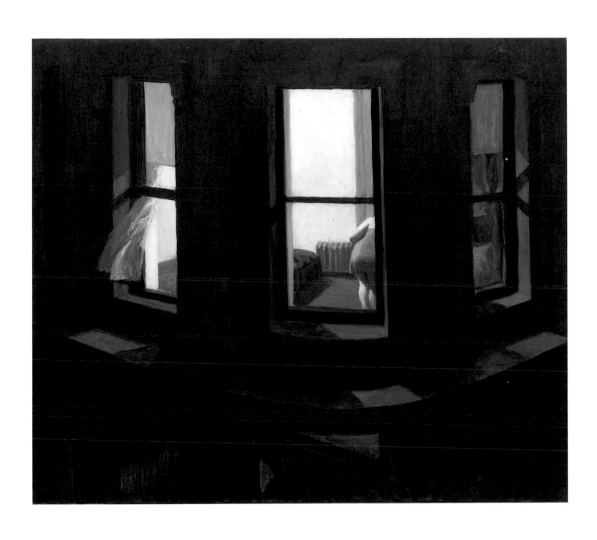

Pl. 1 NIGHT WINDOWS, 1928
Oil on canvas, 29 x 34 inches (73.7 x 86.4 cm)
The Museum of Modern Art, New York; Gift of John Hay Whitney

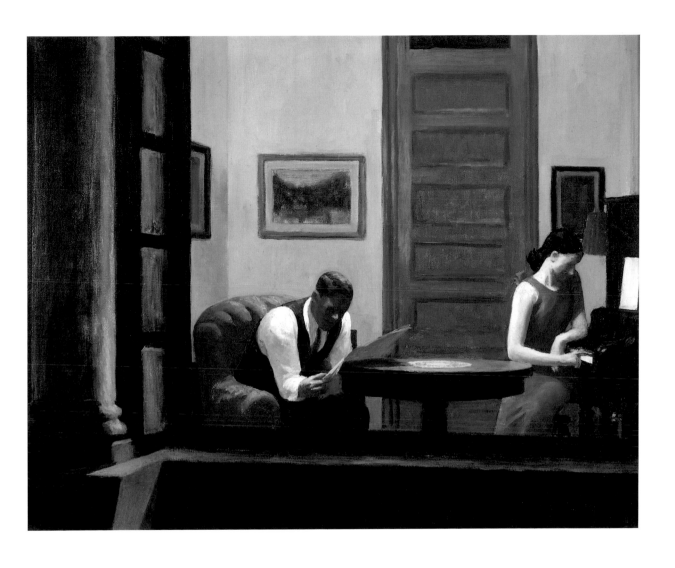

Pl. 2 ROOM IN NEW YORK, 1932
Oil on canvas, 29 x 36 inches (73.7 x 91.4 cm)
Sheldon Memorial Art Gallery, University of Nebraska—Lincoln;
F.M. Hall Collection

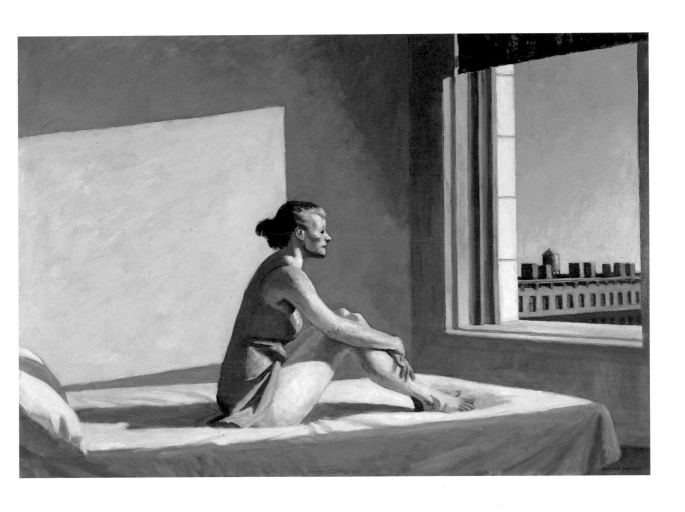

Pl. 3 MORNING SUN, 1952
Oil on canvas, 28 1/8 x 40 1/8 inches (71.4 x 101.9 cm)
Columbus Museum of Art, Ohio; Museum Purchase, Howald Fund

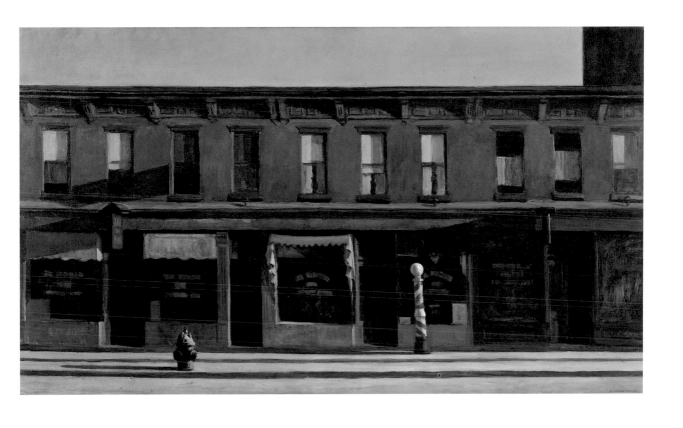

Pl. 4 EARLY SUNDAY MORNING, 1930
Oil on canvas, 35 x 60 inches (88.9 x 152.4 cm)
Whitney Museum of American Art, New York; Purchase, with funds
from Gertrude Vanderbilt Whitney 31.426

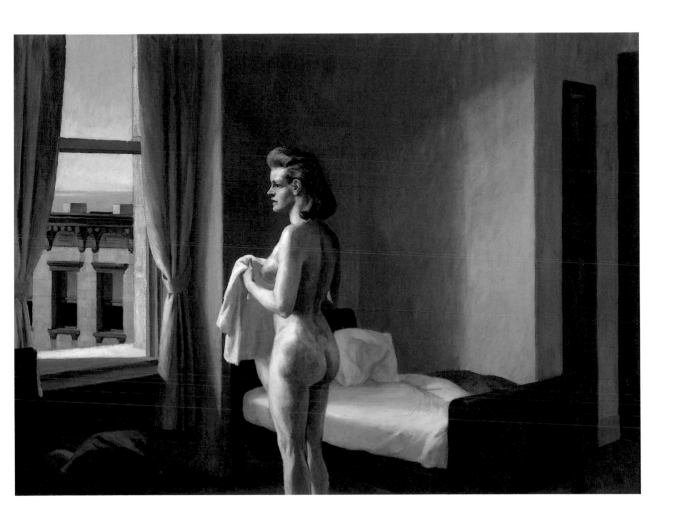

Pl. 5 MORNING IN A CITY, 1944
Oil on canvas, 44 5/16 x 59 13/16 inches (112.6 x 151.9 cm)
Williams College Museum of Art, Williamstown, Massachusetts;
Bequest of Lawrence H. Bloedel, Class of 1923

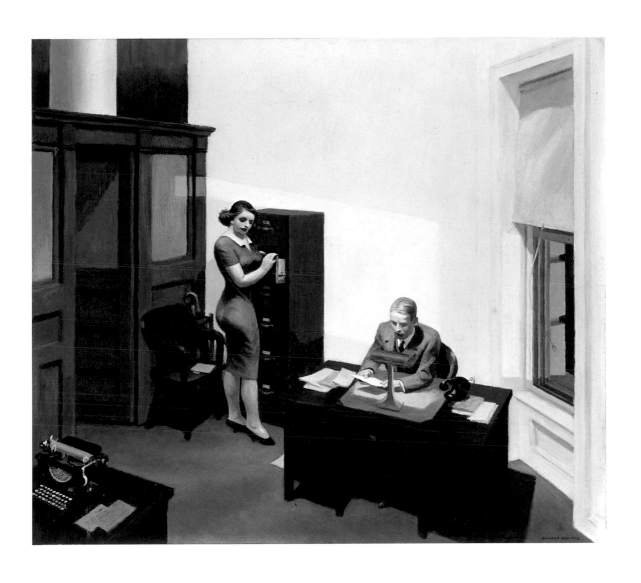

Pl. 6 OFFICE AT NIGHT, 1940
Oil on canvas, 22 3/16 x 25 1/8 inches (56.4 x 63.8 cm)
Walker Art Center, Minneapolis; Gift of the T.B. Walker
Foundation, Gilbert M. Walker Fund, 1948

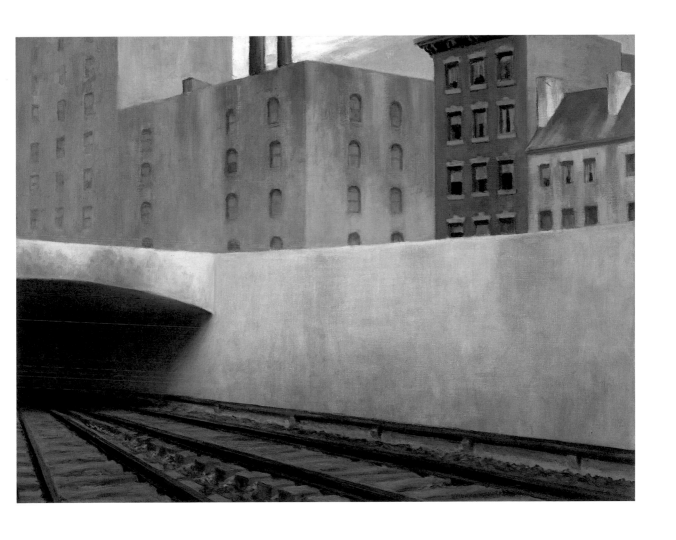

Pl. 7 APPROACHING A CITY, 1946
Oil on canvas, 27 1/8 x 36 inches (68.9 x 91.4 cm)
The Phillips Collection, Washington, D.C.

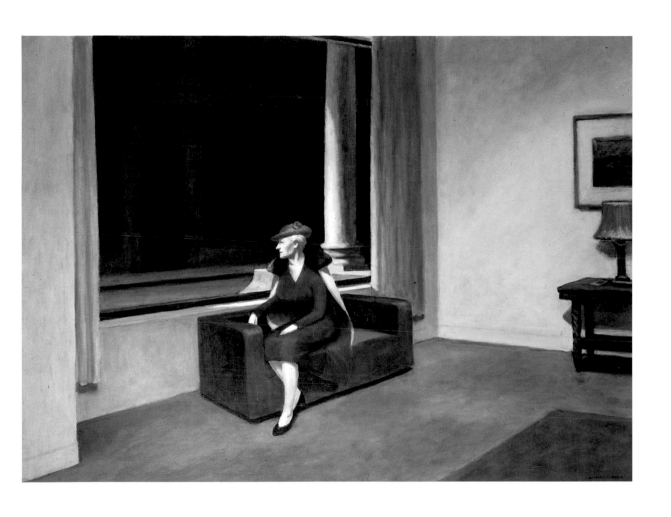

Pl. 8 HOTEL WINDOW, 1955
Oil on canvas, 40 x 55 inches (101.6 x 139.7 cm)
The *FORBES* Magazine Collection, New York

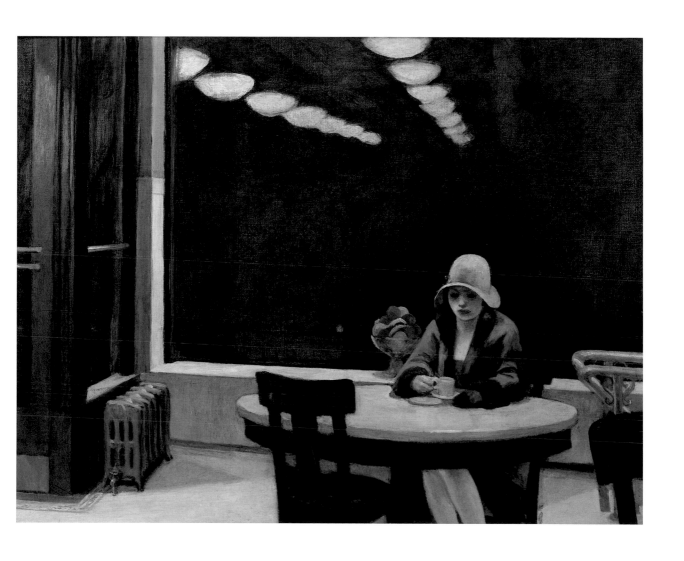

Pl. 9 AUTOMAT, 1927
Oil on canvas, 28 1/8 x 36 inches (71.4 x 91.4 cm)
Des Moines Art Center Permanent Collection, Iowa; Purchased with
funds from the Edmundson Art Foundation, Inc.

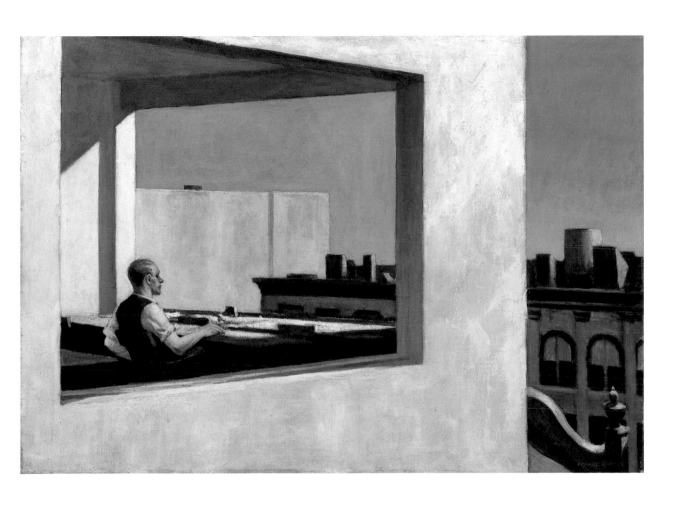

Pl. 10 OFFICE IN A SMALL CITY, 1953
Oil on canvas, 28 x 40 inches (71.1 x 101.6 cm)
The Metropolitan Museum of Art, New York; George A. Hearn Fund

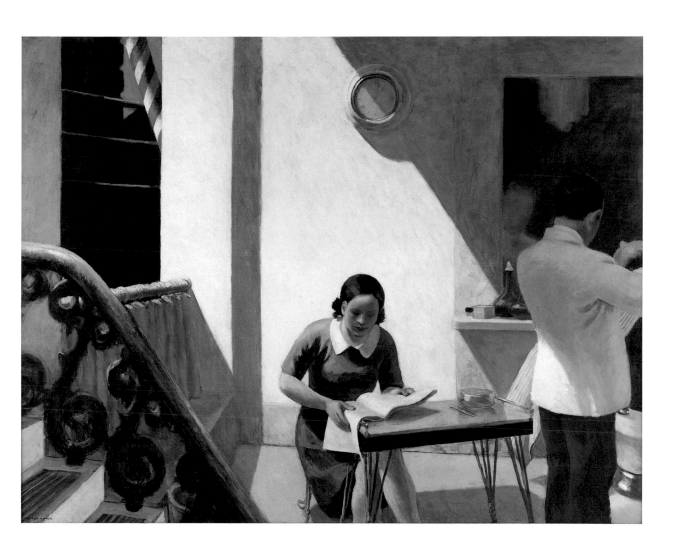

Pl. 11 BARBER SHOP, 1931
Oil on canvas, 60 x 78 inches (152.4 x 198.1 cm)
Neuberger Museum of Art, Purchase College, State University of
New York; Gift of Roy R. Neuberger

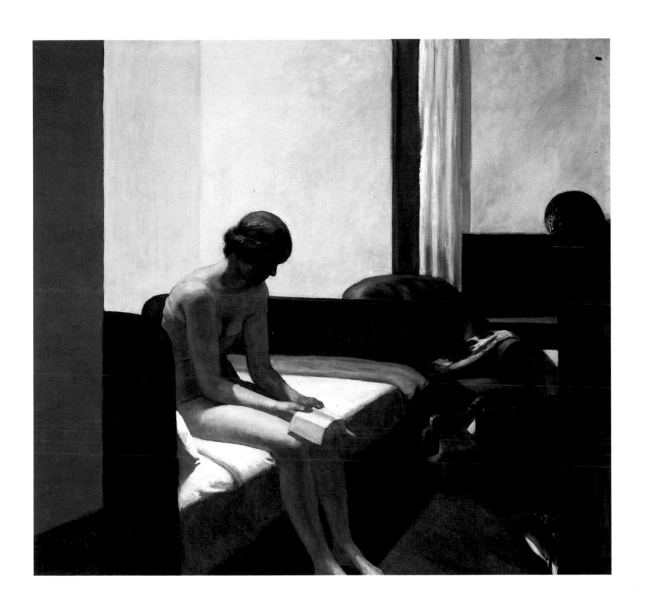

Pl. 12 HOTEL ROOM, 1931

Oil on canvas, 60 x 65 1/4 inches (152.4 x 165.7 cm)

Fundación Colección Thyssen-Bornemisza, Madrid

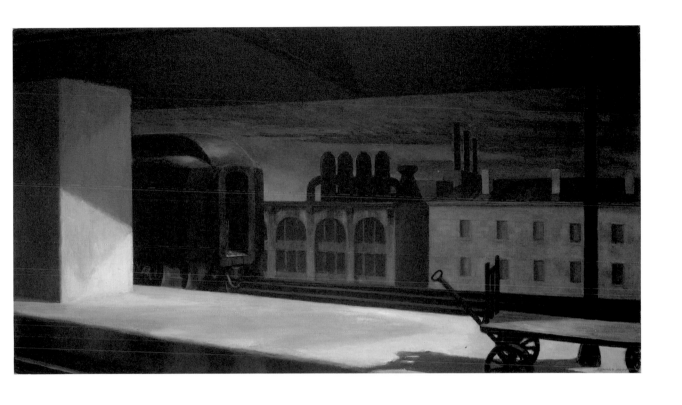

Pl. 13 DAWN IN PENNSYLVANIA, 1942

Oil on canvas, 24 1/2 x 44 1/4 inches (62.2 x 112.4 cm)

Collection of Daniel J. Terra

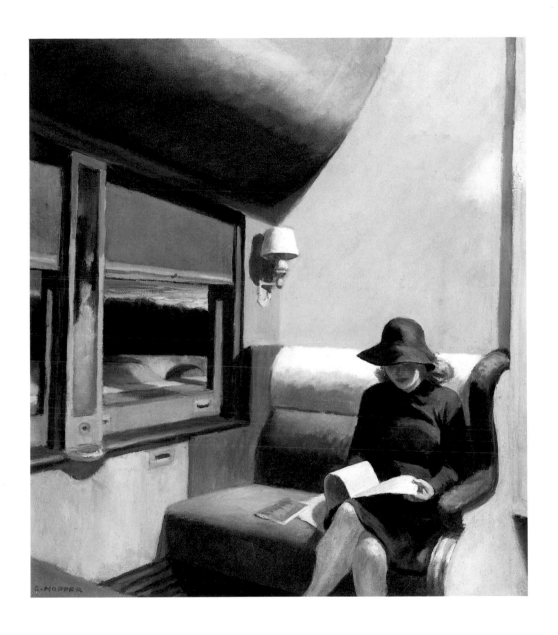

Pl. 14 COMPARTMENT C, CAR 293, 1938

Oil on canvas, 20 x 18 inches (50.8 x 45.7 cm)

IBM Corporation, Armonk, New York

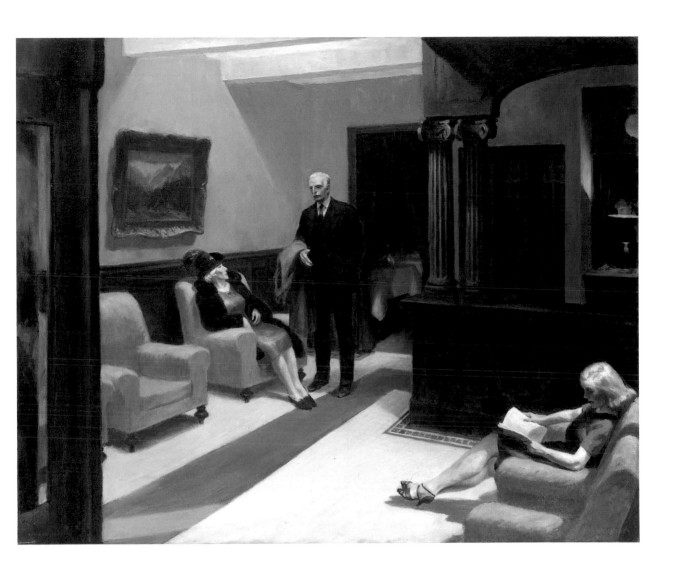

Pl. 15 HOTEL LOBBY, 1943
Oil on canvas, 32 1/2 x 40 3/4 inches (82.6 x 103.5 cm)
Indianapolis Museum of Art; William Ray Adams Memorial Collection

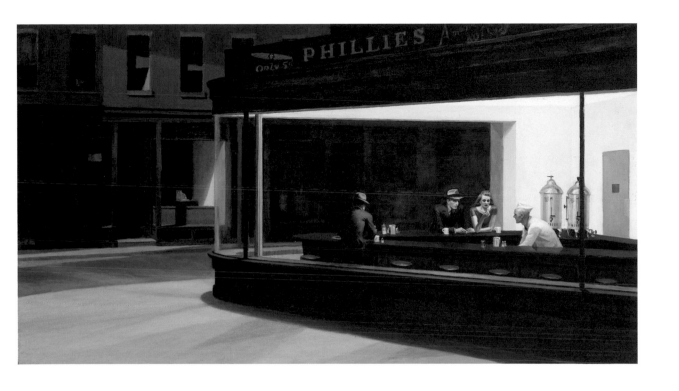

Pl. 16 NIGHTHAWKS, 1942

Oil on canvas, 30 x 56 11/16 inches (76.2 x 144 cm)

The Art Institute of Chicago; Friends of American Art Collection

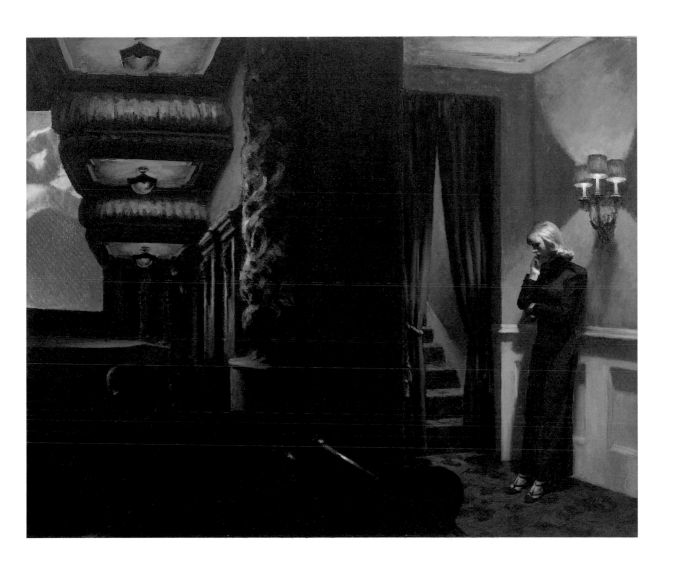

Pl. 17 NEW YORK MOVIE, 1939

Oil on canvas, 32 1/4 x 40 1/8 inches (81.9 x 101.9 cm)

The Museum of Modern Art, New York; Given anonymously

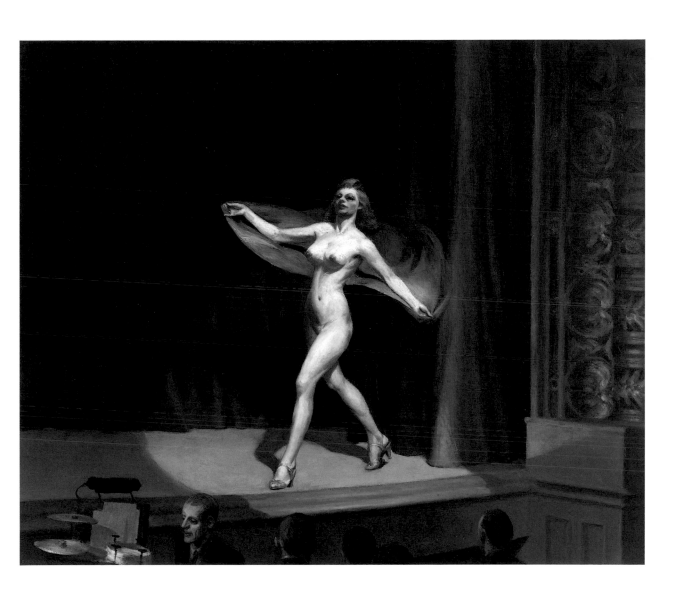

Pl. 18 GIRLIE SHOW, 1941
Oil on canvas, 32 x 38 inches (81.3 x 96.5 cm)
Private collection

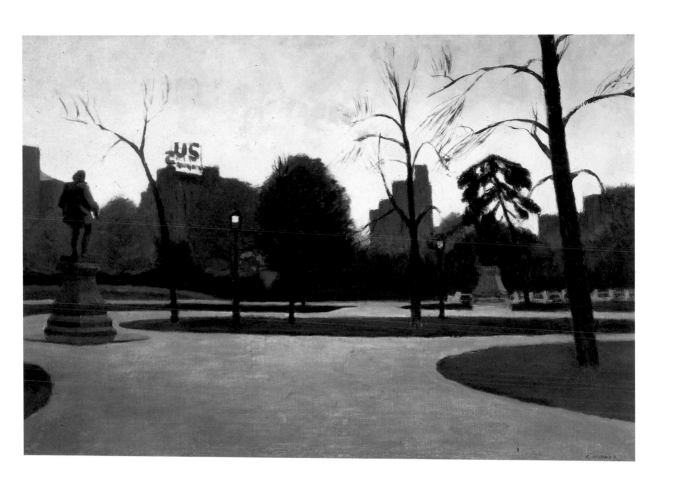

Pl. 19 SHAKESPEARE AT DUSK, 1935
Oil on canvas, 17 x 25 inches (43.2 x 63.5 cm)
Collection of Carl D. Lobell

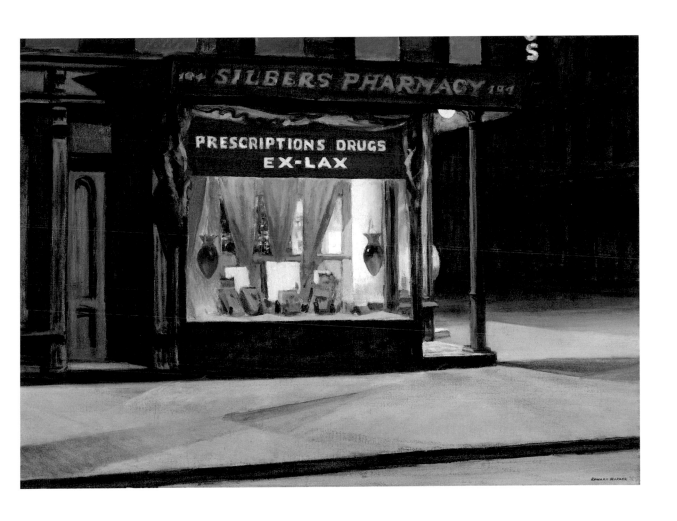

Pl. 20 DRUG STORE, 1927

Oil on canvas, 29 x 40 inches (73.7 x 101.6 cm)

Museum of Fine Arts, Boston; Bequest of John T. Spaulding

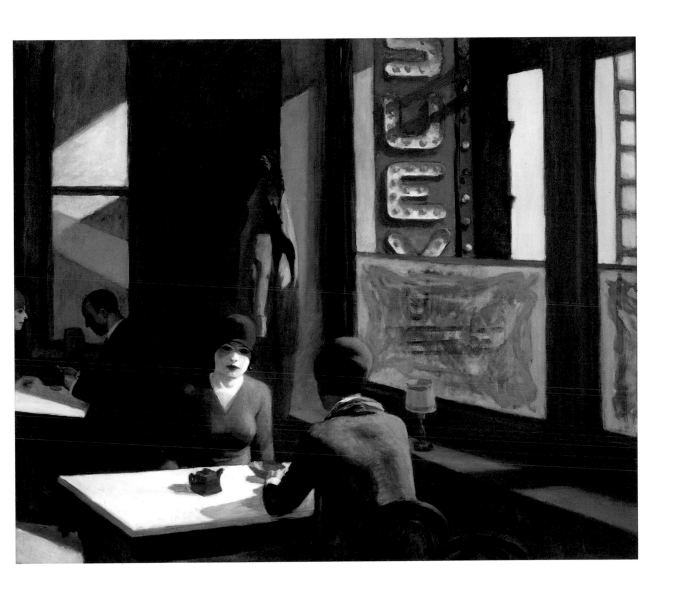

Pl. 21 CHOP SUEY, 1929

Oil on canvas, 32 x 38 inches (81.3 x 96.5 cm)

Collection of Mr. and Mrs. Barney A. Ebsworth

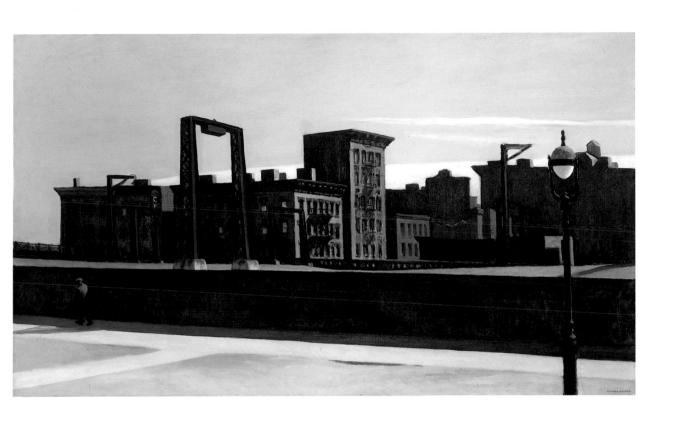

Pl. 22 MANHATTAN BRIDGE LOOP, 1928
Oil on canvas, 35 x 60 inches (88.9 x 152.4 cm)
Addison Gallery of American Art, Phillips Academy, Andover,
Massachusetts; Gift of Mr. Stephen C. Clark, Esq.

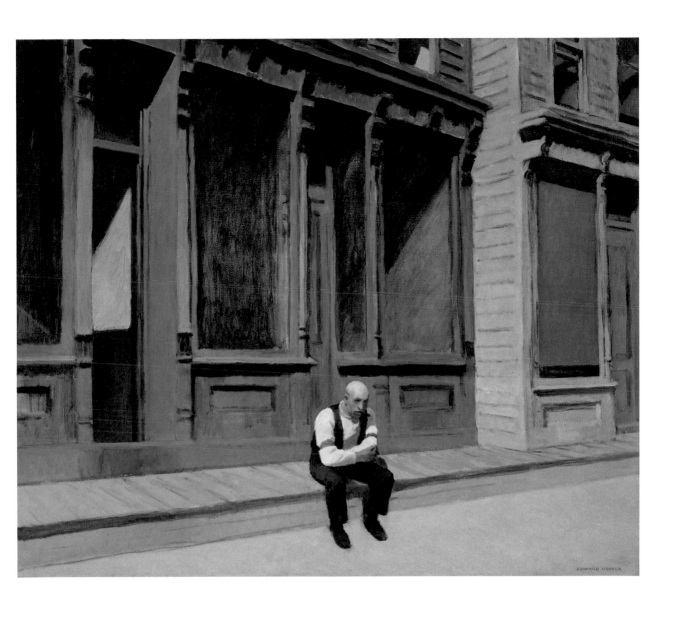

Pl. 23 SUNDAY, 1926
Oil on canvas, 29 x 34 inches (73.7 x 86.4 cm)
The Phillips Collection, Washington, D.C.

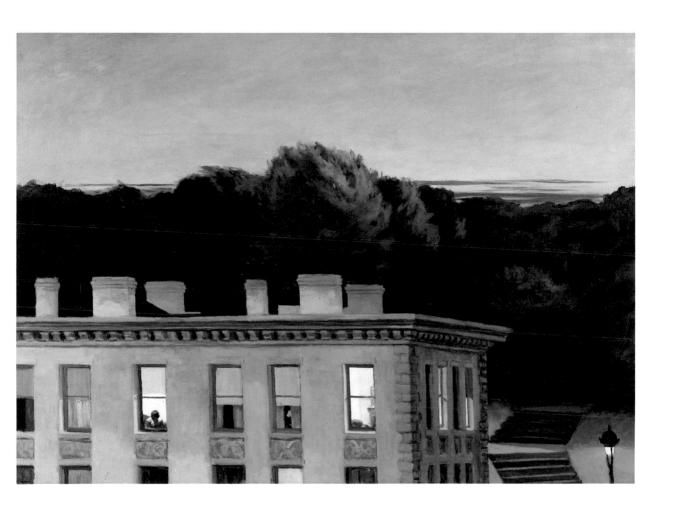

Pl. 24 HOUSE AT DUSK, 1935

Oil on canvas, 36 1/4 x 50 inches (92.1 x 127 cm)

Virginia Museum of Fine Arts, Richmond; The John Barton Payne Fund

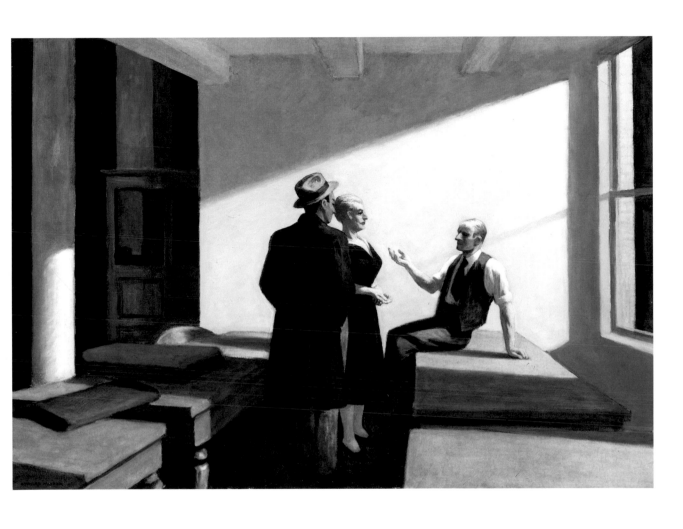

Pl. 25 CONFERENCE AT NIGHT, 1949
Oil on canvas, 28 3/8 x 40 3/8 inches (72.1 x 102.6 cm)
Wichita Art Museum, Kansas; Roland P. Murdock Collection

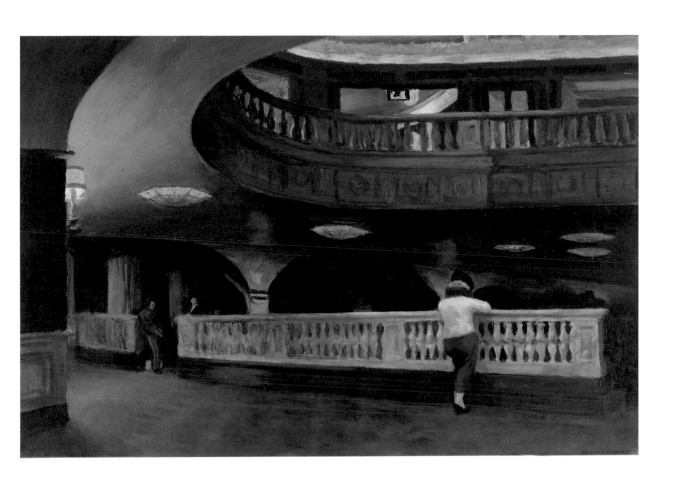

Pl. 26 THE SHERIDAN THEATRE, 1937
Oil on canvas, 17 1/8 x 25 1/4 inches (43.5 x 64.1 cm)
The Newark Museum, New Jersey; Purchase 1940 Felix Fuld Bequest Fund

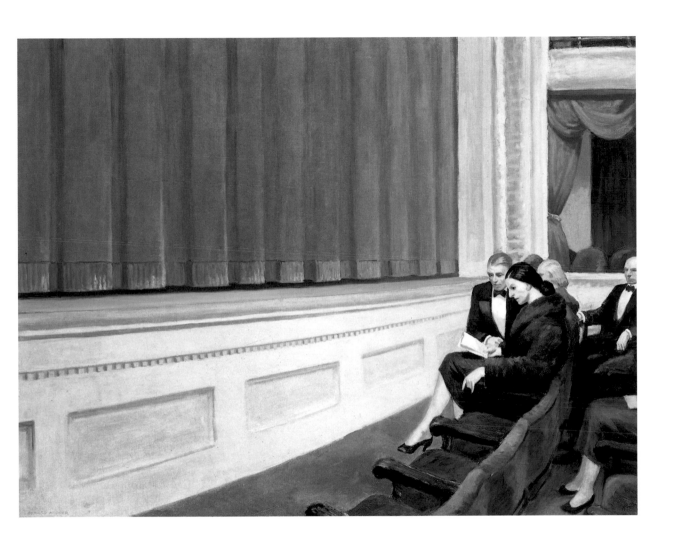

Pl. 27 FIRST ROW ORCHESTRA, 1951
Oil on canvas, 31 1/8 x 40 1/8 inches (79 x 101.9 cm)
Hirshhorn Museum and Sculpture Garden, Smithsonian Institution,
Washington, D.C.; Gift of the Joseph H. Hirshhorn Foundation, 1966

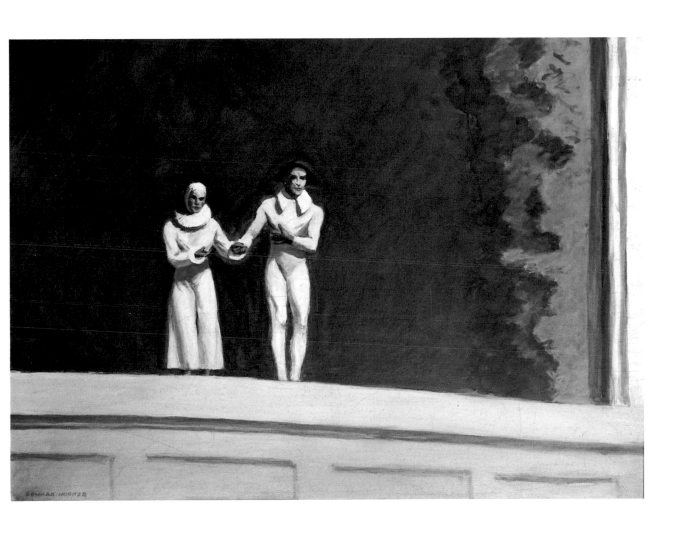

Pl. 28 TWO COMEDIANS, 1966
Oil on canvas, 29 x 40 inches (73.7 x 101.6 cm)
Collection of Mr. and Mrs. Frank Sinatra

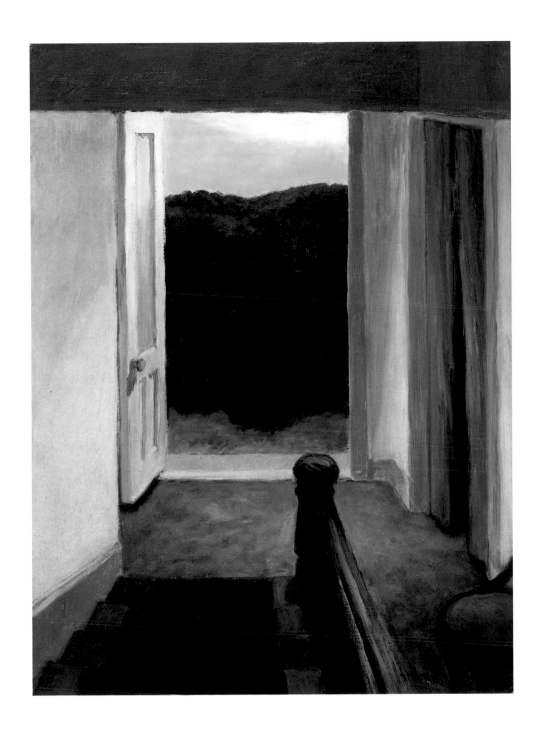

Pl. 29 STAIRWAY, 1949

Oil on wood, 16 x 11 7/8 inches (40.6 x 30.2 cm)

Whitney Museum of American Art, New York; Josephine N. Hopper Bequest 70.1265

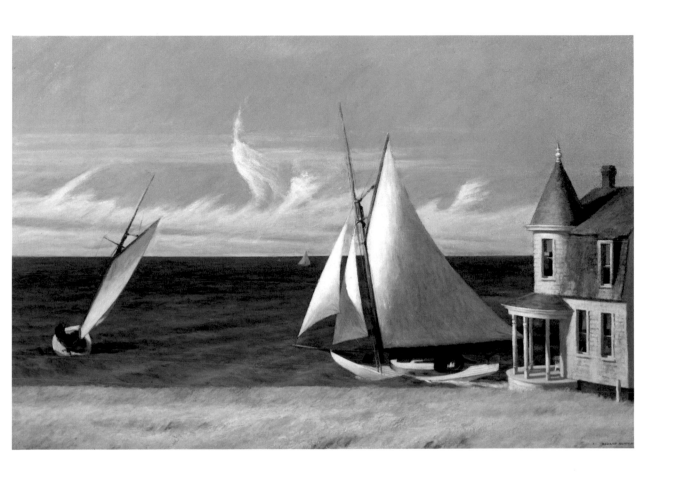

Pl. 30 LEE SHORE, 1941
Oil on canvas, 28 1/4 x 43 inches (71.8 x 109.2 cm)
Private collection

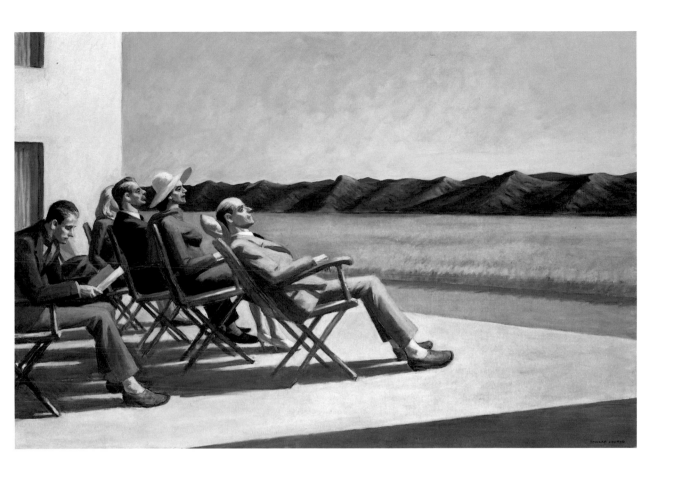

Pl. 31 PEOPLE IN THE SUN, 1960
Oil on canvas, 40 3/8 x 60 3/8 inches (102.6 x 153.4 cm)
National Museum of American Art, Smithsonian Institution,
Washington, D.C.; Gift of S.C. Johnson & Son, Inc.

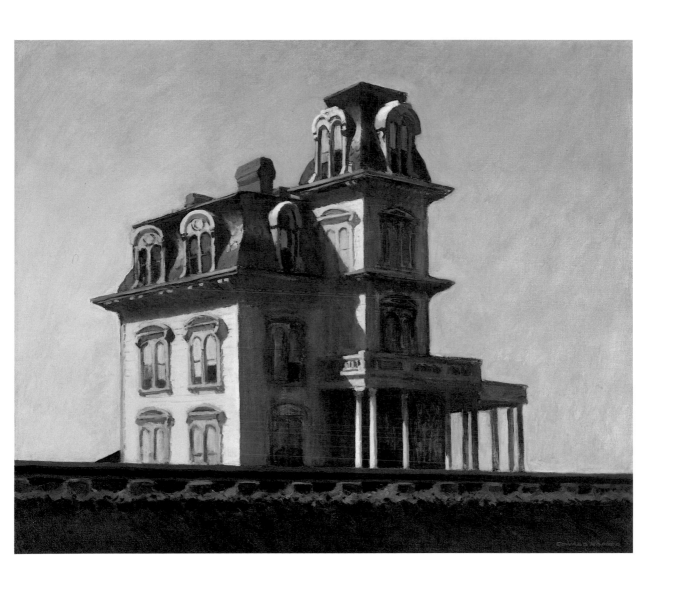

Pl. 32 HOUSE BY THE RAILROAD, 1925
Oil on canvas, 24 x 29 inches (61 x 73.7 cm)
The Museum of Modern Art, New York; Given anonymously

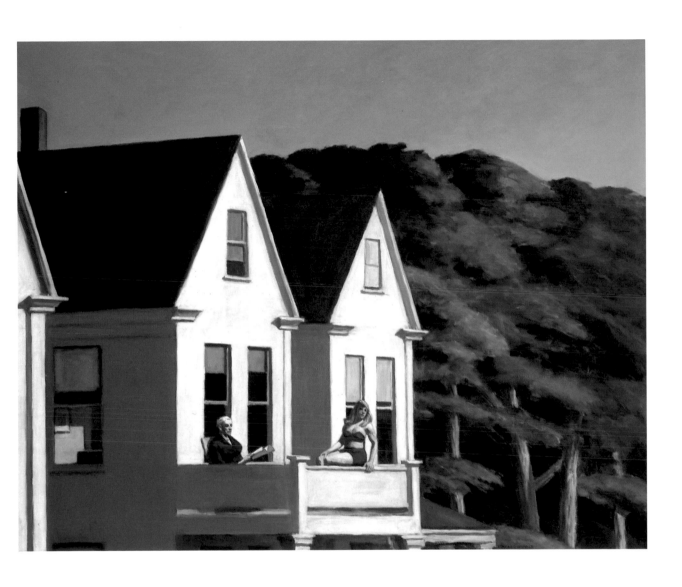

Pl. 33 SECOND STORY SUNLIGHT, 1960
Oil on canvas, 40 x 50 inches (101.6 x 127 cm)
Whitney Museum of American Art, New York; Purchase, with funds
from the Friends of the Whitney Museum of American Art 60.54

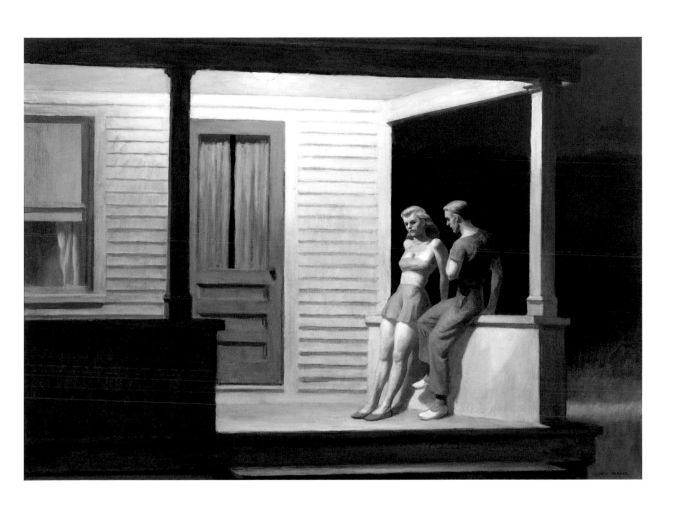

Pl. 34 SUMMER EVENING, 1947

Oil on canvas, 30 x 42 inches (76.2 x 106.7 cm)

Collection of Mr. and Mrs. Gilbert H. Kinney

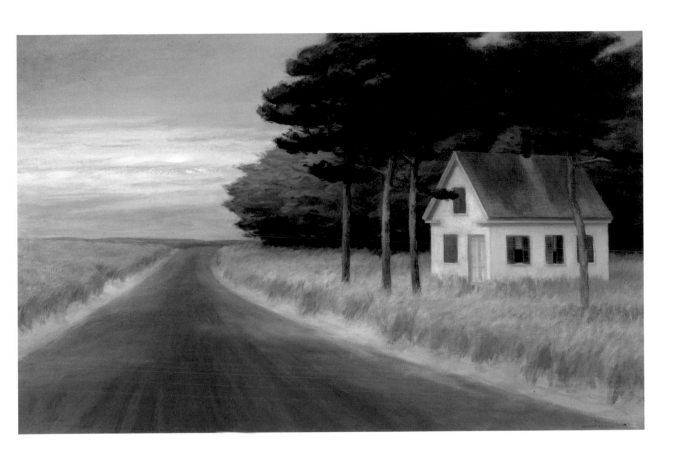

Pl. 35 SOLITUDE #56, 1944
Oil on canvas, 32 x 50 inches (81.3 x 127 cm)
Private collection

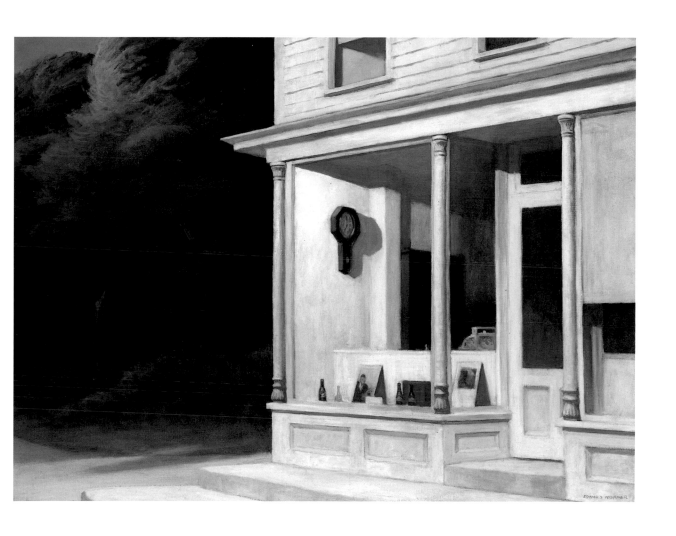

Pl. 36 SEVEN A.M., 1948
Oil on canvas, 30 x 40 inches (76.2 x 101.6 cm)
Whitney Museum of American Art, New York; Purchase and exchange 50.8

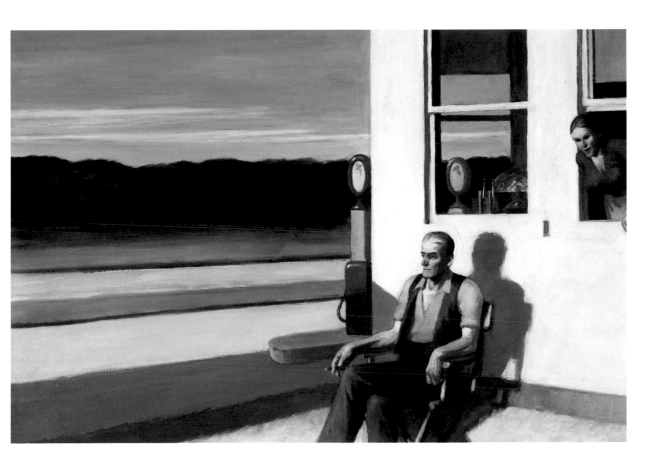

Pl. 37 FOUR LANE ROAD, 1956
Oil on canvas, 27 1/2 x 41 1/2 inches (69.9 x 105.4 cm)
Private collection

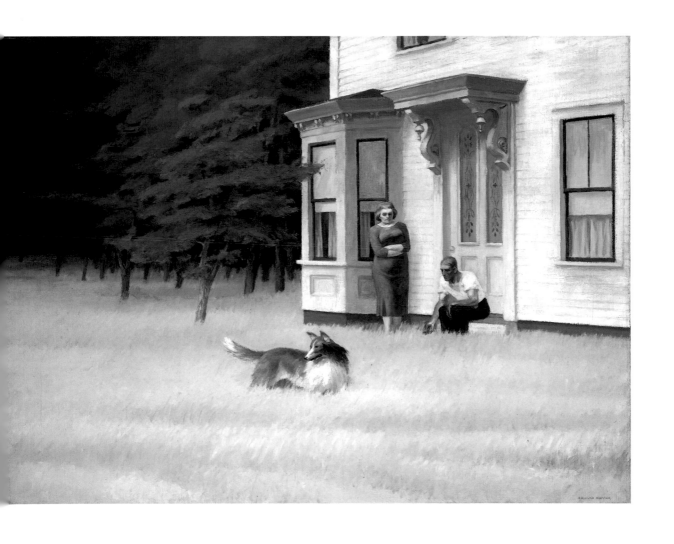

Pl. 38 CAPE COD EVENING, 1939
Oil on canvas, 30 1/4 x 40 1/4 inches (76.8 x 102.2 cm)
National Gallery of Art, Washington, D.C.; John Hay Whitney Collection

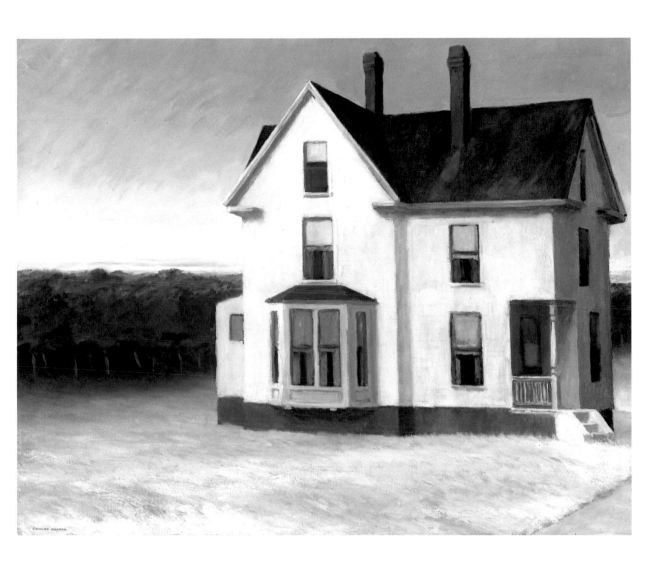

Pl. 39 CAPE COD SUNSET, 1934

Oil on canvas, 28 7/8 x 35 7/8 inches (73.3 x 91.1 cm)

Whitney Museum of American Art, New York; Josephine N. Hopper Bequest 70.1166

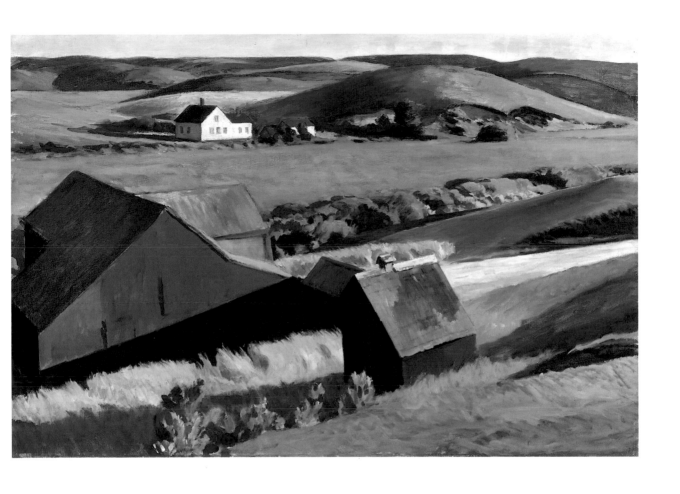

Pl. 40 COBB'S BARNS AND DISTANT HOUSES, 1930–33

Oil on canvas, 28 1/2 x 42 3/4 inches (72.4 x 108.6 cm)

Whitney Museum of American Art, New York; Josephine N. Hopper Bequest 70.1206

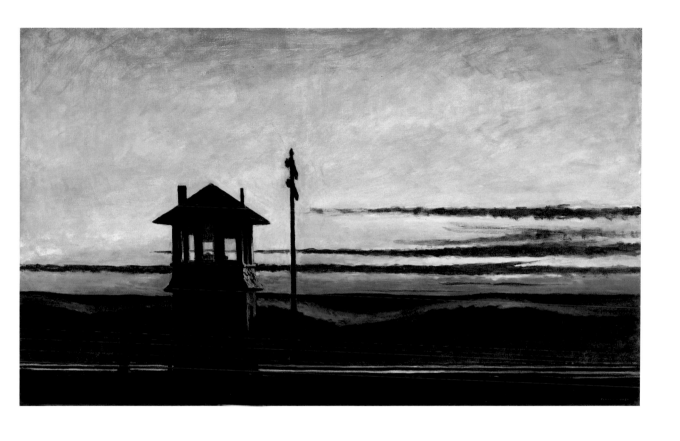

Pl. 41 RAILROAD SUNSET, 1929
Oil on canvas, 28 1/4 x 47 3/4 inches (71.8 x 121.3 cm)
Whitney Museum of American Art, New York; Josephine N. Hopper Bequest 70.1170

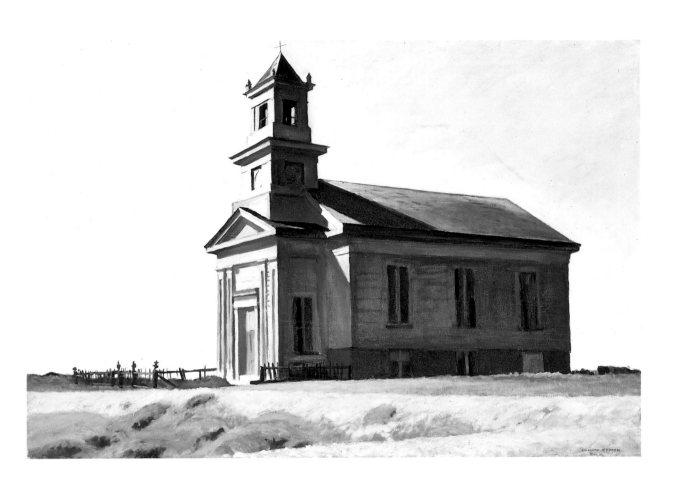

Pl. 42 SOUTH TRURO CHURCH, 1930
Oil on canvas, 29 x 43 inches (73.7 x 109.2 cm)
Private collection

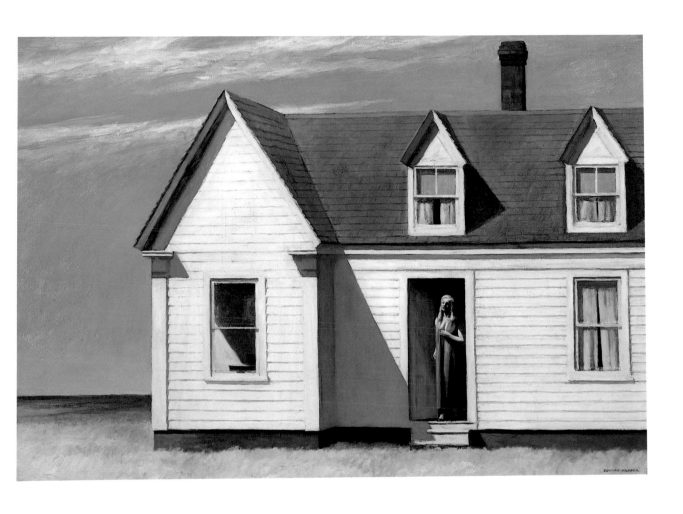

Pl. 43 HIGH NOON, 1949
Oil on canvas, 27 1/2 x 39 1/2 inches (69.9 x 100.3 cm)
The Dayton Art Institute, Ohio; Gift of Mr. and Mrs. Anthony Haswell

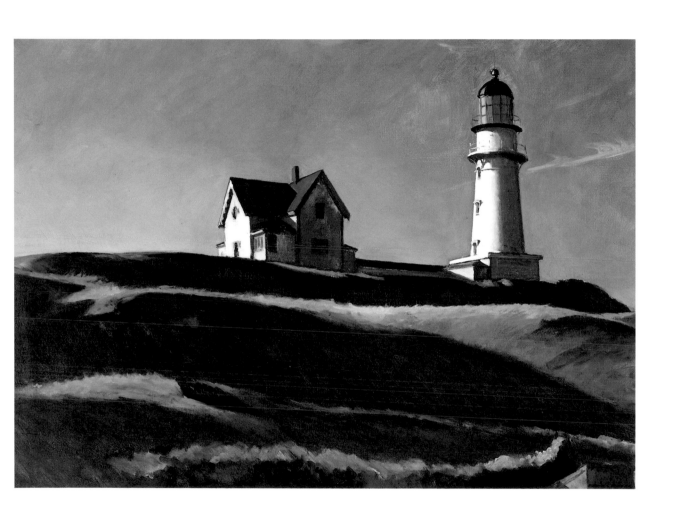

Pl. 44 LIGHTHOUSE HILL, 1927
Oil on canvas, 29 1/16 x 40 1/4 inches (73.8 x 102.2 cm)
Dallas Museum of Art; Gift of Mr. and Mrs. Maurice Purnell

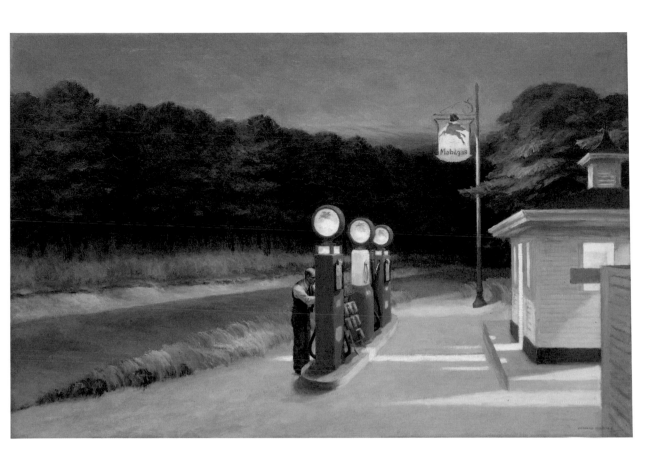

Pl. 45 GAS, 1940
Oil on canvas, 26 1/4 x 40 1/4 inches (66.7 x 102.2 cm)
The Museum of Modern Art, New York; Mrs. Simon Guggenheim Fund

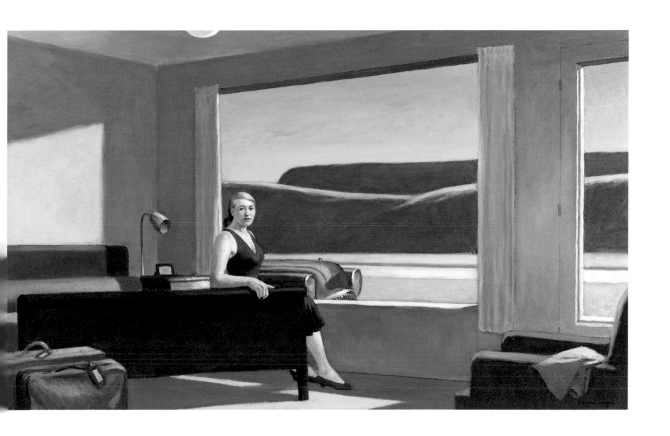

Pl. 46 WESTERN MOTEL, 1957
Oil on canvas, 30 1/4 x 50 1/8 inches (76.8 x 127.3 cm)
Yale University Art Gallery, New Haven, Connecticut; Bequest of Stephen Carlton Clark, B.A. 1903

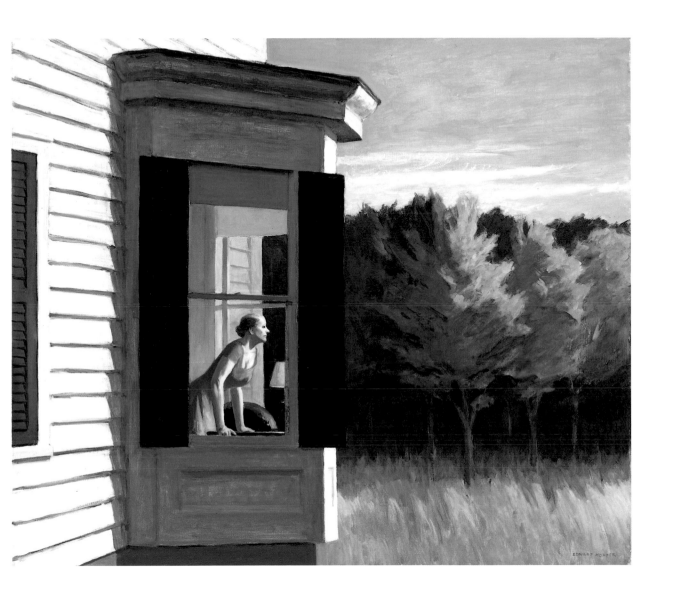

Pl. 47 CAPE COD MORNING, 1950
Oil on canvas, 34 1/8 x 40 1/4 inches (86.7 x 102.2 cm)
National Museum of American Art, Smithsonian Institution,
Washington, D.C.; Gift of the Sara Roby Foundation

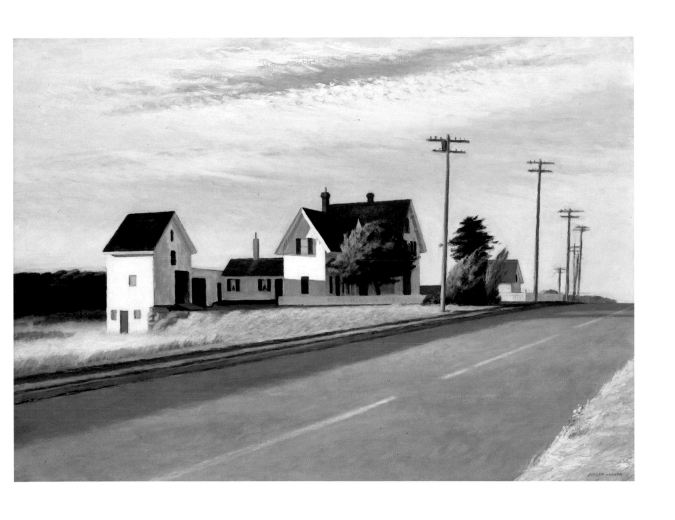

Pl. 48 ROUTE 6, EASTHAM, 1941

Oil on canvas, 27 1/2 x 38 1/4 inches (69.9 x 97.2 cm)

Sheldon Swope Art Museum, Terre Haute, Indiana

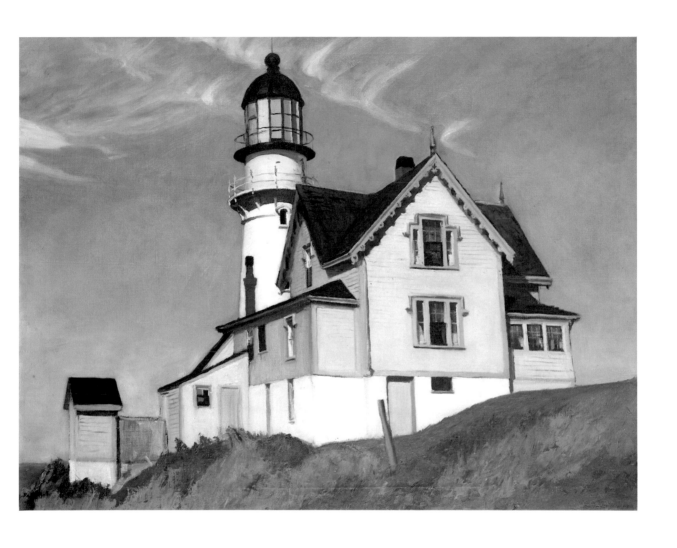

Pl. 49 CAPTAIN UPTON'S HOUSE, 1927

Oil on canvas, 28 x 36 inches (71.1 x 91.4 cm)

Collection of Steve Martin

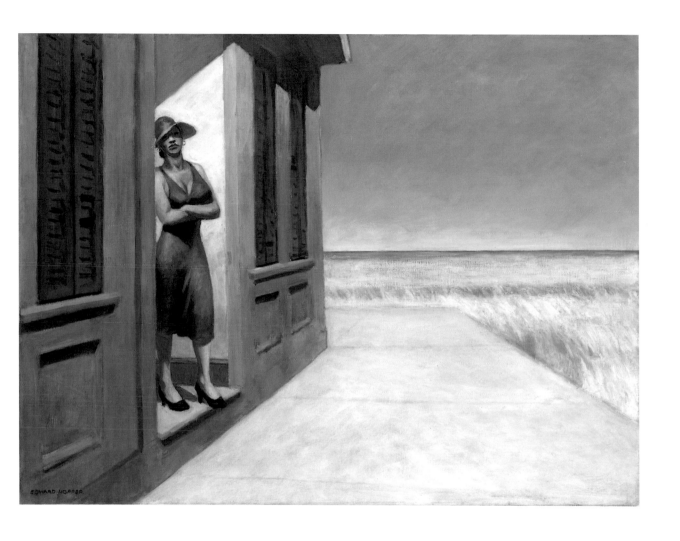

Pl. 50 SOUTH CAROLINA MORNING, 1955

Oil on canvas, 30 x 40 inches (76.2 x 101.6 cm)

Whitney Museum of American Art, New York; Given in memory of Otto L. Spaeth by his Family 67.13

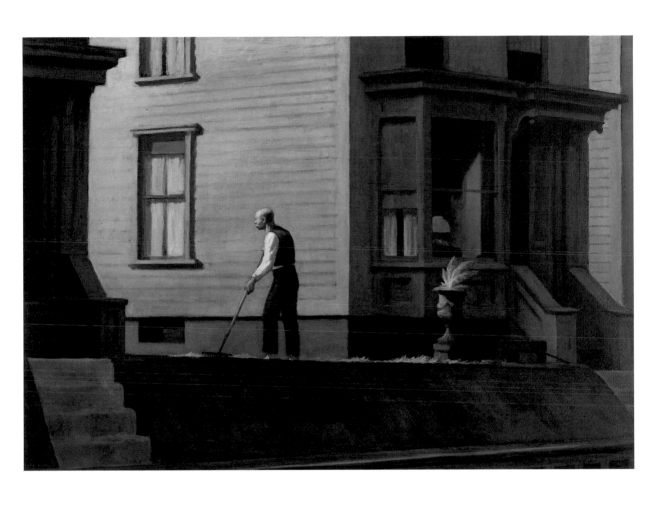

Pl. 51 PENNSYLVANIA COAL TOWN, 1947
Oil on canvas, 28 x 40 inches (71.1 x 101.6 cm)
The Butler Institute of American Art, Youngstown, Ohio

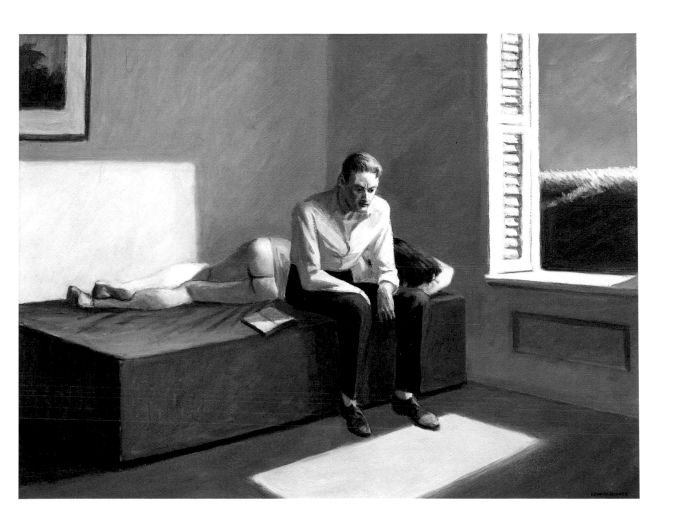

Pl. 52 EXCURSION INTO PHILOSOPHY, 1959

Oil on canvas, 30 x 40 inches (76.2 x 101.6 cm)

Collection of Richard M. Cohen

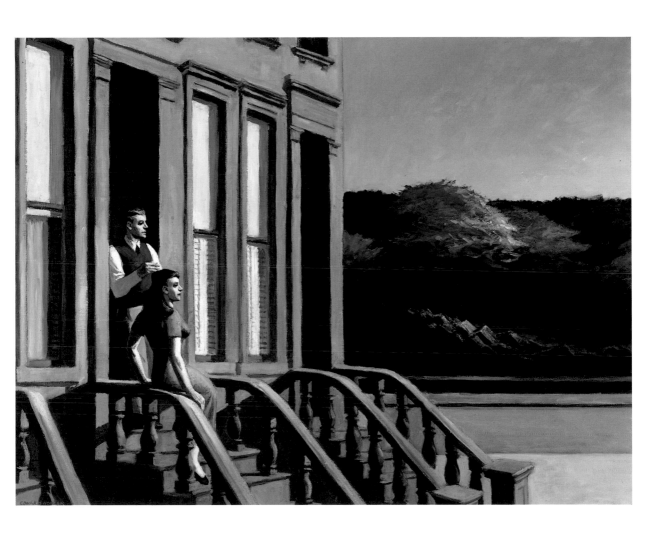

Pl. 53 SUNLIGHT ON BROWNSTONES, 1956
Oil on canvas, 30 3/8 x 40 1/8 inches (77.2 x 102 cm)
Wichita Art Museum, Kansas; Roland P. Murdock Collection

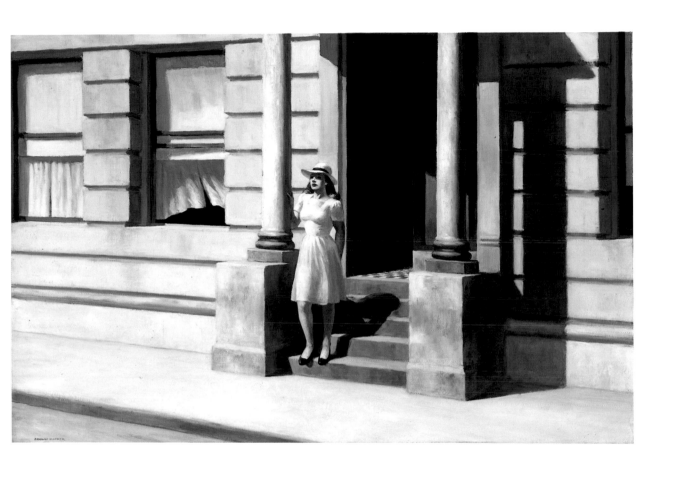

Pl. 54 SUMMERTIME, 1943
Oil on canvas, 29 1/8 x 44 inches (74 x 111.8 cm)
Delaware Art Museum, Wilmington; Gift of Dora Sexton Brown

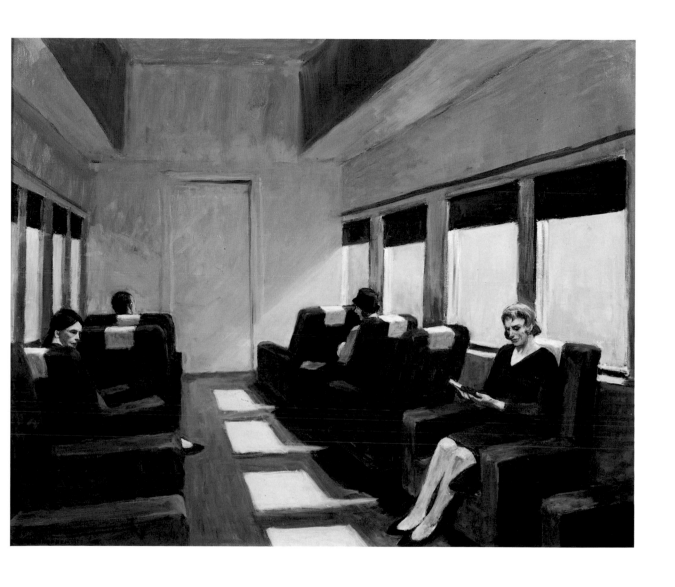

Pl. 55 CHAIR CAR, 1965
Oil on canvas, 40 x 50 inches (101.6 x 127 cm)
Private collection

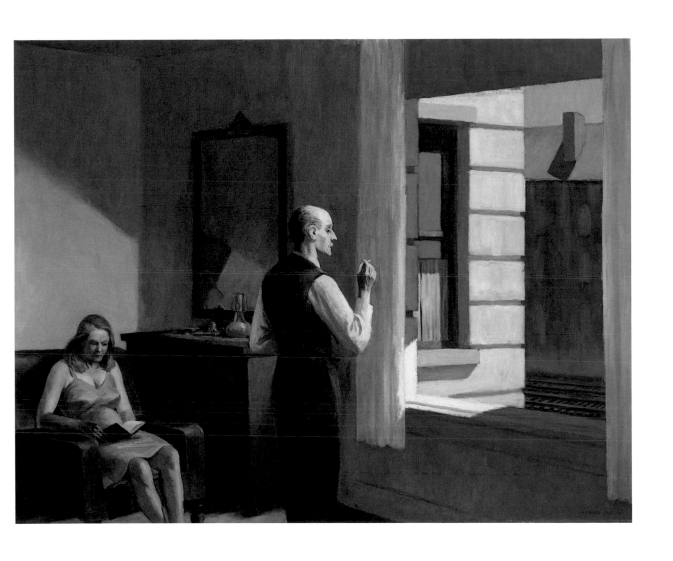

Pl. *56* HOTEL BY A RAILROAD, 1952
Oil on canvas, 31 1/4 x 40 1/8 inches (79.4 x 101.9 cm)
Hirshhorn Museum and Sculpture Garden, Smithsonian Institution,
Washington, D.C.; Gift of the Joseph H. Hirshhorn Foundation, 1966

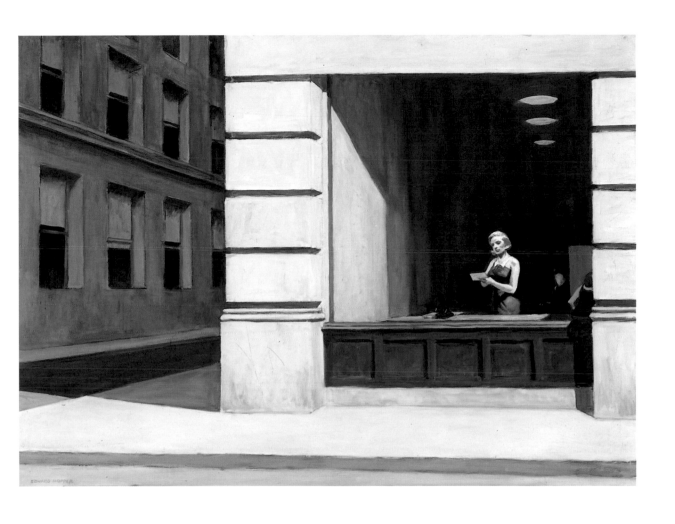

Pl. 57 NEW YORK OFFICE, 1962
Oil on canvas, 40 x 55 inches (101.6 x 139.7 cm)
Montgomery Museum of Fine Arts, Alabama; The Blount Collection

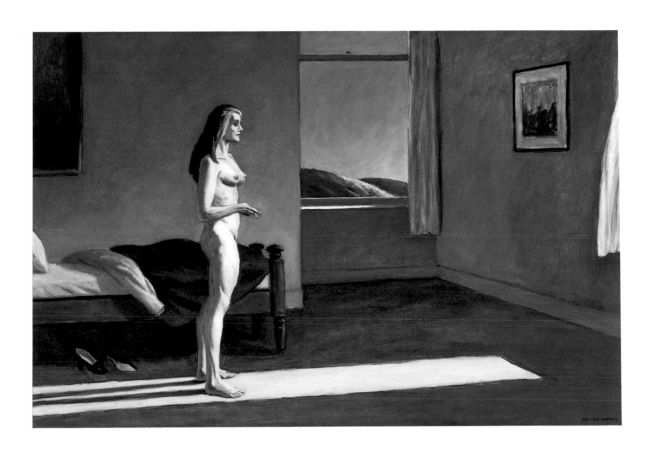

Pl. 58 A WOMAN IN THE SUN, 1961

Oil on canvas, 40 x 60 inches (101.6 x 152.4 cm)

Whitney Museum of American Art, New York; 50th Anniversary Gift

of Mr. and Mrs. Albert Hackett in honor of Edith and Lloyd Goodrich 84.31

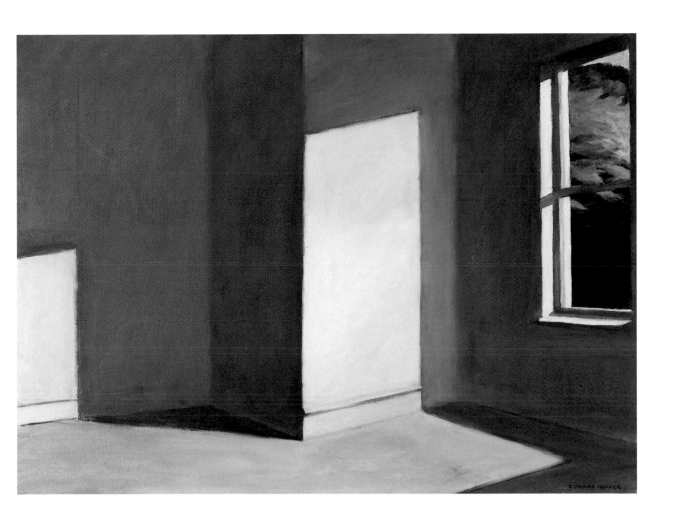

PL. 59 SUN IN AN EMPTY ROOM, 1963
Oil on canvas, 28 3/4 x 39 1/2 inches (73 x 100.3 cm)
Private collection

INDEX OF PLATES

NOTES ON THE CONTRIBUTORS

·Paul Auster is the author of ·The New York Trilogy, The Invention of Solitude, In the Country of Last Things, Moon Palace, The Music of Chance, Leviathan, and Mr. Vertigo, among other books. He lives in Brooklyn, New York.

Ann Beattie's recent works include Picturing Will, What Was Mine, and the forthcoming Another You. She lives in Charlottesville, Virginia, and Maine.

Tess Gallagher's poetry collections include Amplitude, Portable Kisses, and Moon Crossing Bridge. She is also the author of A Concert of Tenses, a collection of essays on poetry, and The Lover of Horses and Other Stories. She lives in Port Angeles, Washington.

Thom Gunn's most recent works include The Passages of Joy, The Man with Night Sweats, and Collected Poems. His honors include a Lila Acheson Wallace/Reader's Digest Fellowship (1991), a MacArthur Fellowship (1993), and the Lenore Marshall/Nation Poetry Prize (1993). He lives in San Francisco.

John Hollander's most recent books are Tesserae and Selected Poetry; forthcoming is The Gazer's Spirit. He was awarded the Bollingen Prize (1983) and a MacArthur Fellowship (1990). He teaches at Yale University.

William Kennedy is a lifelong resident of Albany, New York. His novels include Legs, Billy Phelan's Greatest Game, Ironweed (which was awarded the Pulitzer Prize in 1983), Quinn's Book, and Very Old Bones.

Galway Kinnell lives in Vermont and New York City. His works include What a Kingdom It Was, Mortal Acts, Mortal Words, When One Has Lived a Long Time Alone, Imperfect Thirst, and Selected Poems, which was awarded both the National Book Award and the Pulitzer Prize in 1982. A former MacArthur Fellow, he is the state poet of Vermont.

Ann Lauterbach lives in New York. Her books include *Clamor* and *And For Example*. She was the recipient of a 1993 MacArthur Fellowship.

Gail Levin is professor of art history at Baruch College and The Graduate School of The City University of New York. Among her most recent books on Edward Hopper are *Edward Hopper: A Catalogue Raisonné* and the forthcoming *Edward Hopper: An Intimate Biography*.

Norman Mailer is the author of twenty-seven books, including *The Naked and the Dead*, *Armies of the Night* (which won the National Book Award and the Pulitzer Prize in 1968), *The Executioner's Song* (which won the Pulitzer Prize in 1980), and, most recently, *Harlot's Ghost*. He lives in Brooklyn, New York.

Leonard Michaels' books include *The Men's Club*, *Going Places*, *I Would Have Saved Them If I Could*, *Shuffle*, and the forthcoming *A Cat*. His writing has been nominated for the National Book Award and the National Book Critics Circle Award. He lives in the Bay Area of California.

Walter Mosley is a native of Los Angeles who now lives in New York City. He is the author of *Devil in a Blue Dress*, *A Red Death*, *White Butterfly*, *Black Betty*, and the forthcoming *RL's Dream*.

Grace Paley lives in Vermont and New York City. Her books include *The Little Disturbances of Man*, *Enormous Changes at the Last Minute*, *Later the Same Day*, and *Collected Stories*.

James Salter is the author of *A Sport and a Pastime*, *Light Years*, *Solo Faces*, and *Dusk*, which won the PEN/Faulkner Award in 1989. He lives in New York and Colorado.

WHITNEY MUSEUM OF AMERICAN ART
OFFICERS AND TRUSTEES

Leonard A. Lauder, *Chairman*

Gilbert C. Maurer, *President*

Nancy Brown Wellin, *Vice Chairman*

Robert W. Wilson, *Vice Chairman*

Joanne Leonhardt Cassullo, *Vice President*

Sondra Gilman Gonzalez-Falla,
 Vice President

Emily Fisher Landau, *Vice President*

Adriana Mnuchin, *Vice President*

Stephen E. O'Neil, *Vice President*

Joel S. Ehrenkranz, *Treasurer*

David A. Ross, *Alice Pratt Brown Director*

Flora Miller Biddle, *Honorary Chairman*

Murray H. Bring

Joan Hardy Clark

Beth Rudin DeWoody

Fiona Donovan

Arthur Fleischer, Jr.

Henry Louis Gates, Jr.

Philip H. Geier, Jr.

Robert F. Greenhill

David W. Harleston

Robert J. Hurst

George S. Kaufman

Henry Kaufman

Raymond J. Learsy

Thomas H. Lee

Douglas B. Leeds

John A. Levin

Faith Golding Linden

Raymond J. McGuire

Peter Norton

H. Charles Price

Allen Questrom

Stephen A. Schwarzman

Charles Simon

David M. Solinger, *Honorary President*

Thurston Twigg-Smith

William S. Woodside

B. H. Friedman, *Honorary Trustee*

Brendan Gill, *Honorary Trustee*

Susan Morse Hilles, *Honorary Trustee*

Michael H. Irving, *Honorary Trustee*

Roy R. Neuberger, *Honorary Trustee*

Thomas N. Armstrong III,
 Director Emeritus

WHITNEY MUSEUM OF AMERICAN ART
EXHIBITION ASSOCIATES
AS OF MARCH 1, 1995

Barbara and Bruce Berger
Susan and Alvin Chereskin
Carol and Maurice Feinberg
Sylvia Olnick Golber
Barbara S. Horowitz
Wendy and Peter T. Joseph
Estelle Konheim
Nanette Laitman
Barbara and Richard S. Lane
Evelyn and Leonard A. Lauder
Jane Lombard
Susan and Edwin Malloy
Ann and Gilbert Maurer
Adriana and Robert Mnuchin
Ruth and Herbert Schimmel
Joan and Jerome Serchuck
Sue Erpf Van de Bovenkamp
Rebecca Cooper Waldman and Michael Waldman
Nancy and Keith Wellin
Thea Westreich and Ethan Wagner
The Norman and Rosita Winston Foundation, Inc.

PHOTOGRAPH CREDITS

Michael Agee: pl. 5

Armen Photographers: pl. 26

Geoffrey Clements: pp. 120, 126; pls. 4, 29

Sheldan C. Collins: pls. 36, 50

Jim Frank: pl. 11

Neil Greentree: pl. 59

Bill Jacobson: pls. 41, 58

Ron Jennings: pl. 24

Robert E. Mates, Inc.: pl. 33

Henry Nelson: pls. 25, 53

Edward Paterson, Jr.: p. 124

Eric Pollitzer: pl. 35

Steven Sloman: © 1995 cover, pl. 29; © 1989 pls. 39, 40

Lee Stalsworth: pls. 27, 34, 56

Bill Swartz/BBS Images: pl. 43